FASHION FIRST

created by
DIANE KEATON
ASHLEY PADILLA

foreword by
RALPH LAUREN

FASHION FIRST

DIANE KEATON

RIZZOLI NEW YORK

New York · Paris · London · Milan

To Fashion, Forever.

FORE

Diane Keaton has always been my kind of woman. Ever since she came to my early fashion shows—before anyone knew her, before she played Michael Corleone's long suffering wife in *The Godfather*, and way before she won her Oscar as Best Actress in *Annie Hall* in 1977—we just clicked. I liked her style, and she liked mine. She understood what I loved and the women who inspired me, like Katherine Hepburn and Marlene Dietrich: they had an attitude and point of view. They were always stylish, but they weren't about fashion like Diane. I am often credited with dressing Diane in her Oscar-winning role as Annie Hall. Not so. Annie's style was Diane's style. Very eclectic. She loved floppy hats and oversized men's jackets. She loved dangly neckties and layers of sweaters and vests and cowboy boots. Around the same time, I sent models down the runway dressed like that. We shared a sensibility, but she had a style that was all her own.

WORD

Annie Hall was pure Diane Keaton. Since then, in real life, Diane has worn my clothes many times, but she has always made them totally her own. Look at the way she's wearing my mix of tweeds and plaids on the cover of this book. She's worn my tuxedos in black, in white, and in a dandy mix for the 2004 Oscars. When I brought my world of Ralph Lauren fashion shows to California last year, she wore a sleek black tuxedo and perched on the edge of her front row seat, clapping and giving back slaps to the models as they walked by. She's my greatest cheerleader—straight from the heart. Diane has always marched to the beat of her own drum, in the way she dresses and the way she lives. Whether she's on stage accepting an award or on a sidewalk walking her dog with her kids, she's always herself. Her style is not defined by the moment. It's not about trends. It's authentic and forever. It's Diane Keaton. One of a kind. My kind of woman.

RALPH LAUREN

THE EARLY DAYS

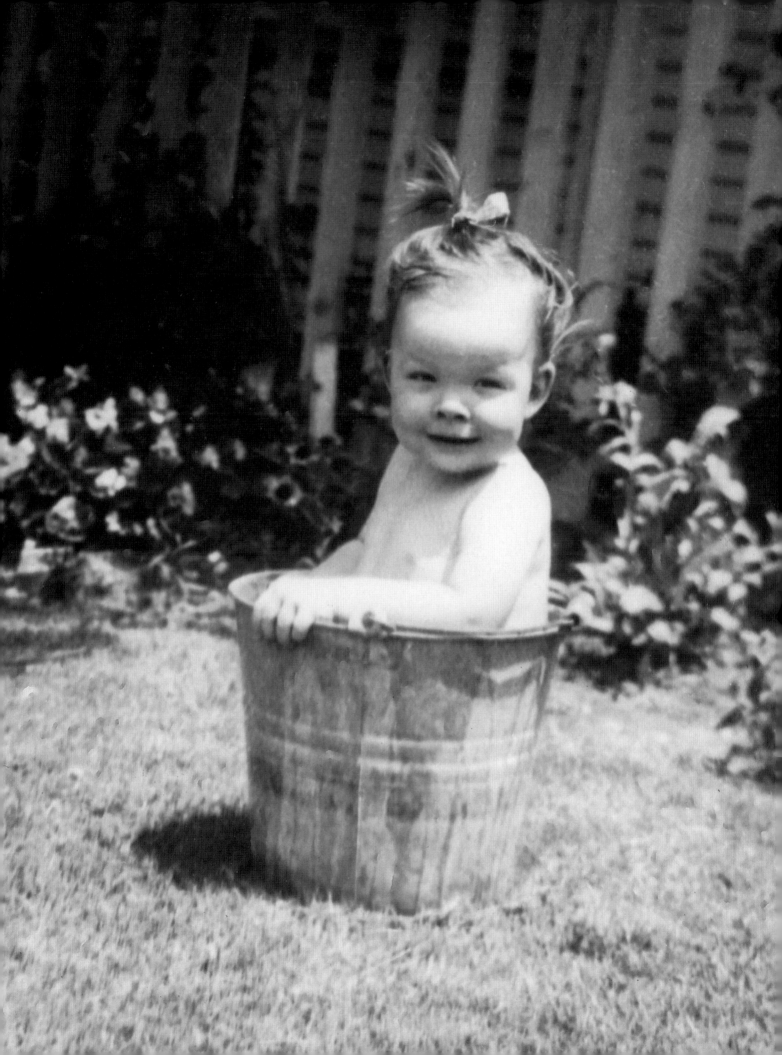

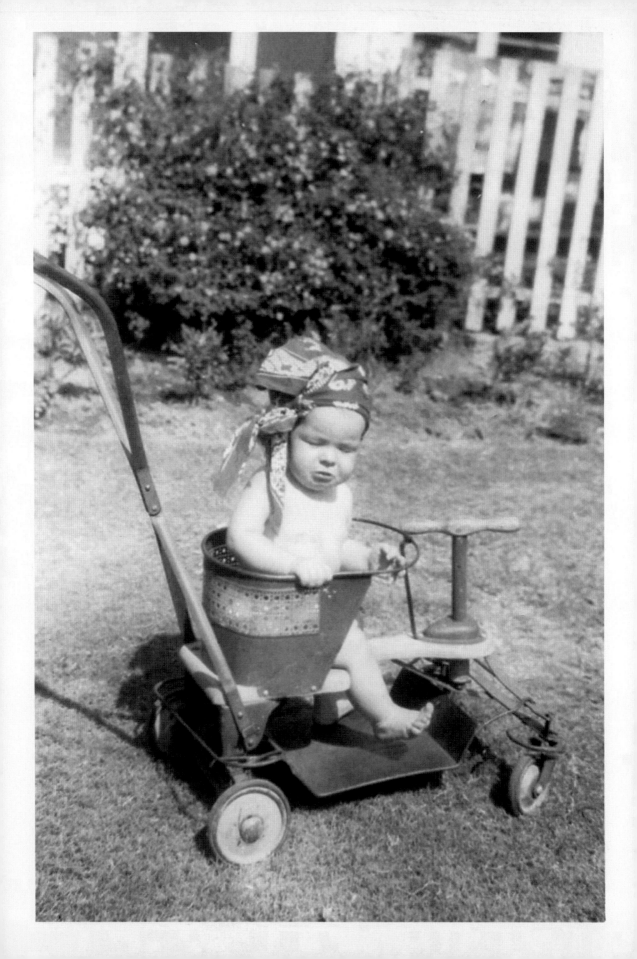

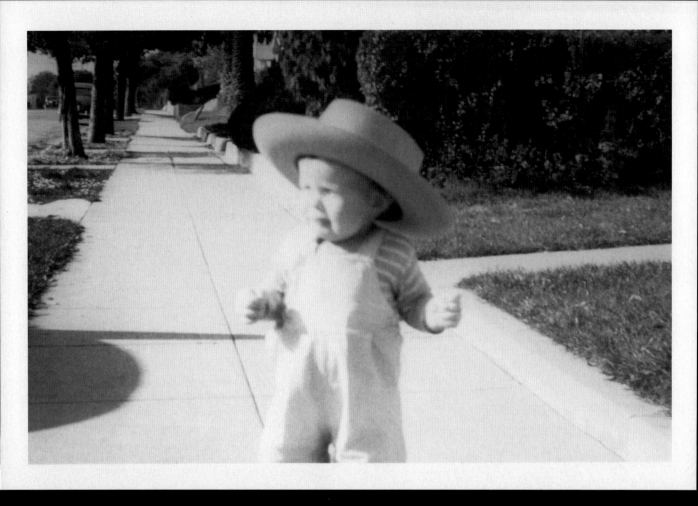

Like any baby, I had no say in what I wore. I did not have a choice in the scarf artfully wrapped around my head in the opposite photo. I did not pair the wide brimmed hat above with a striped long sleeve and a structured overall. No, I had nothing to do with any of that. (And by the looks of the scarf picture, I wasn't too pleased about it either.) My newborn style was at the whim of the most wonderful people in the world: my mother and my father.

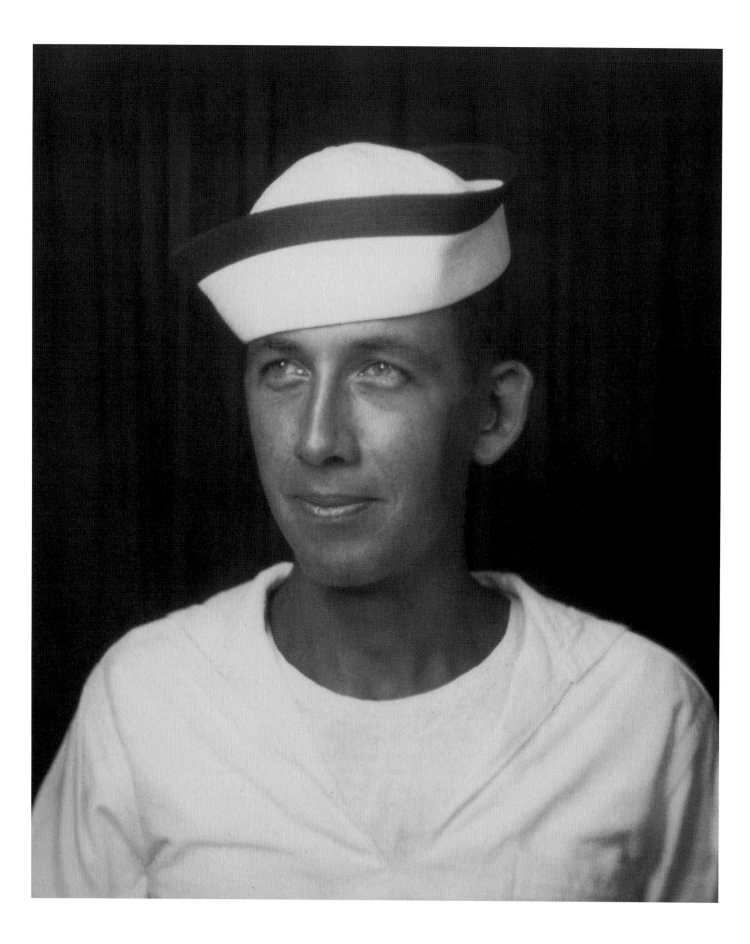

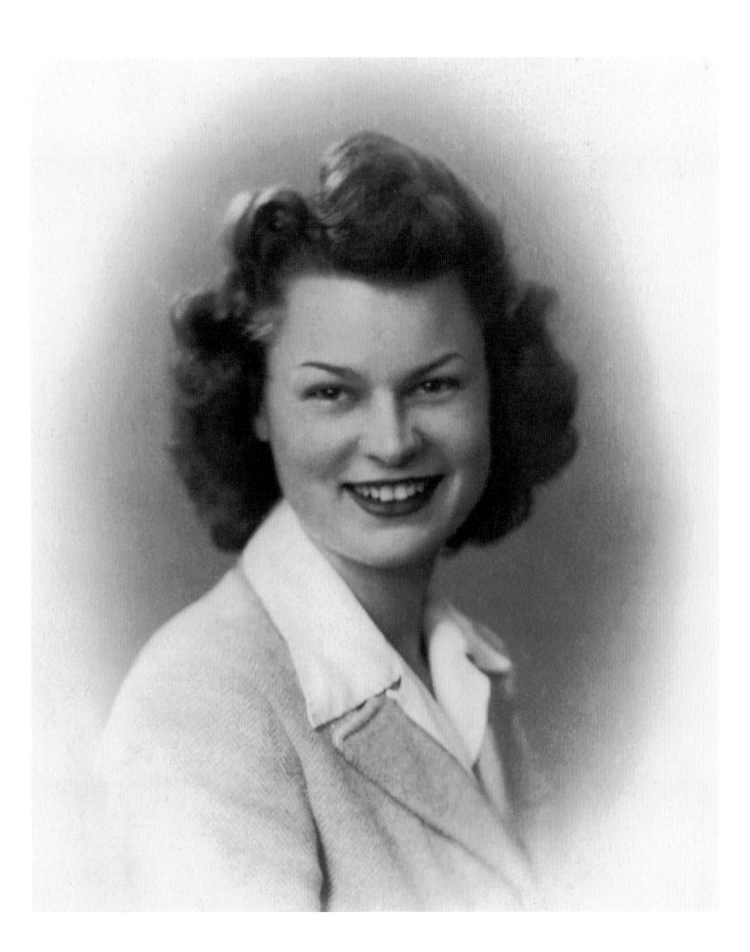

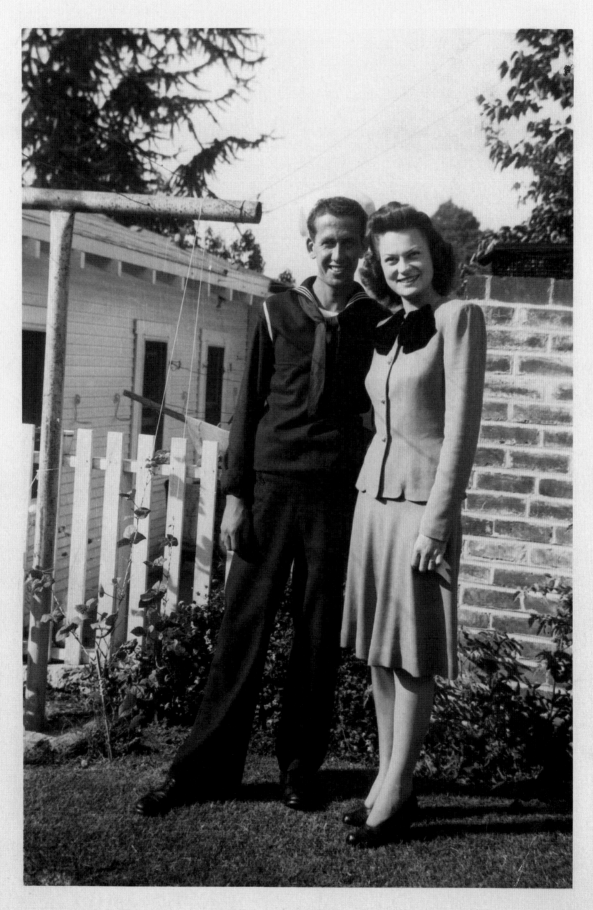

AUG. 8, 1943

Jack and Dorothy Hall were both effortlessly stylish in their own ways. Dad was a uniform kind of man. He looked handsome and cool in his Navy blues. In the 1940s, it was normal for men to wear their uniforms in daily life, and my father did it well. He was eager to wear his white "Dixie Cup" hat and navy wool pull-over adorned with a striped "tire flap" collar. Jack was, of course, showing he was proud to serve his country, but I also like think he just knew he looked great. My mother, on the other hand, was wearing a uniform of her own. The women of the '40s had mastered their look, and mom couldn't have been more adorable in her square-shouldered jacket with her matching fabric skirt and pumps. Mom loved to put an outfit together. There wasn't a moment when getting dolled up seemed like a chore for her. She absolutely loved it, and anyone could tell.

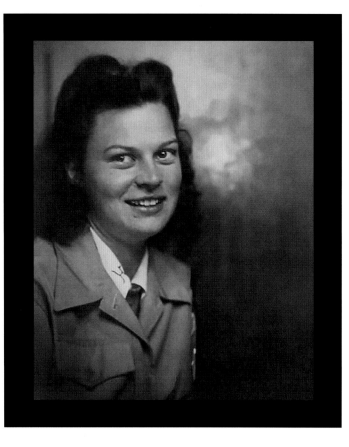

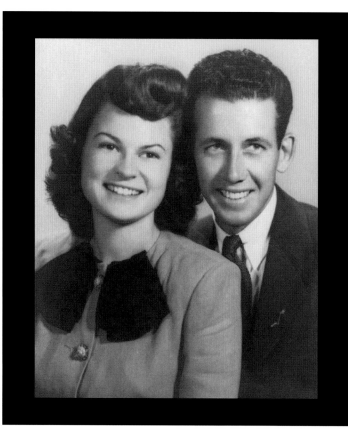

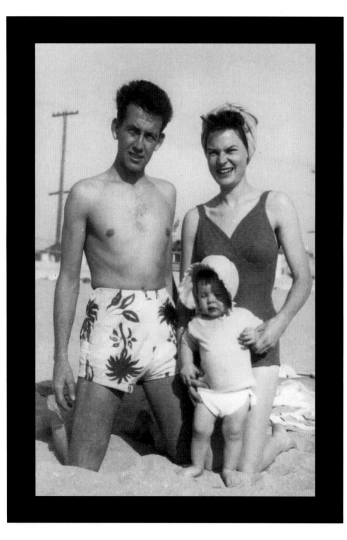

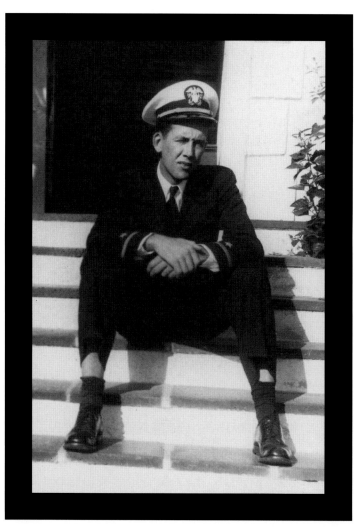

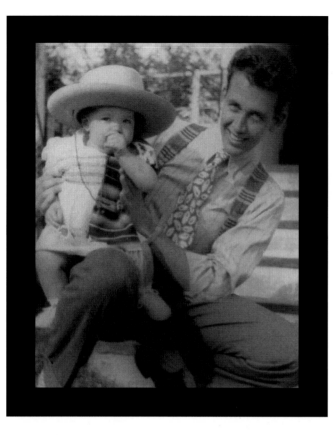
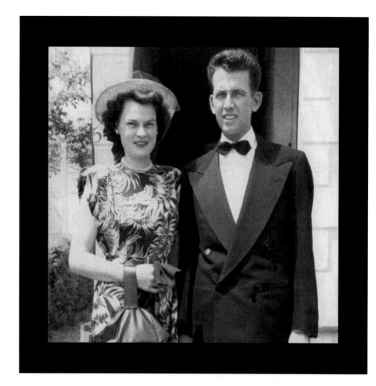
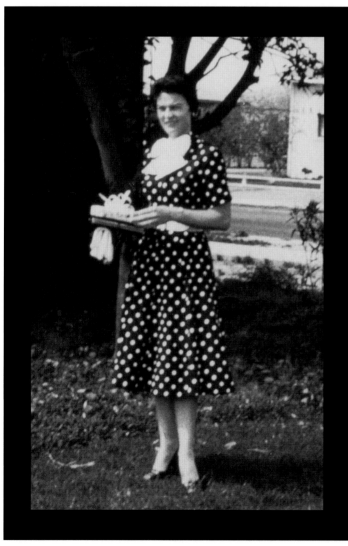
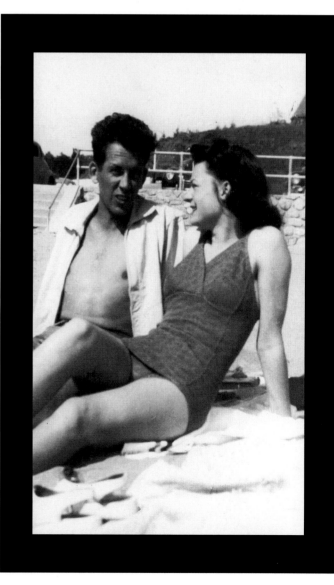

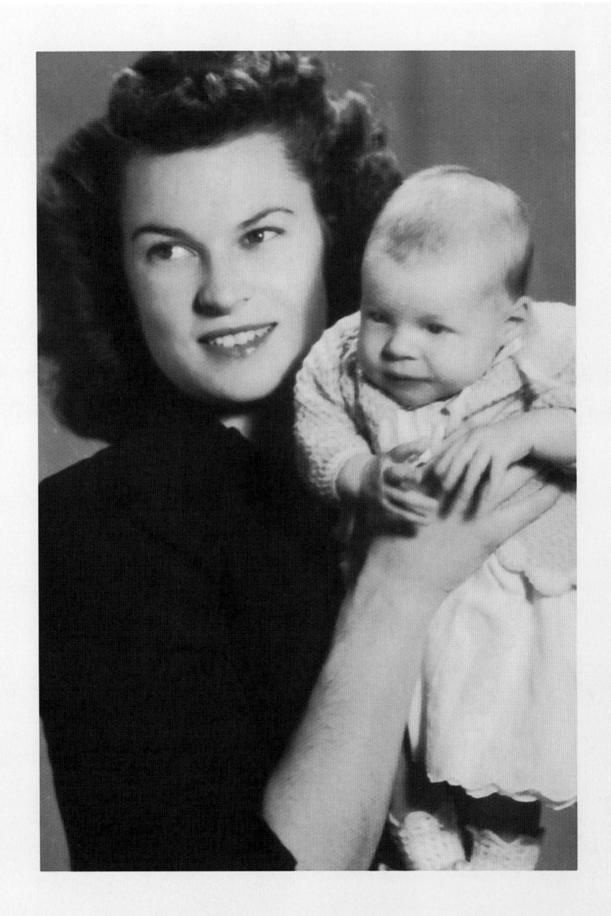

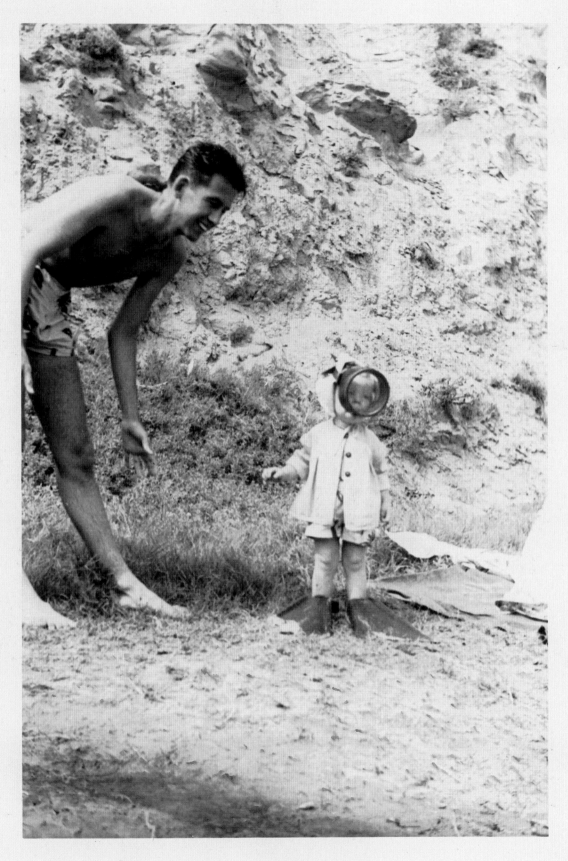

LAGUNA BEACH

My first "Toni" permanent.

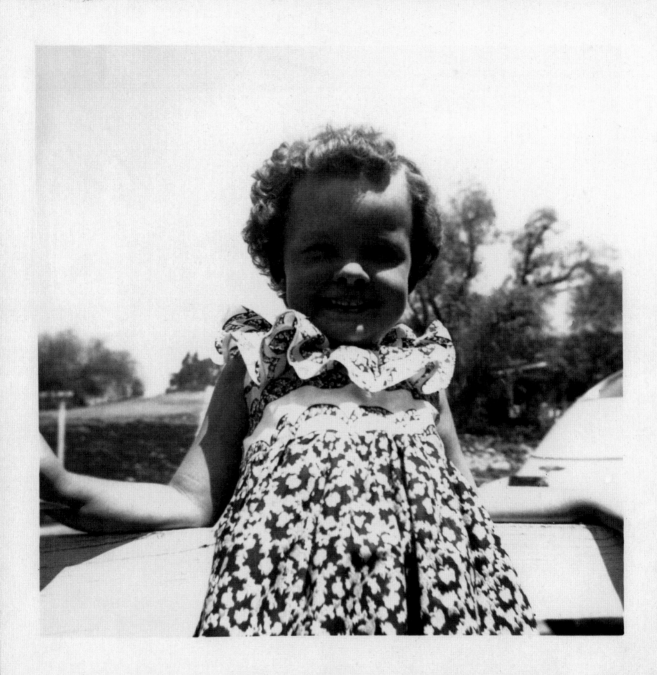

I think all first-born children can relate to the idea that because you are your parent's first child, you are essentially your parent's first doll. There is no better proof of that than when Mom gave me a perm at three.

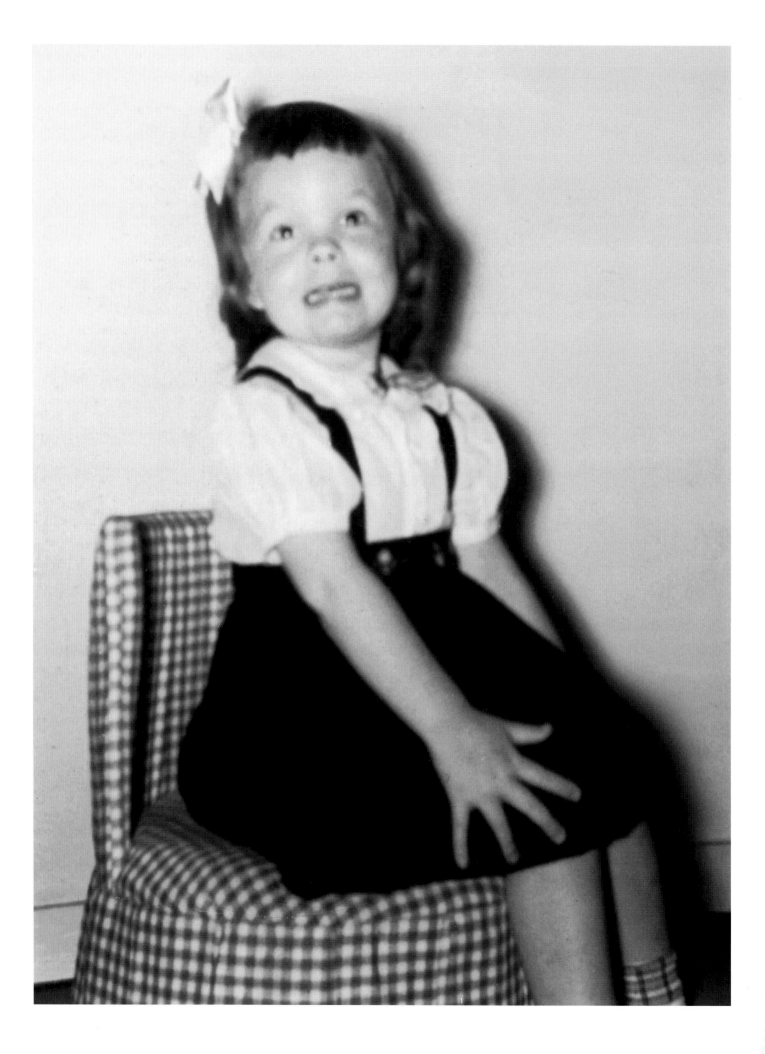

Dad finally came into some money in 1948 and was able to surprise Mom with a brand new sewing machine. Getting a sewing machine for the house was a tremendous luxury, and Mom didn't let it go to waste for a second. She accumulated fabrics and patterns seemingly overnight. She even began making patterns of her own, sewing me all kinds of coats and costumes and dresses. Making my clothes was definitely a money-conscious decision—there is no doubt about that. But my mom also just loved it. She loved to make things. She was an artist and a creator. Any chance she could take to sew me a dress, throw a bow on my head, and plop me in a chair, she would. And I would attempt to smile.

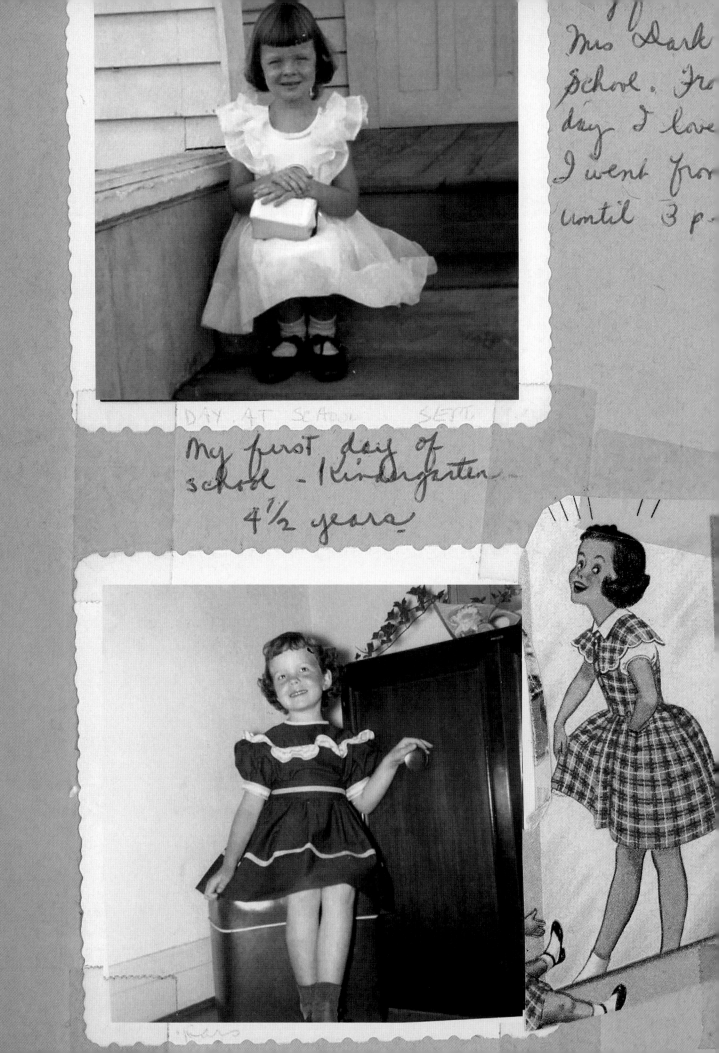

Mrs. Dark
School. Fr
day I love
I went fro
until 3 p.

DAY AT SCHOOL SEPT.

My first day of
school - Kindergarten
4½ years

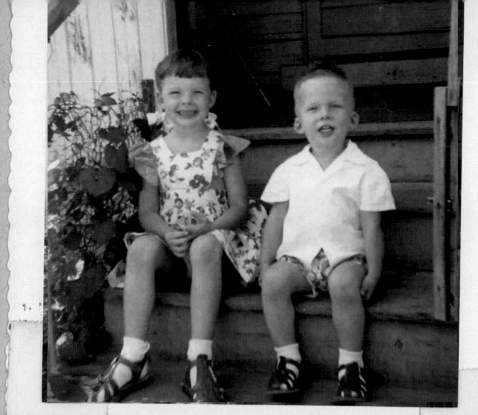

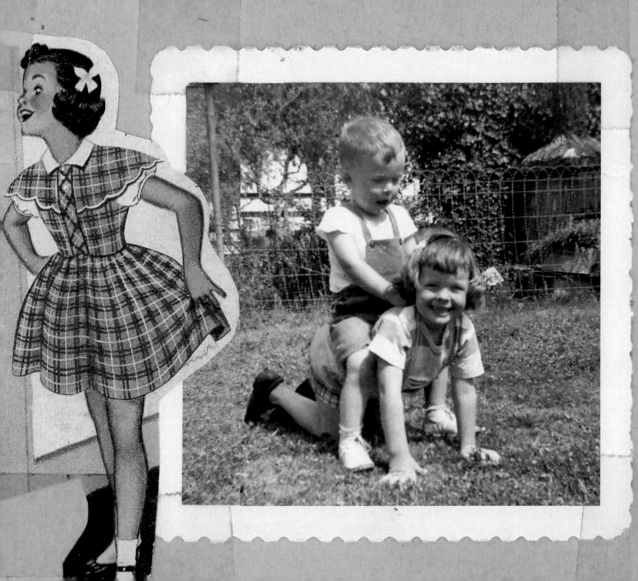

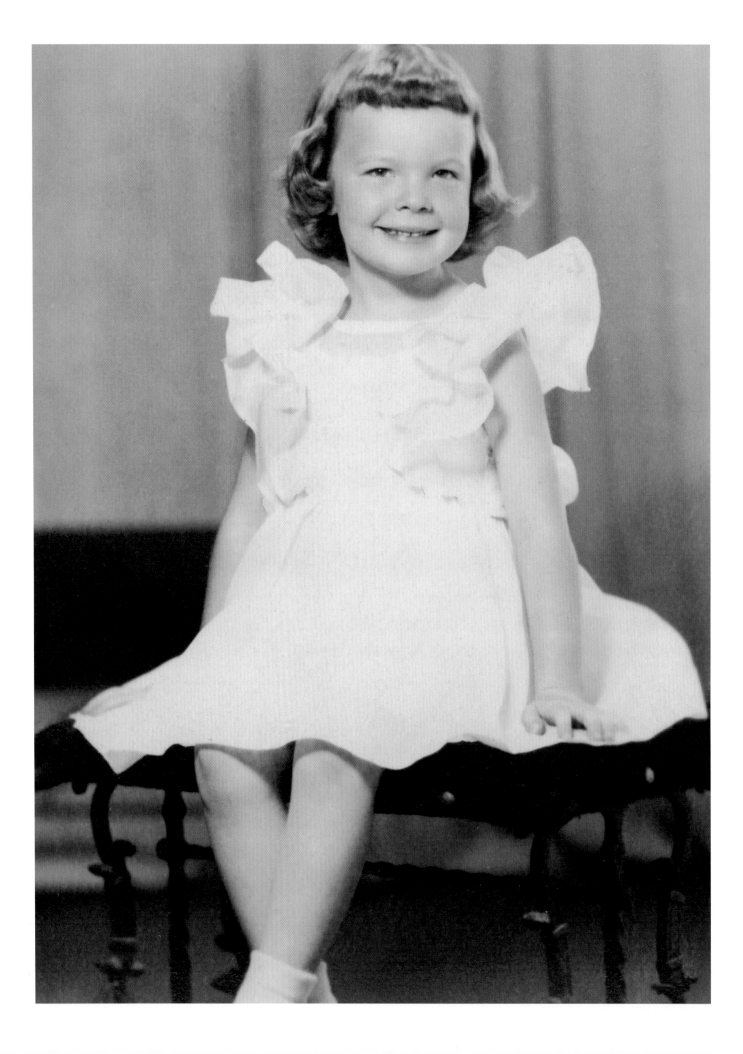

Along with being the family seamstress, my mother was also the family hair-dresser. (Remember the perm from before?) I am not sure who told her that bangs were to be cut this high, but I would love to meet that person and ask a few questions. Like, why? And...why?

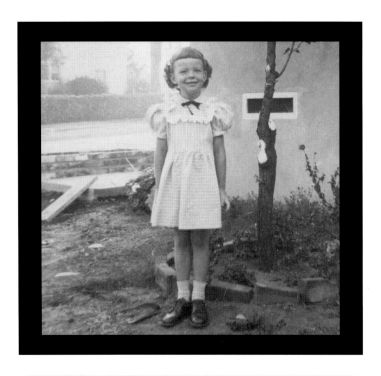
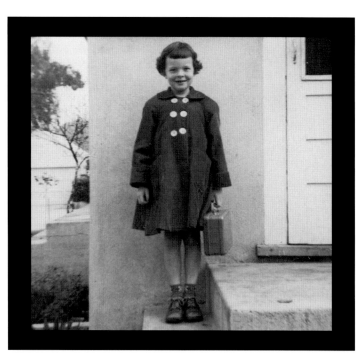
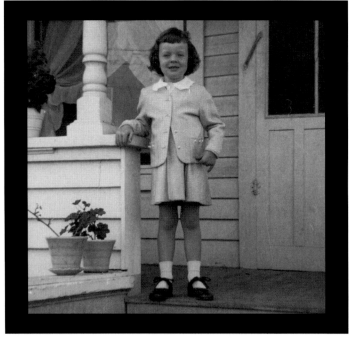
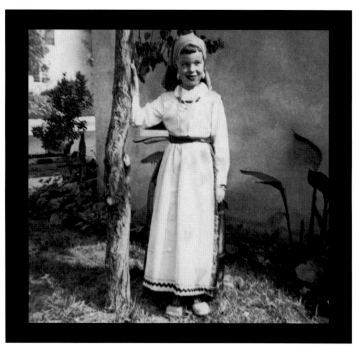

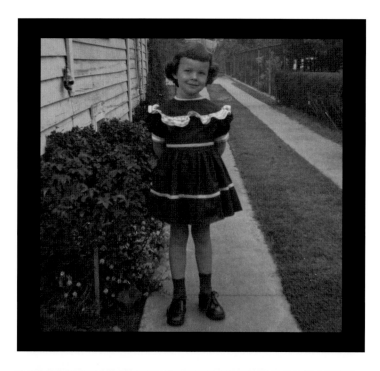
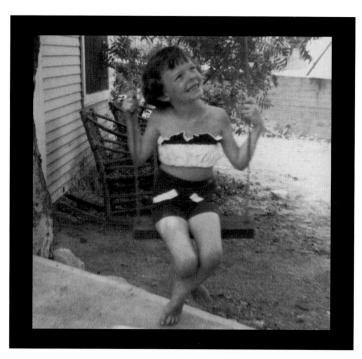
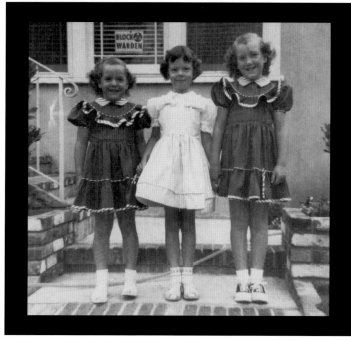
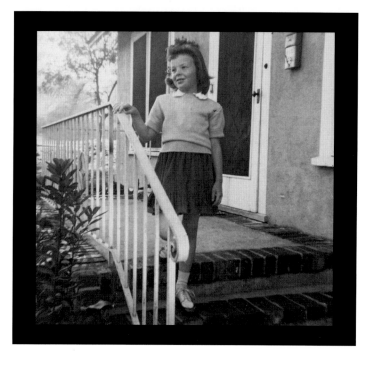

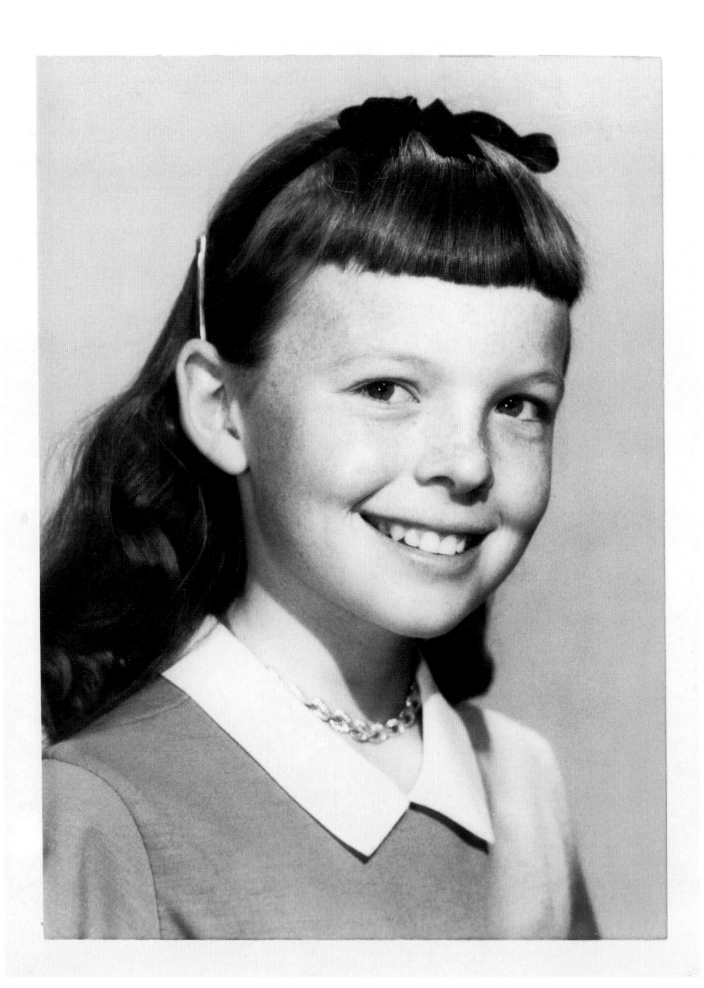

The bangs prevailed well into my early teen years. (It seems to have become a part of my identity at this point and therefore never to be questioned.) I also started to discover my love for jewelry and accessories: purses, bows, necklaces, and the occasional church hat. My mother continued to be fashionable throughout these years as well. Never resting on her appearance, she became my fashion inspiration. She was dolled up no matter what. And I was following right behind her, loving every minute of it.

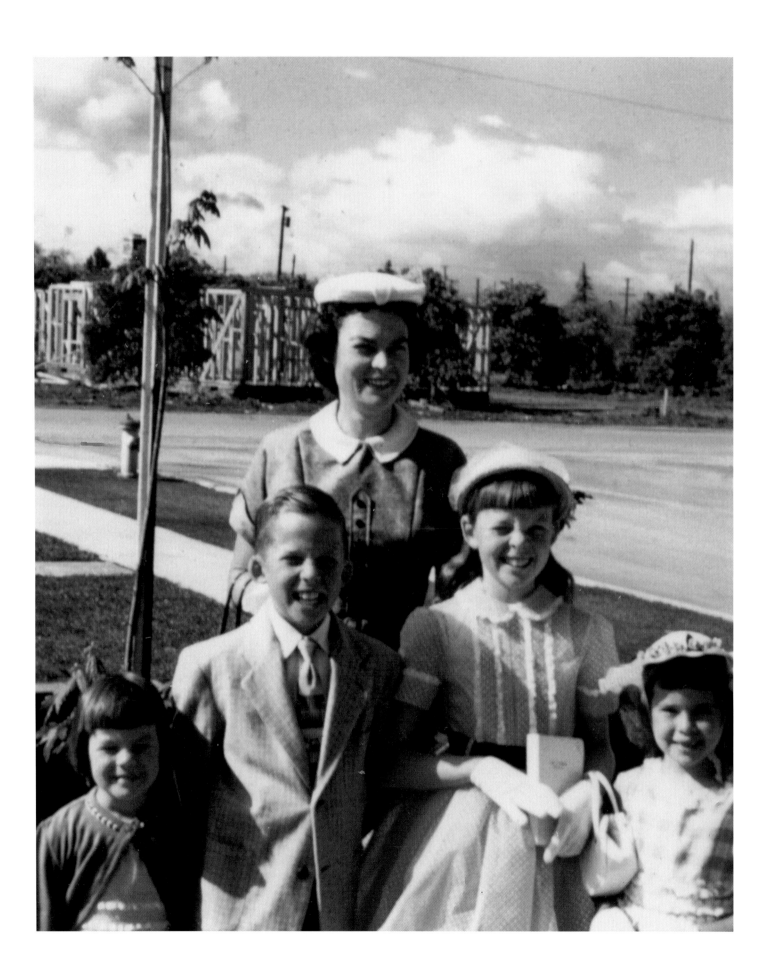

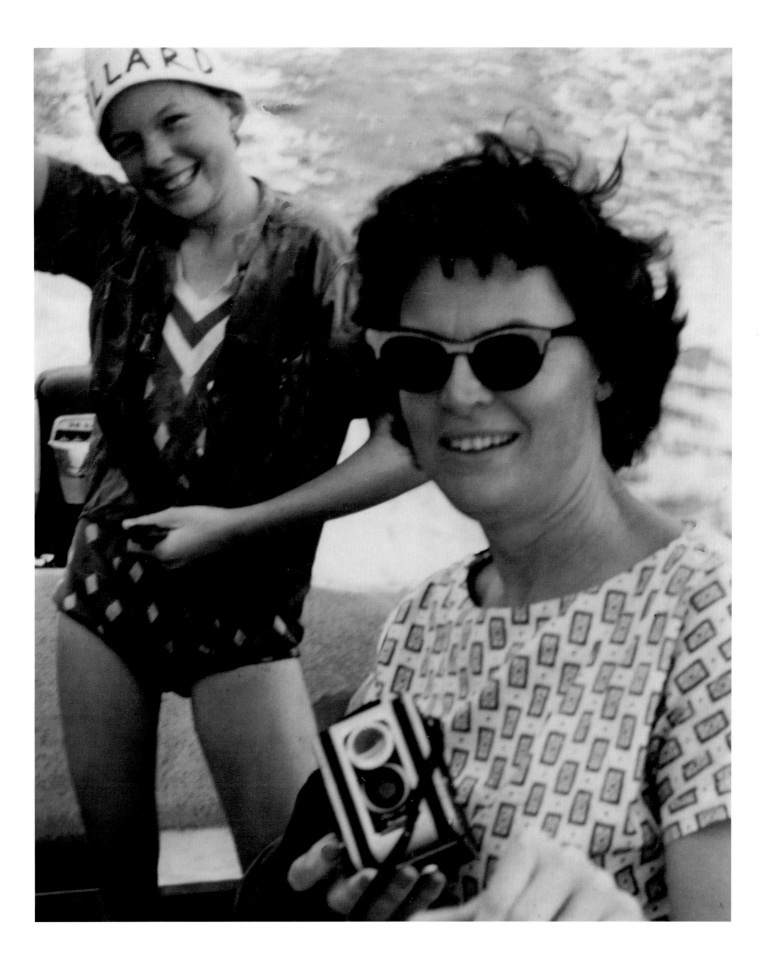

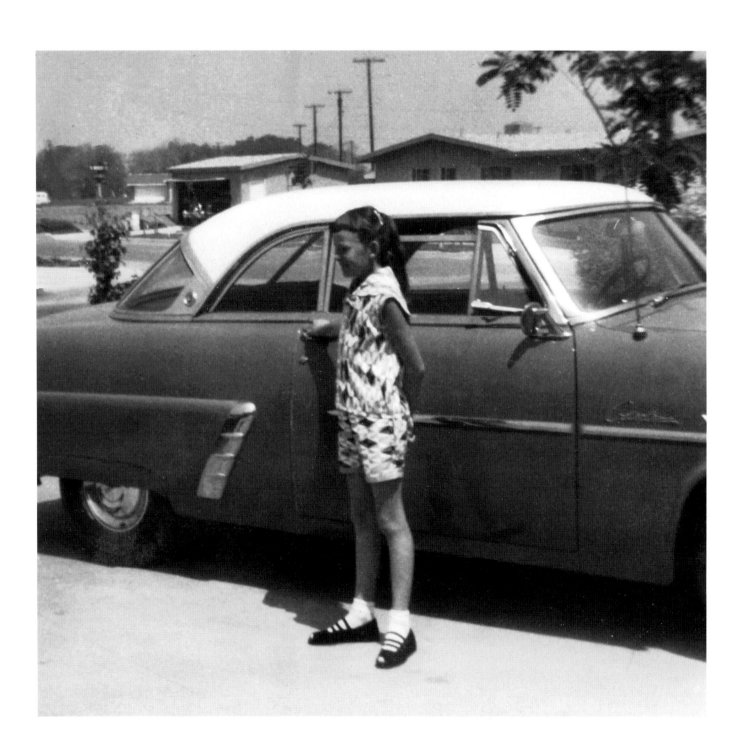

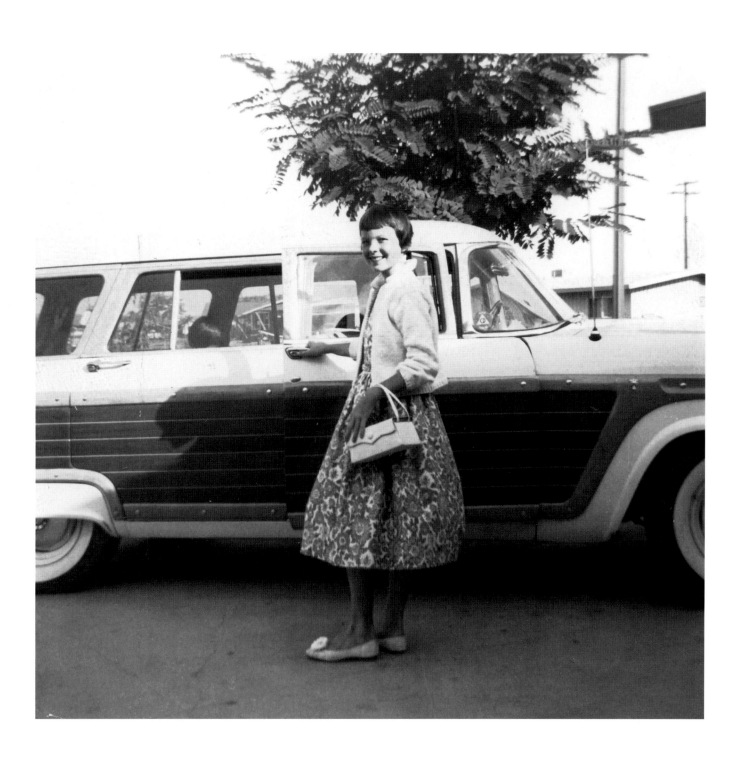

38

1960

The 1960s were a time of rebellion. And I don't mean going to a rock concert kind of rebellion (though I am sure that was also part of it.) Rebellion in the '60s for an eighteen-year-old girl was heavy eyeliner and short skirts. The shorter the skirt, the better. I had just finished high school, and I was experimenting with all kinds of ideas (as you will see.) Just like anybody at this age, I was figuring out what I, Diane, liked. I was already starting to show my true colors at the end of high school when I tried to wear a bowler hat to my prom, but my mother said, "Maybe another time, Diane." And the bowler hat stayed home. But once I was out of school, the world became my oyster. I chopped my hair and then chopped it again. I dyed it black. I wore dresses and light lipstick that practically made my lips disappear. I wore enough eyeliner to scare someone on the street. I wore rings and hairwraps and high-heeled boots. I discovered the Goodwill. I cut up clothes and hairsprayed my hair so much it could crack. I was having fun.

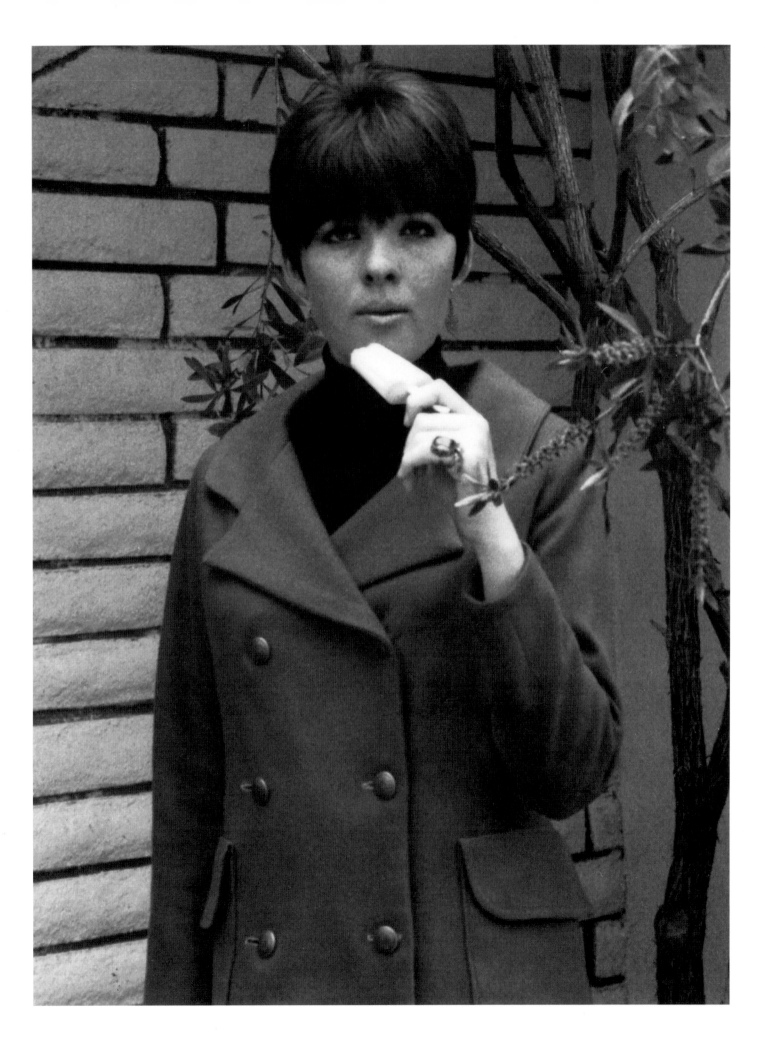

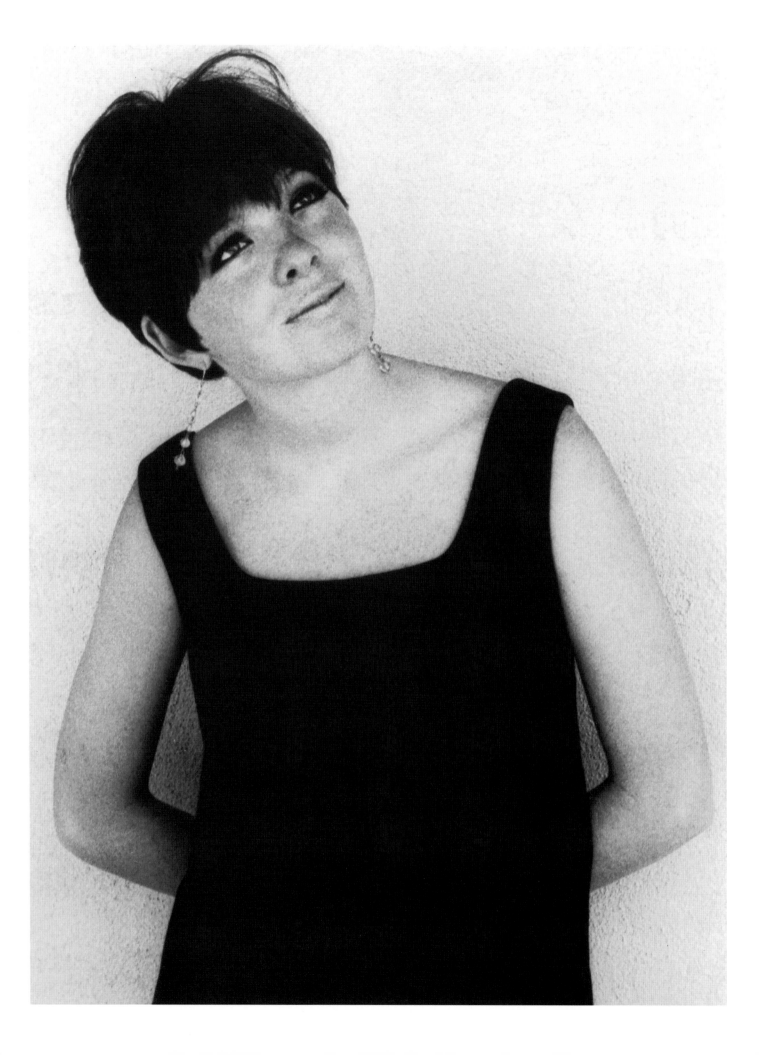

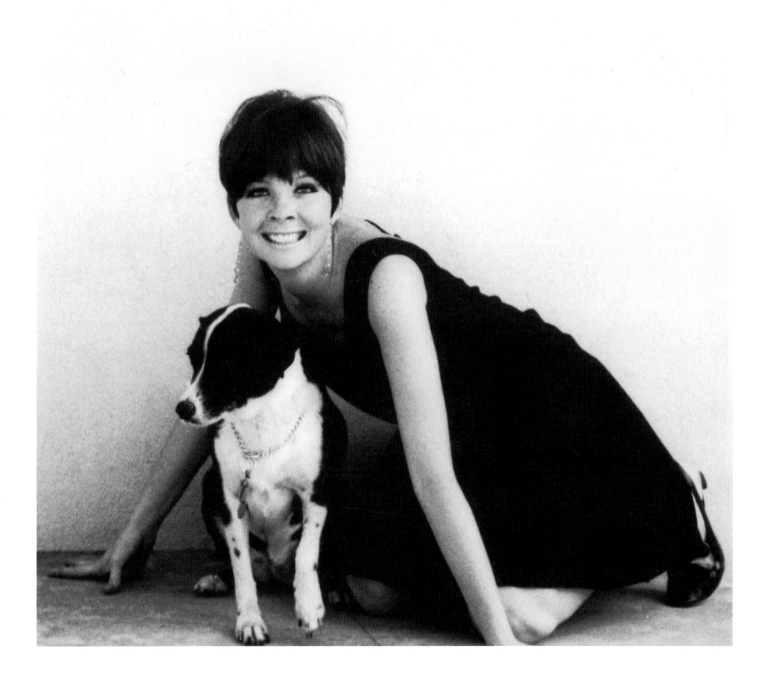

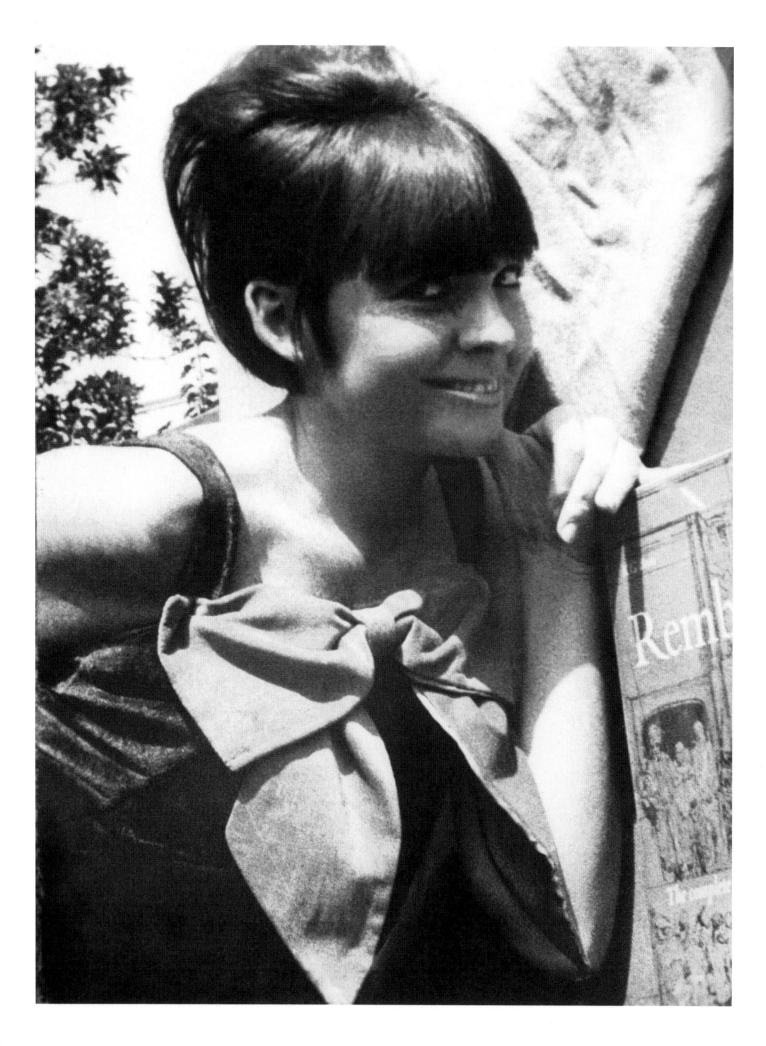

After high school, I became heavily involved in theater. I loved to act, yes, but I also just loved the clothes! Theater meant costumes. And costumes meant things like this photo: dresses with giant bows that had no place off the stage. (Not that that ever stopped me.) My mother continued to sew for me. She even made me this bow that we sewed onto a dress we found at the Goodwill. Our motto was "The bigger the better." I wanted my clothes to scream, "Hey! Look! Look over here!" I think we accomplished our goal.

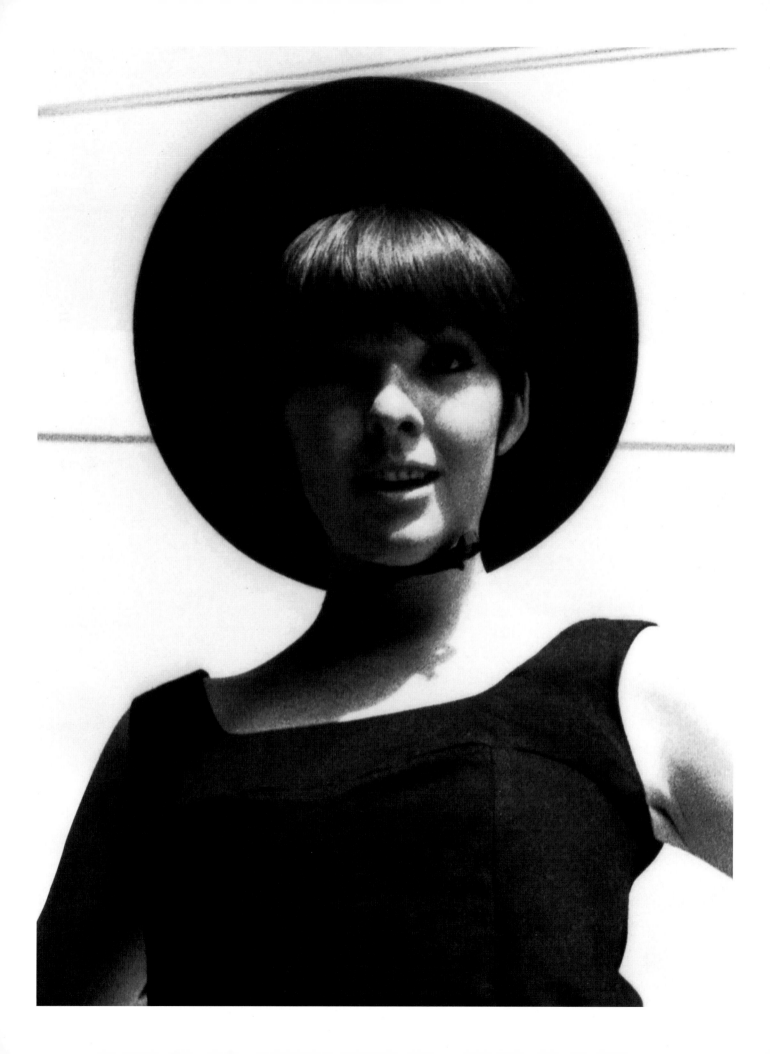

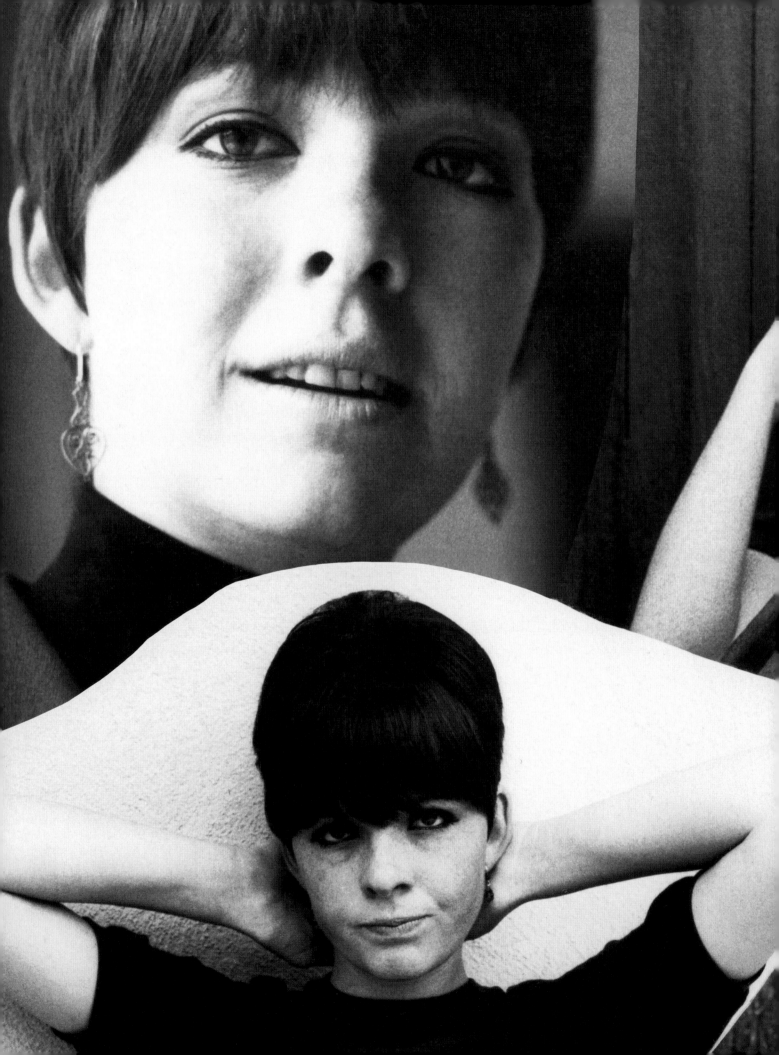

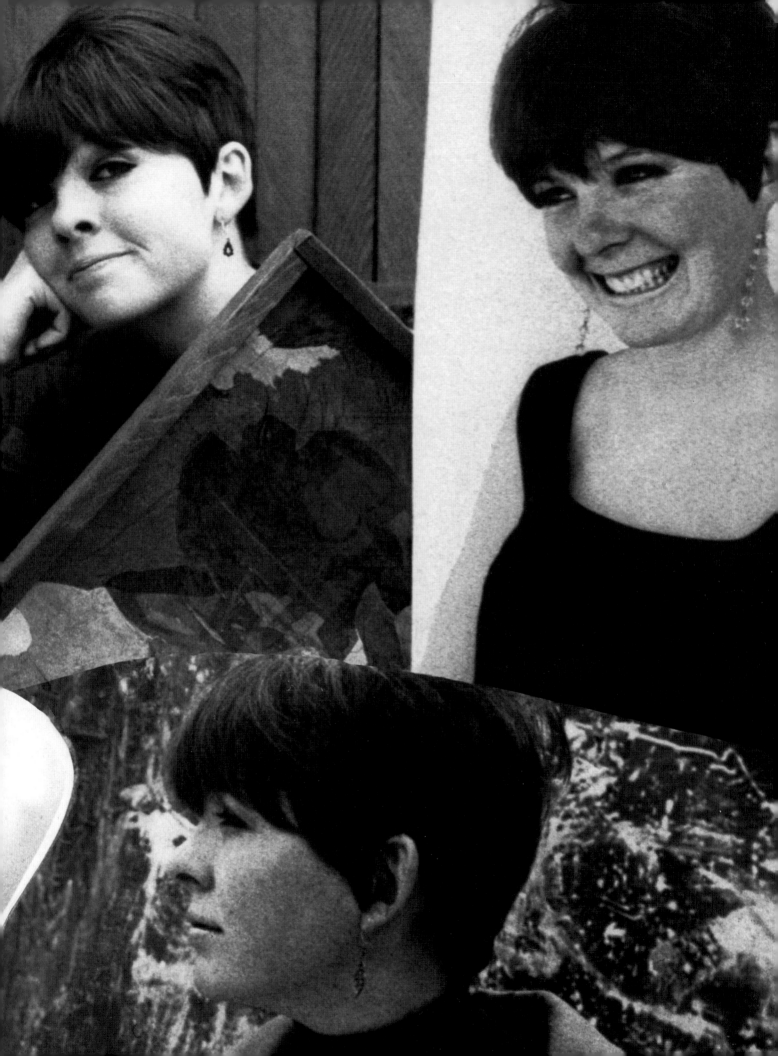

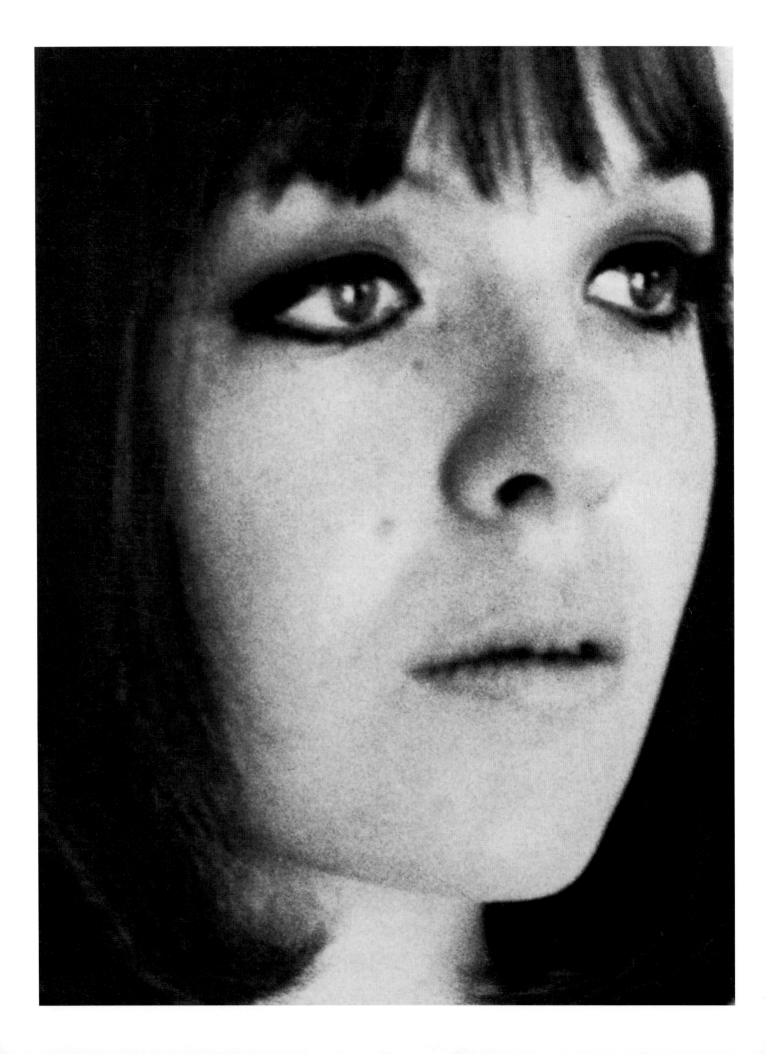

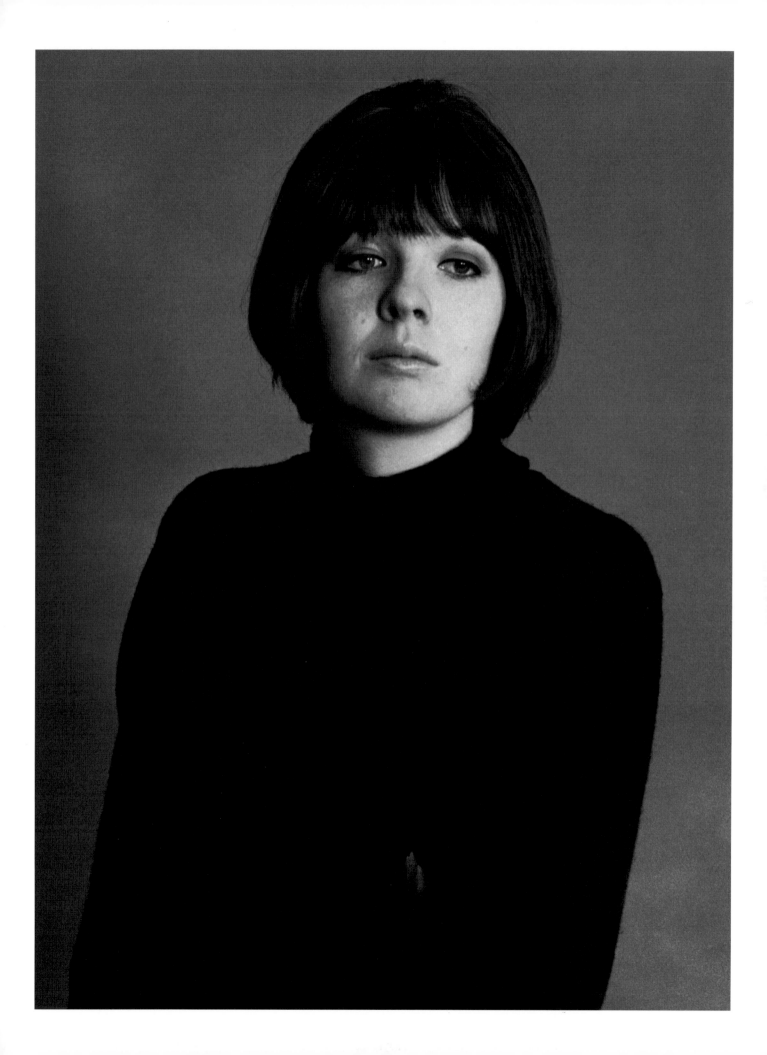

After wearing the "pixie cut" hairstyle for the beginning of the '60s, I thought it was time to grow it out so I could participate in the phenomenon that was "the beehive." All I ever wanted was to have enough hair that I could tease it to the sky and then hairspray it so much that I needed to use an entire bottle a day. Dolly Parton said it best when she declared, "The higher the hair, the closer to God." Well, I guess that means I was in Heaven.

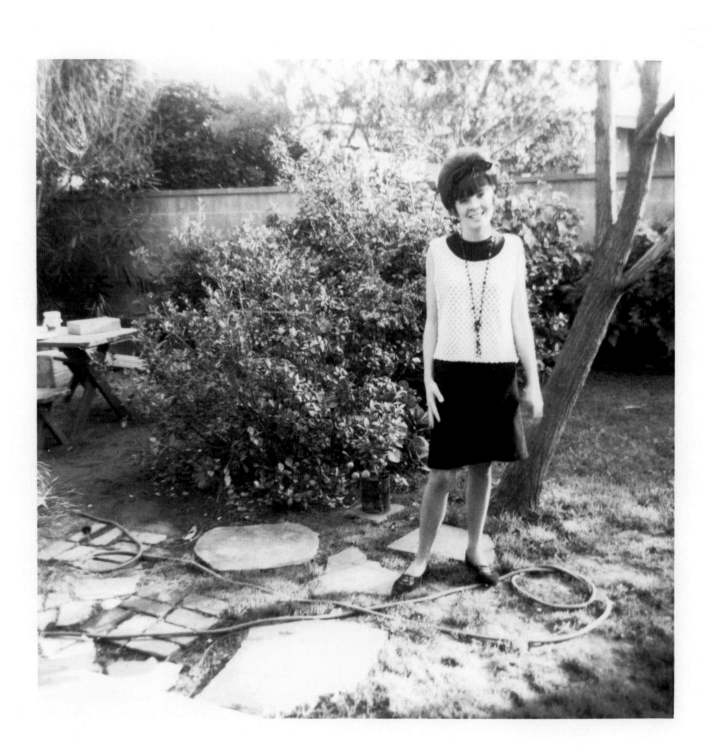

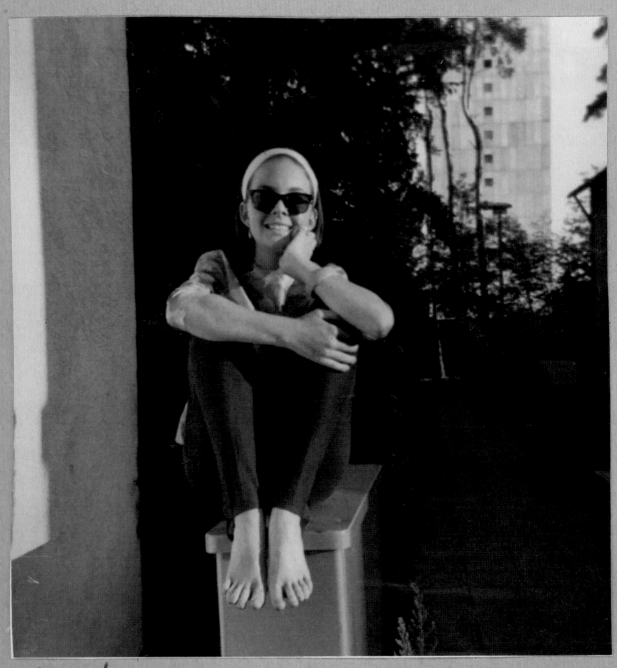

ME' OUTSIDE THE APARTMENT
WAITING FOR SOMEONE TO
DISCOVER ME!

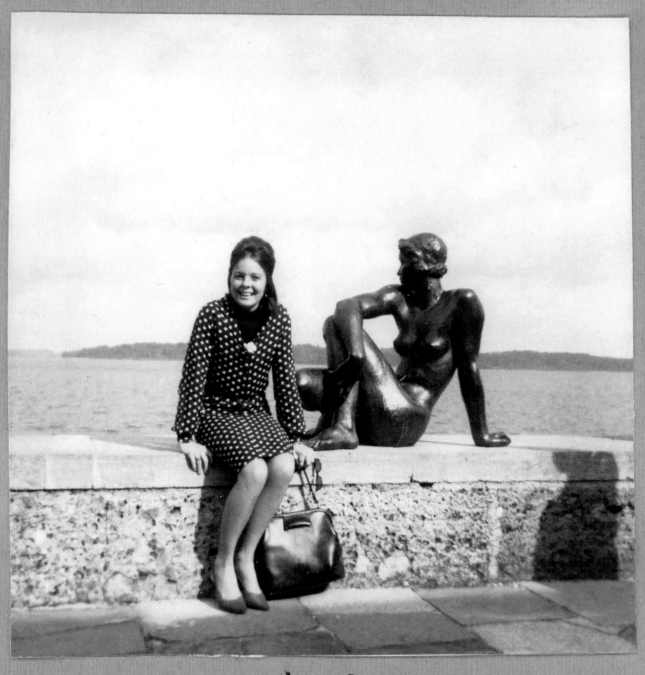

LOOK WHO'S BEEN EATING
TOO MUCH GERMAN FOOD.

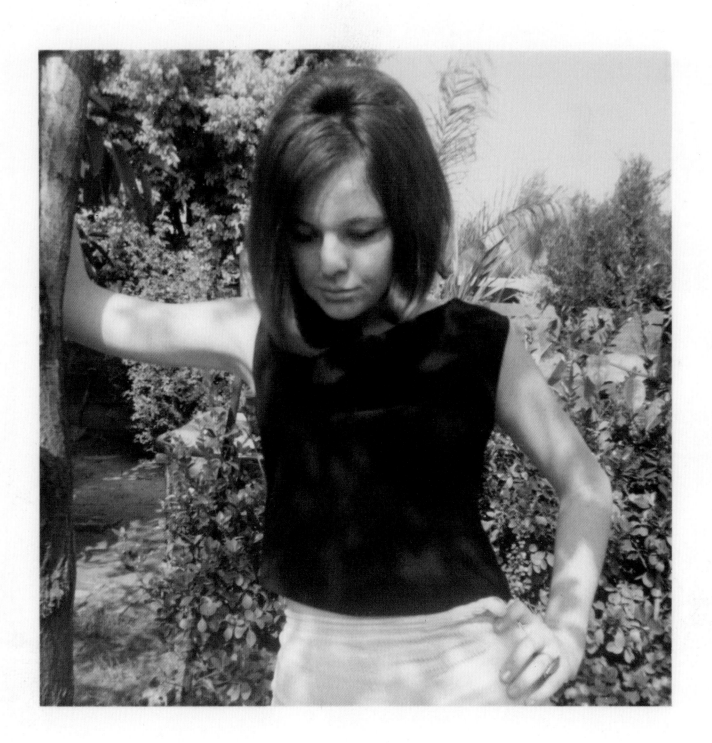

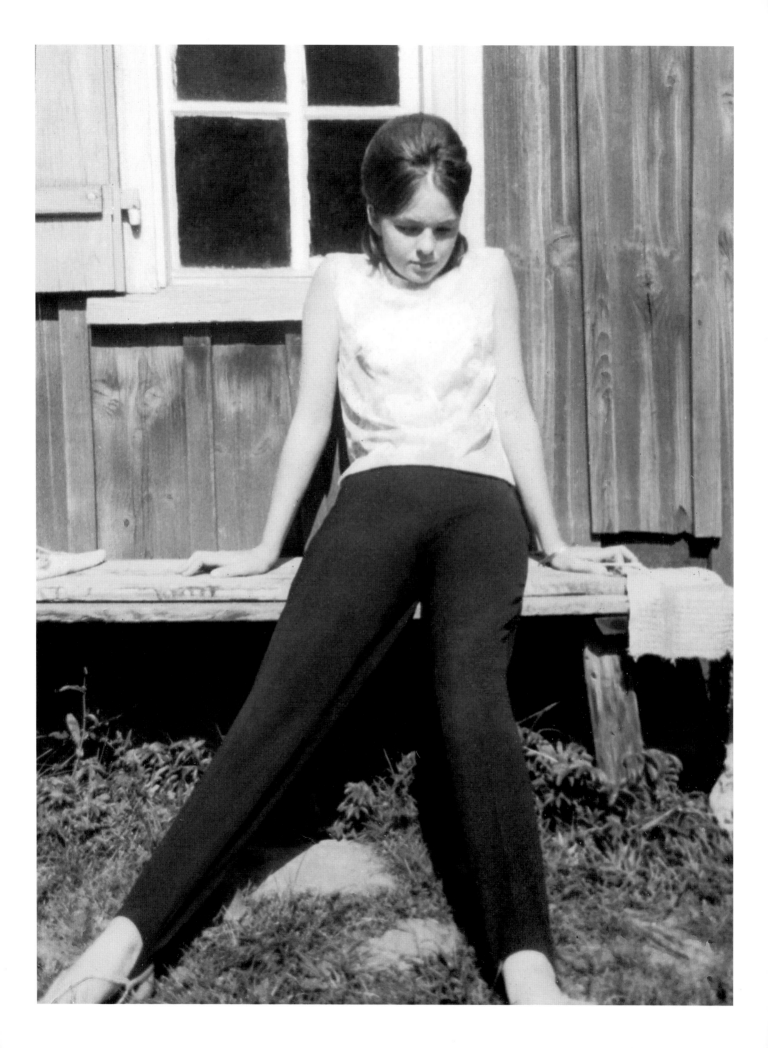

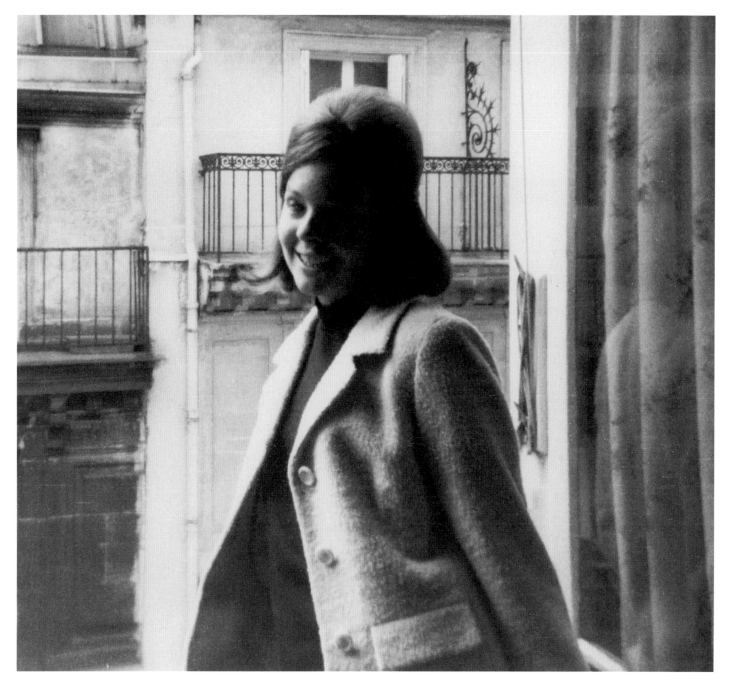

I remember getting this coat at Ohrbach's with my mom. I was going on a trip to Europe, and I guess that meant I needed a more sophisticated wardrobe to bring along. Ohrbach's was a huge department store located further from home but worth the drive. On occasion Mom would take me there and say I could pick out a few items. I couldn't get in the car fast enough. Once inside the store, I would try on outfit after outfit after outfit. I can still see the face of the dressing room attendant hating me as I would walk up with ten times the amount you're allowed to bring in.

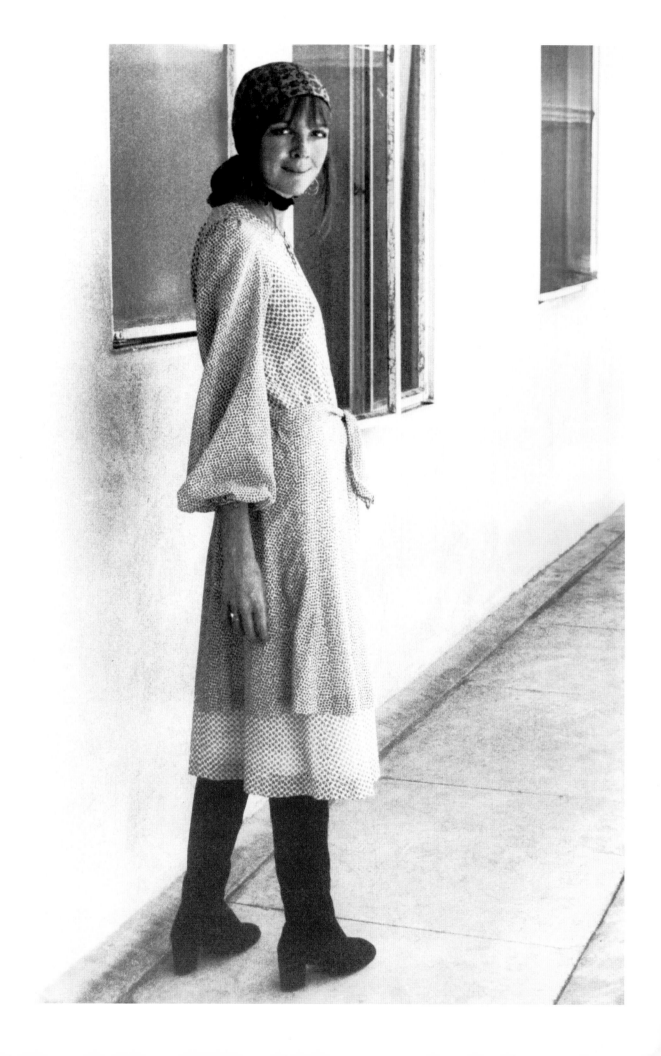

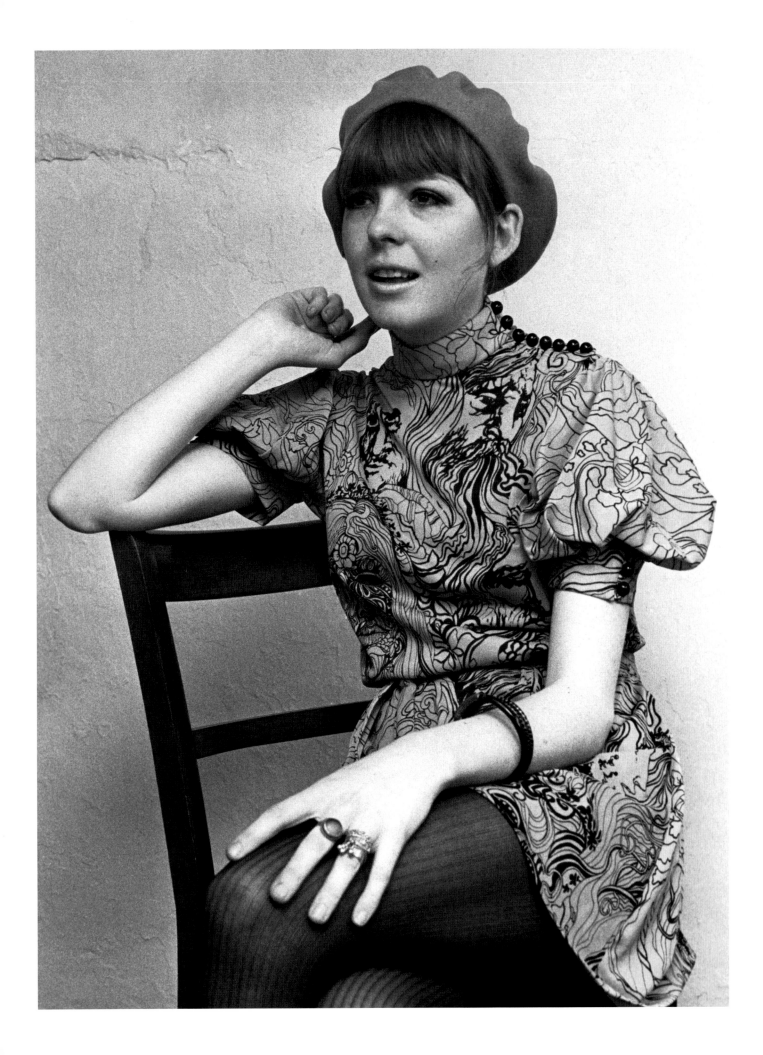

Could my collar be any longer?!

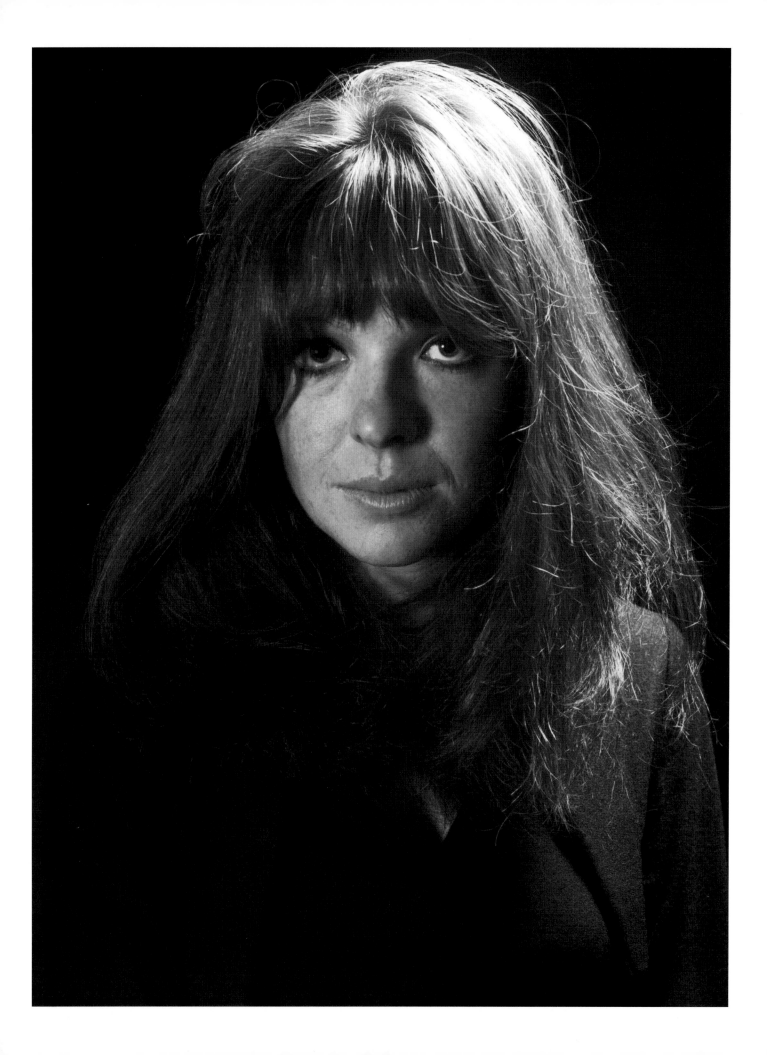

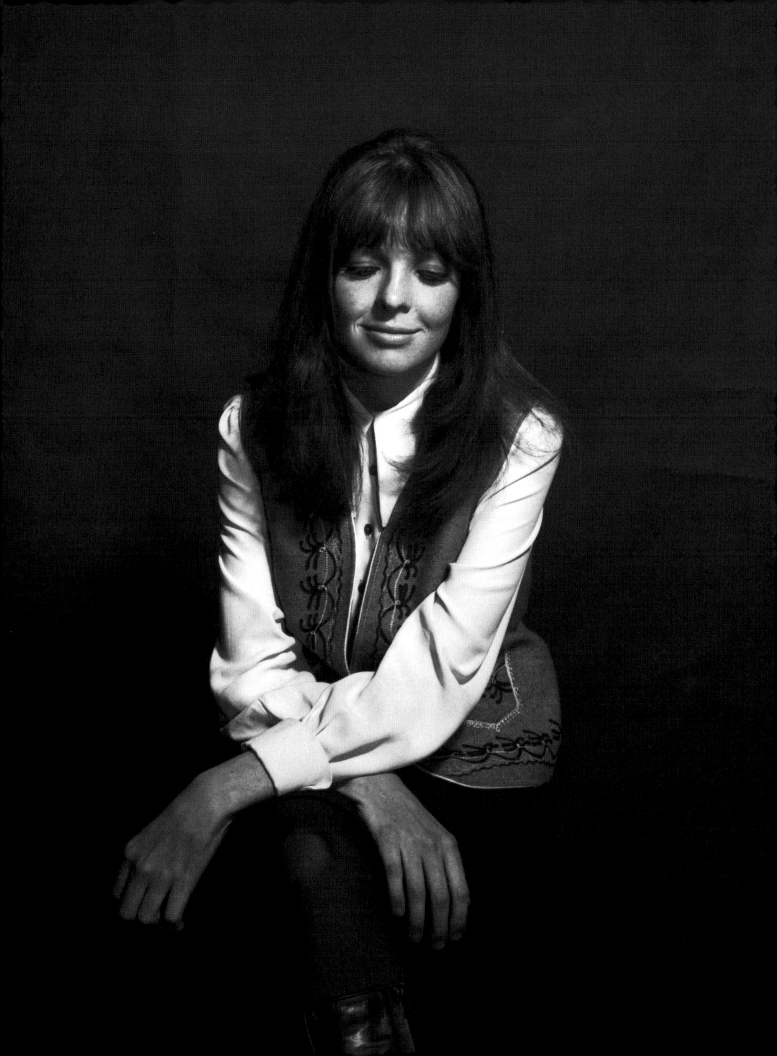

I desperately wanted to look like Raquel Welch (along with every other woman in the world in the late '6os). She was an icon in more ways than one, but I could not get over her hair. The bounce, the curl, the height. I could only dream of making mine look even a bit like Raquel's. But I tried very hard. I would curl, tease, spray, repeat. Over and over and over again. (And, occasionally, I would pray.)

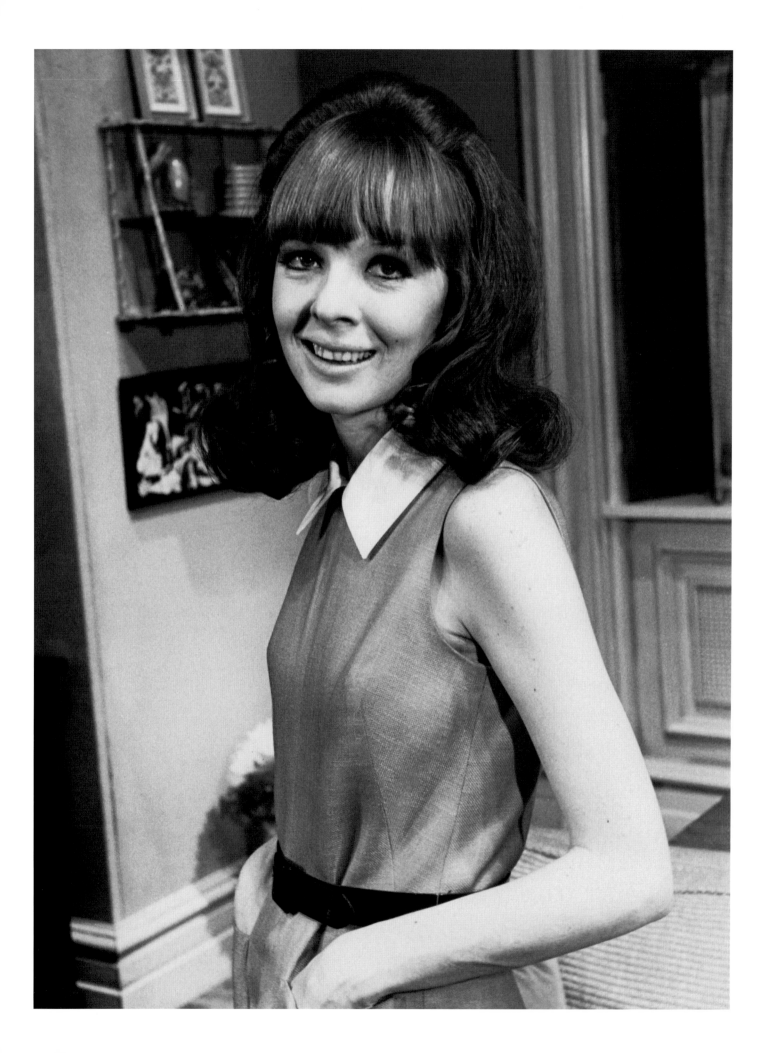

Mom and I loved to put an outfit together. We would assemble our idea, do my hair and makeup, and then head to the backyard (or even find some wall to pose up against in the neighborhood) to take pictures. We had such a love for it. I vividly remember putting this outfit together. We found the top and skirt at the Goodwill. I thought the top was perfection. But the slit in the skirt meant I needed stockings. End of story. I couldn't do our backyard photo shoot without stockings?! What are we? Insane?! Luckily, Mom saw my vision. She knew the only stockings fancy enough to finish our look would be lying on a table at Bullock's. We rarely went there because it was more fancy than the other stores, but Mom insisted. Bullock's was where you went if you wanted something special. It was where I got my first high heels. It was where I gawked at my first mannequin, dressed in the clothes I could only wish to own one day. It was where we went to copy what we saw and then run to the Goodwill to find something similar. It was where we got our ideas. But there we were, in line at Bullock's, holding the most beautiful stockings I could find. I almost put them on in the car I was so excited. When we got home, I rushed inside the house, picked the appropriate heel to finish our look, and then bolted into the backyard with Mom to pose against a brick wall, like it was for *Vogue*. I miss my backyard photo shoots with my mom.

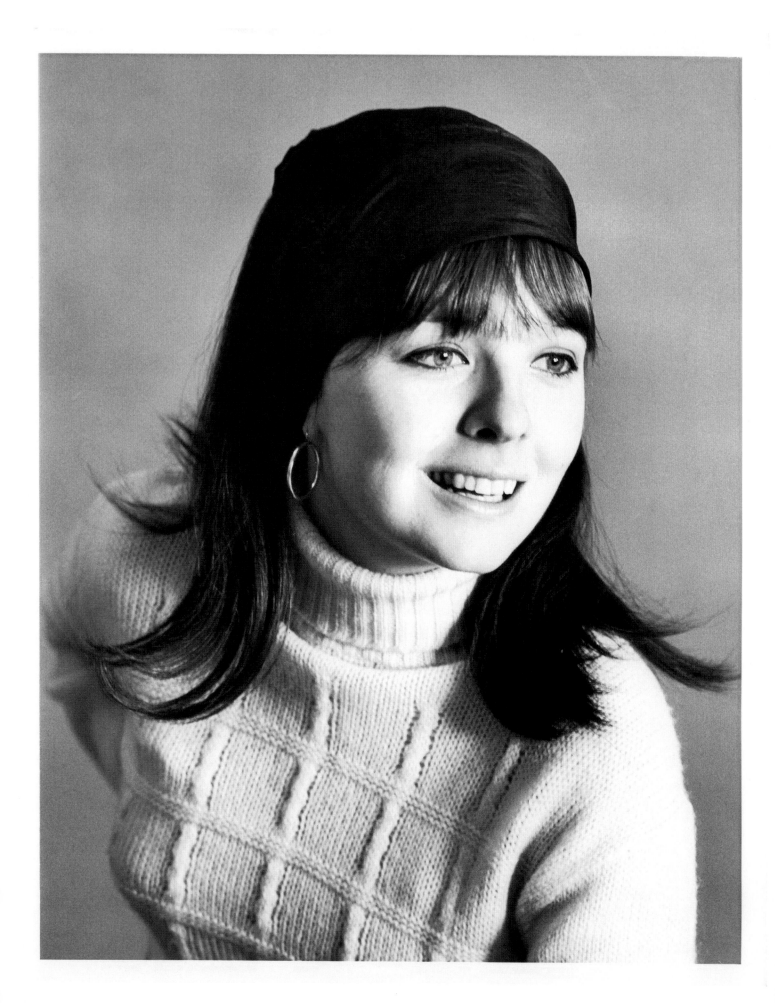

Guy Gillette took my first headshots after Mom suggested the idea. I was so excited. Real headshots?! Like a real actress?! I had previous headshots for stupid things like school but nothing professionally. This was it. I was investing in my career. I was investing in my dreams! I decided to wear a wool turtleneck (which I borrowed from my sister), and I paired it with some silver hoops and a black headband like Brigitte Bardot wore. I loved Brigitte Bardot. She was unbelievable. Her headbands were so chic. So very French. I wanted to copy it completely. She was the reason I got bangs. I went with a black headband so as to appear more understated. I even let the bangs hang out of the headband to really nail home my salute to Brigitte. Guy took a few shots that day, and I walked away feeling like I could do anything. I was finally a real actress. Looking back, I did not look like Brigitte Bardot. Not even close. But, boy, did I think I did while taking my headshots.

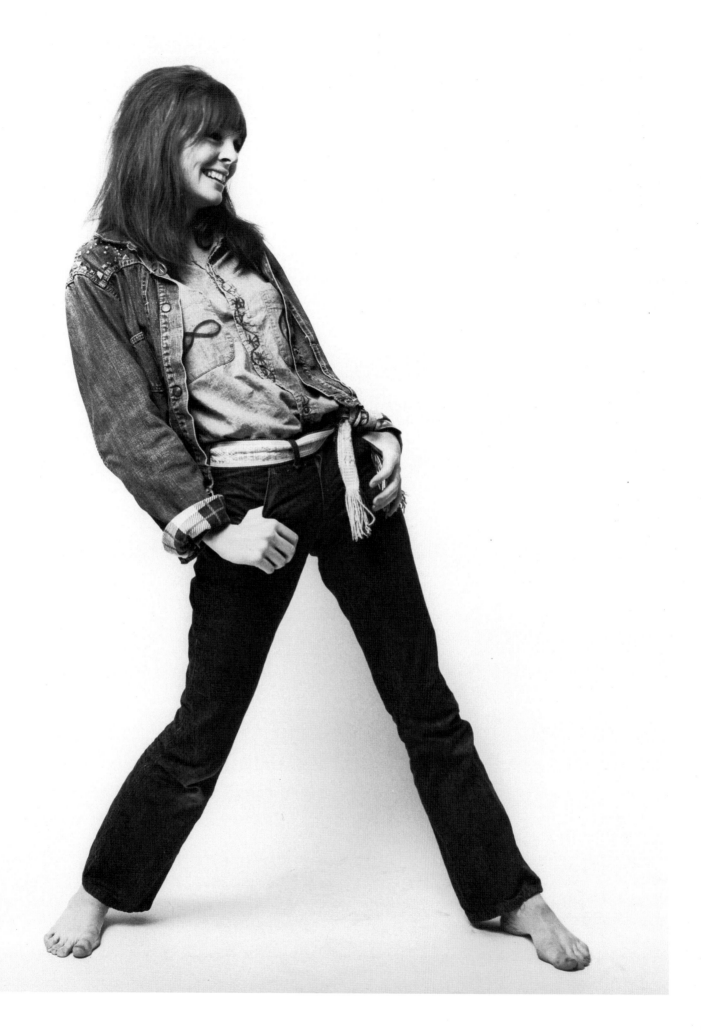

I finally got my first real acting job on Broadway doing *Hair* in 1968. I guess I loved fashion so much that I refused to take my clothes off. (I just didn't want to be stark naked in front of an audience.) My *Hair* costume was very '60s but also making its way into '70s fashion. I was finally beginning to wear pants, and there was a sort of looseness to the clothing. And it wasn't just my clothes that were changing. My hair and makeup were changing as well. No more teasing, spraying, and repeating. No more eyeliner smoking around the eyes. No more pale lipstick. The late '60s were much more fresh-faced with long, natural hair. My look was becoming much more relaxed—just in time for the '70s (no bras).

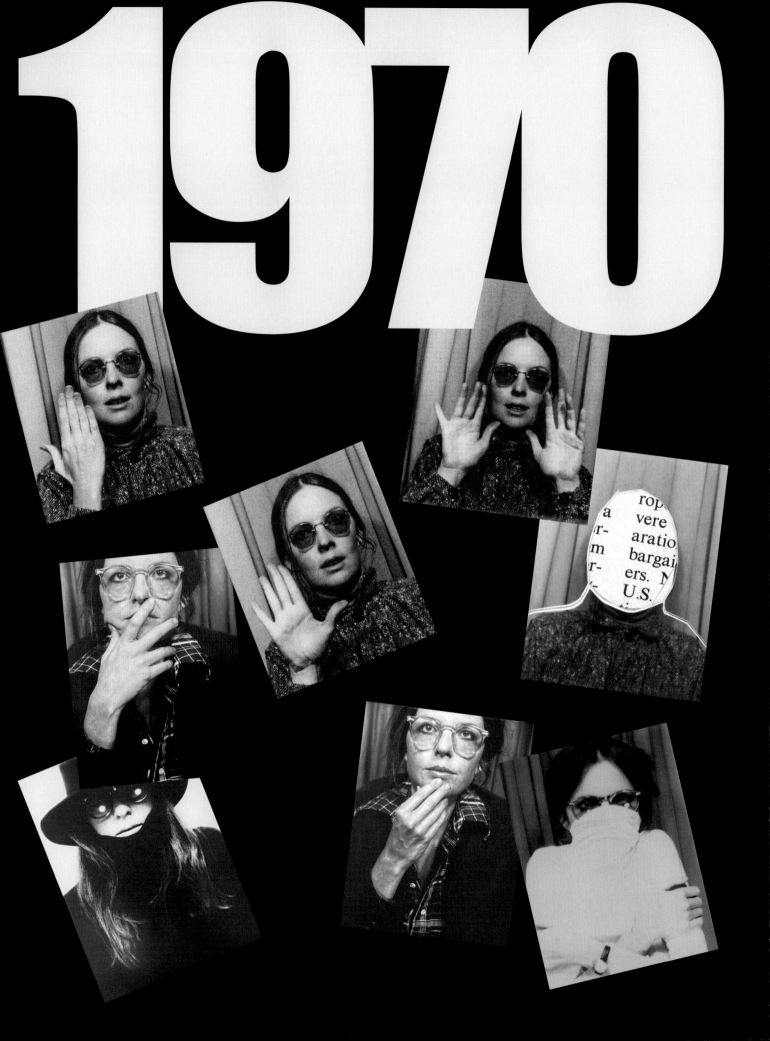

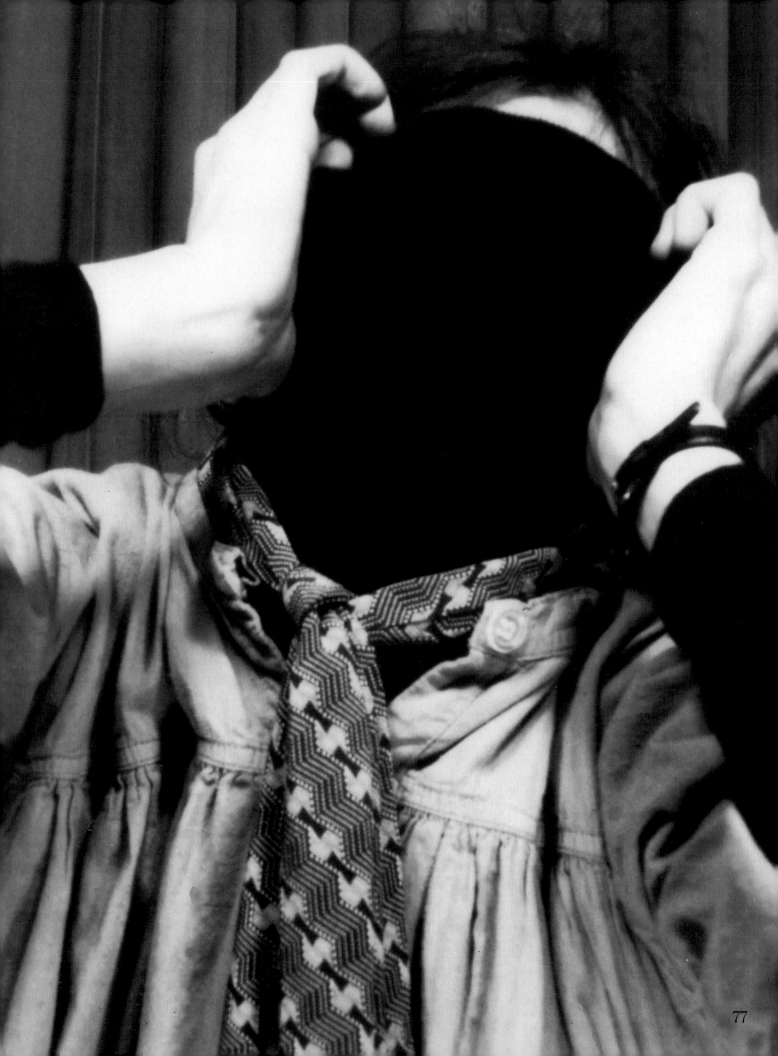

I really began to find what I like in the 1970s. I became more in tune with myself and my thoughts about clothing. I was dressing much more "masculine" compared to the babydoll dresses I was wearing in 1963. I was finding my style and slowly finding my career. Though *The Godfather* was a huge success, it didn't exactly put me on the map in terms of fashion. Kay Corleone's orange and red ensembles were not my usual day to day. I was wearing ties and hats and cargo pants in my real life. It wasn't until *Annie Hall* that I was able to really dress as myself on screen. I couldn't believe it. I look back on *Annie Hall* and can't talk about that movie without talking about the fashion. It was everything to me. I loved being able to dress like myself. To be comfortable as myself. Sure, there were times throughout the '70s when I wore a dress here or there, but I promise you they were far and few between. I was no longer copying the fashion of beautiful, famous actresses. My new muses were the women of New York City, who were walking the streets of Soho in baggy trousers and a blazer. I was layering pieces I would find at the vintage shops in the city and experimenting with suits I dreamt of being able to wear. The '70s is when I started to show people the real Diane. And, thank God, people seemed not to hate it completely.

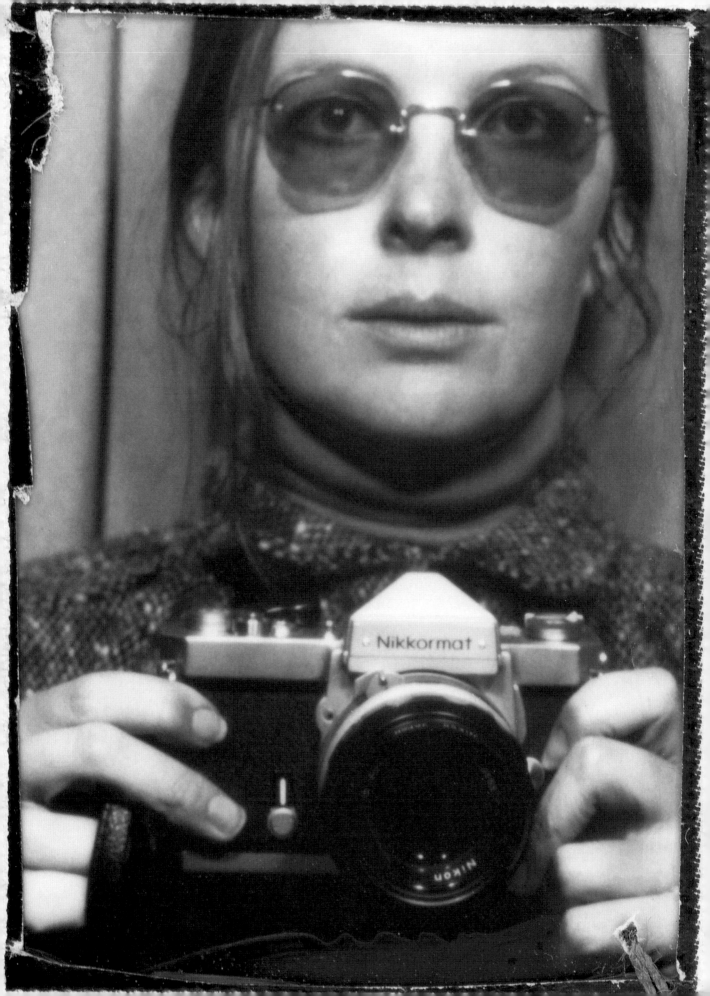

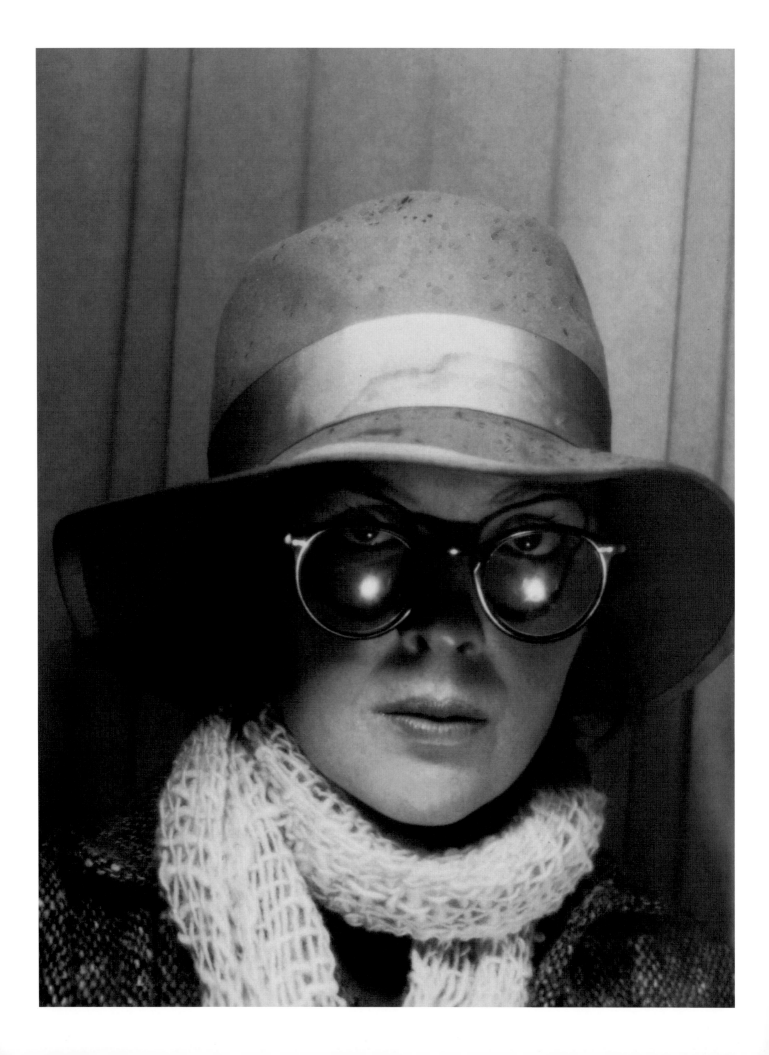

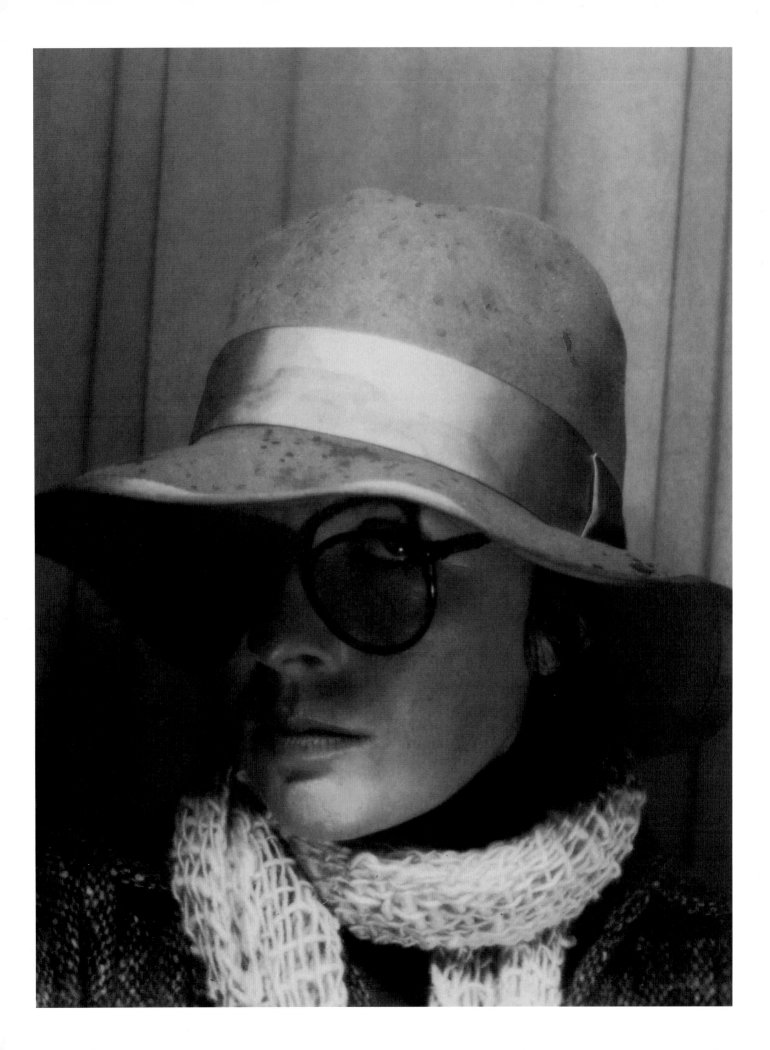

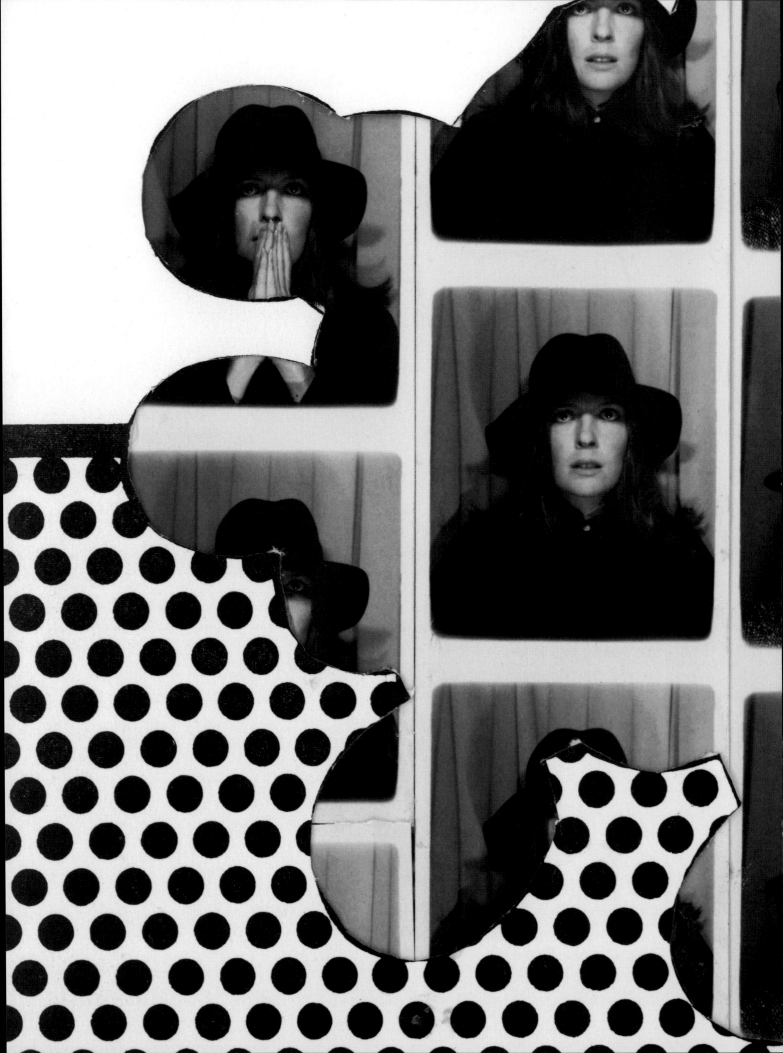

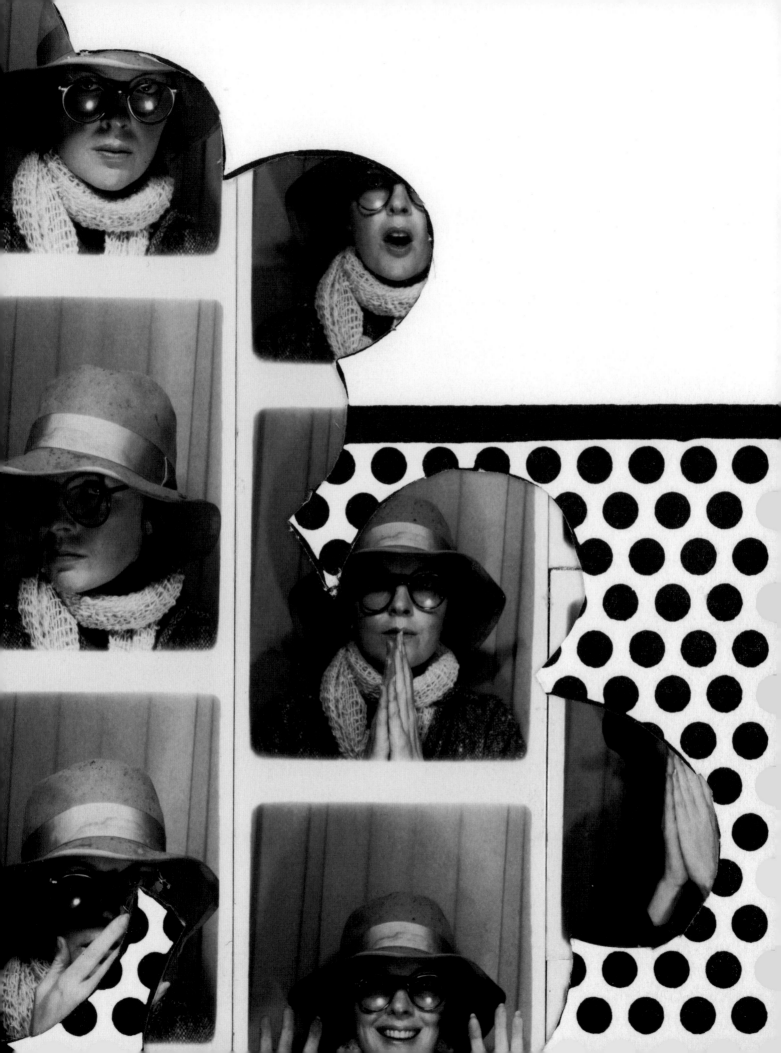

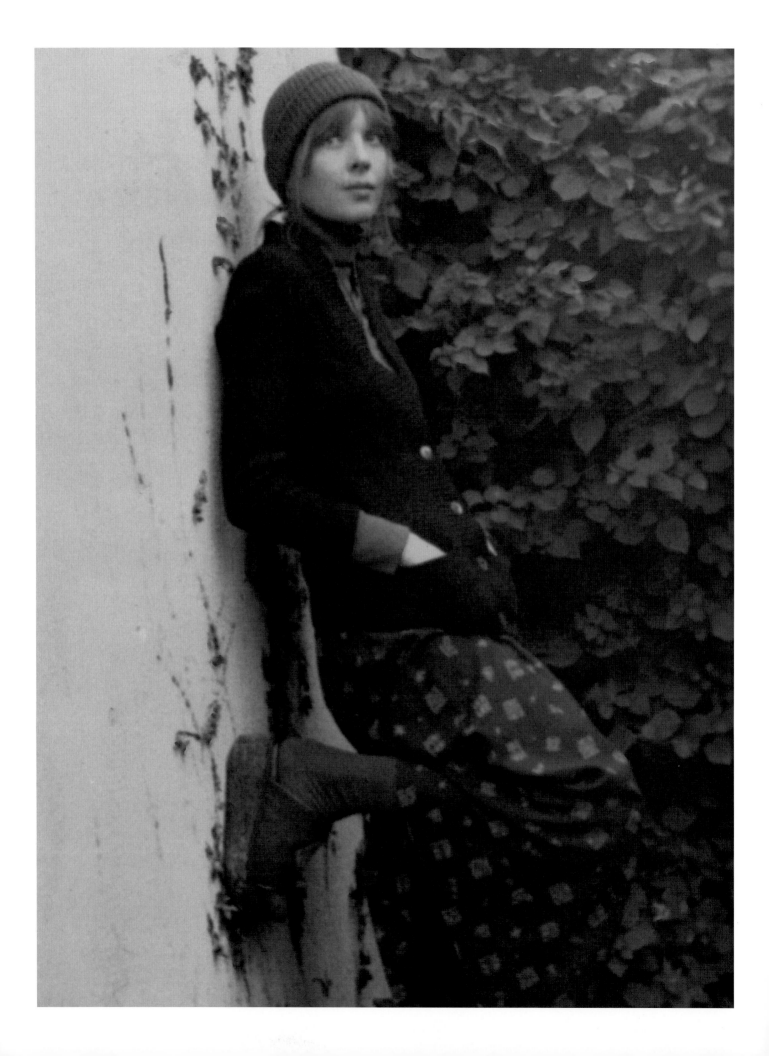

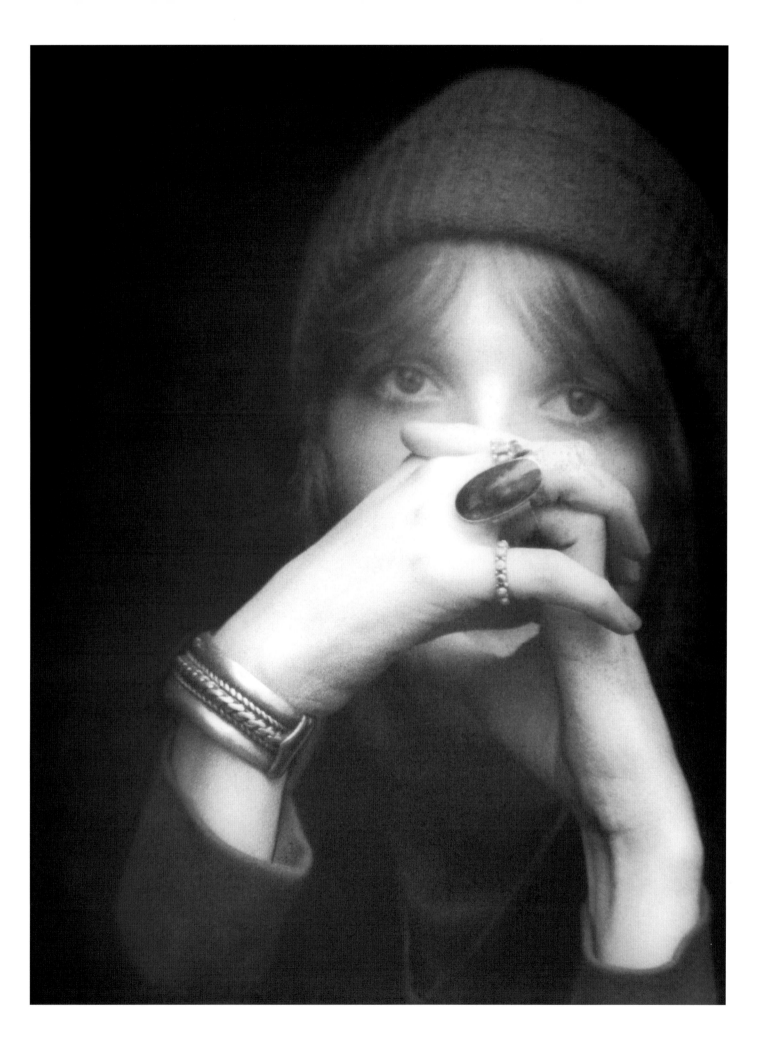

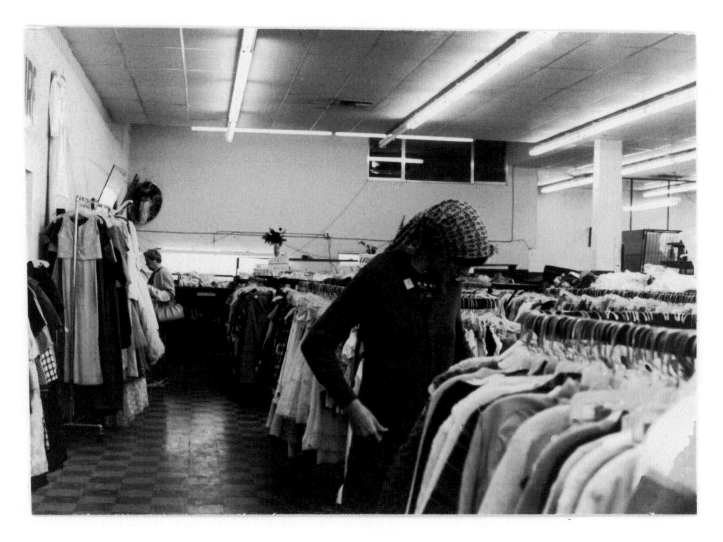

The Goodwill really was our sanctuary. Mom taught my sister Dorrie and me to rummage for the best and alter if needed. We would spend hours hunting through racks and racks for anything that had the slightest potential. We would discuss and share our thoughts on a piece. We would debate if something was too short or too colorful, if something could be fixed with the right tailoring or a new set of buttons, or if something was just a lost cause and should go back on the rack immediately, never to be discussed again. And after hours of "it's just too long" and "I don't know. I just don't like the arms," you'd find it. That jacket. Or that pair of pants that was so perfect, so fashionable, you couldn't believe someone would ever let them go. Someone else's junk was now our perfect treasure. Once home, we would put together outfits the rest of the day, while discussing when we would go back to the Goodwill.

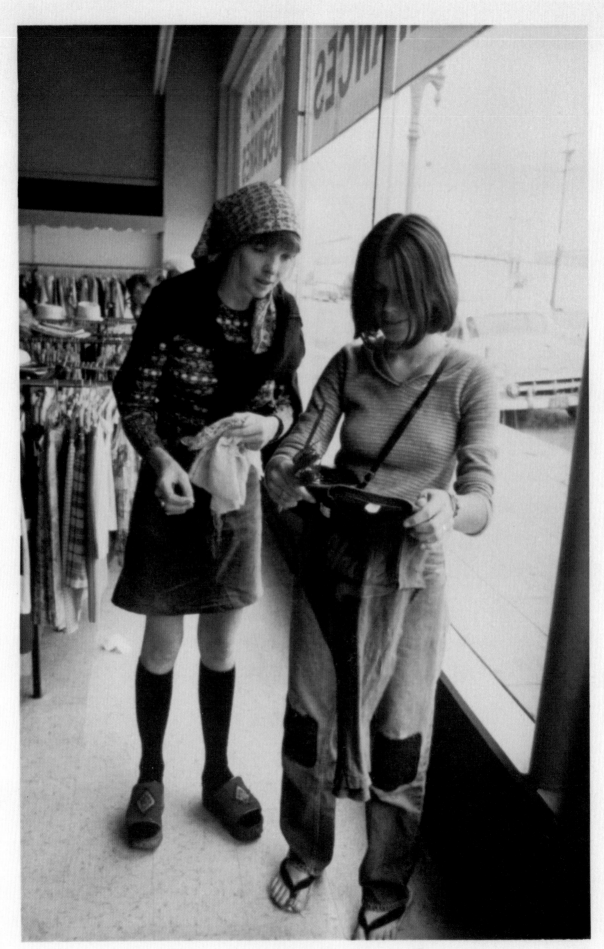

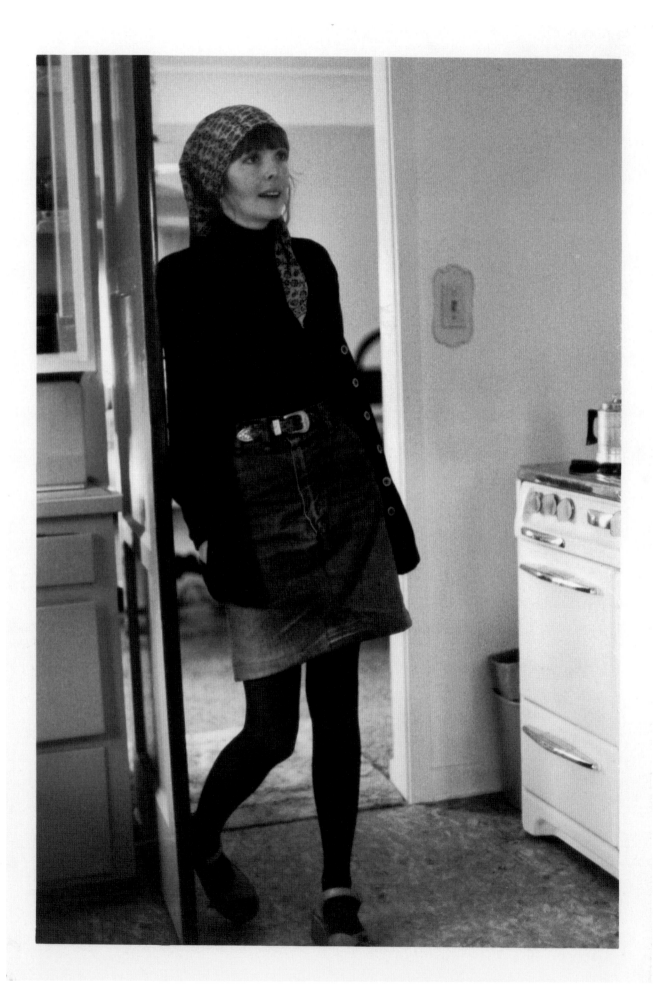

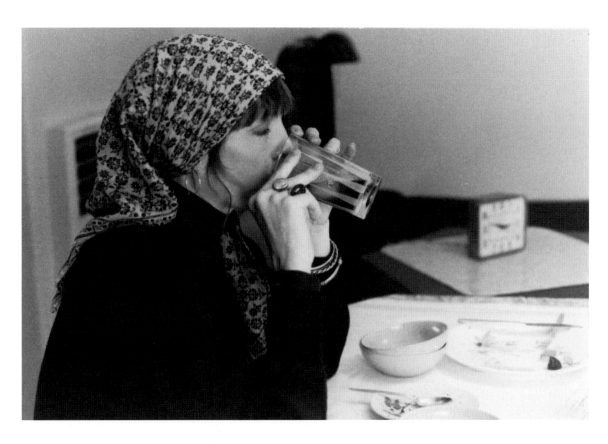

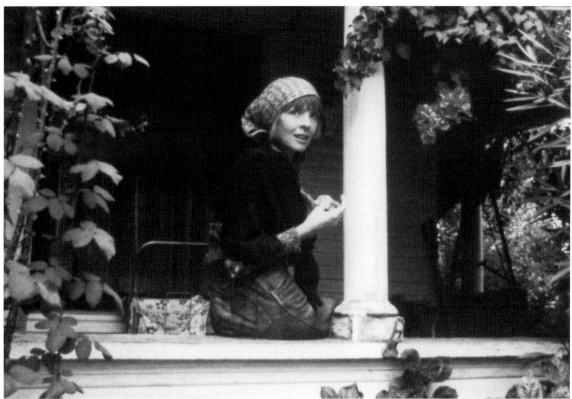

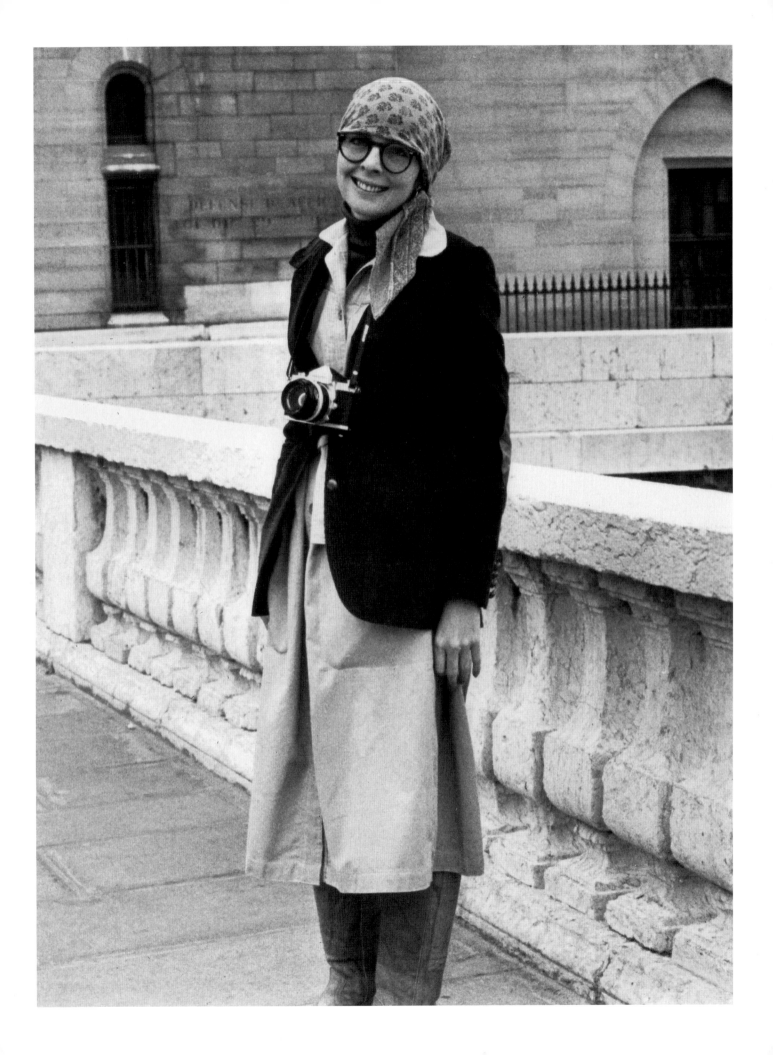

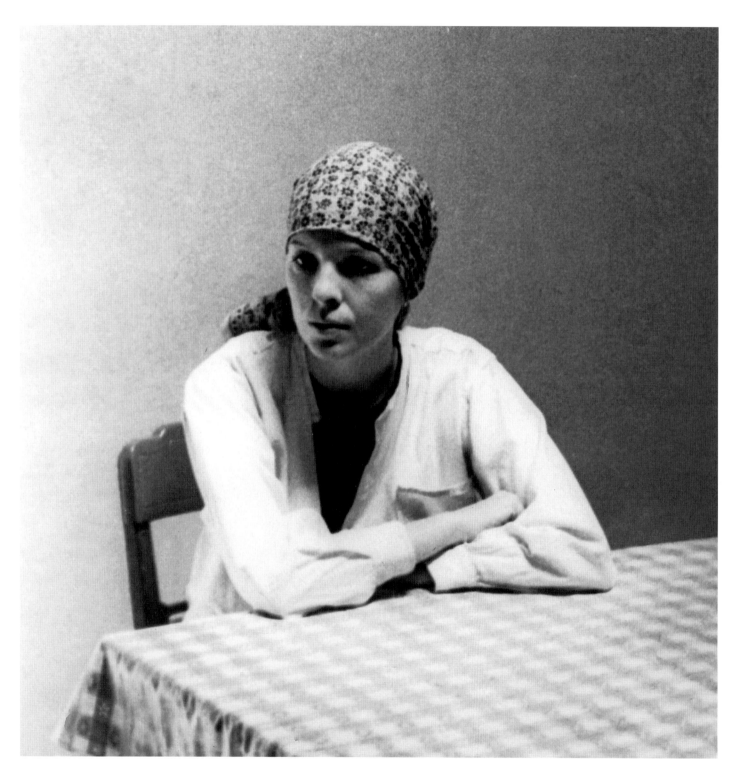

You might see my headwraps and think it was a fashion statement.
But, to be honest, it was simply the easier thing to do.

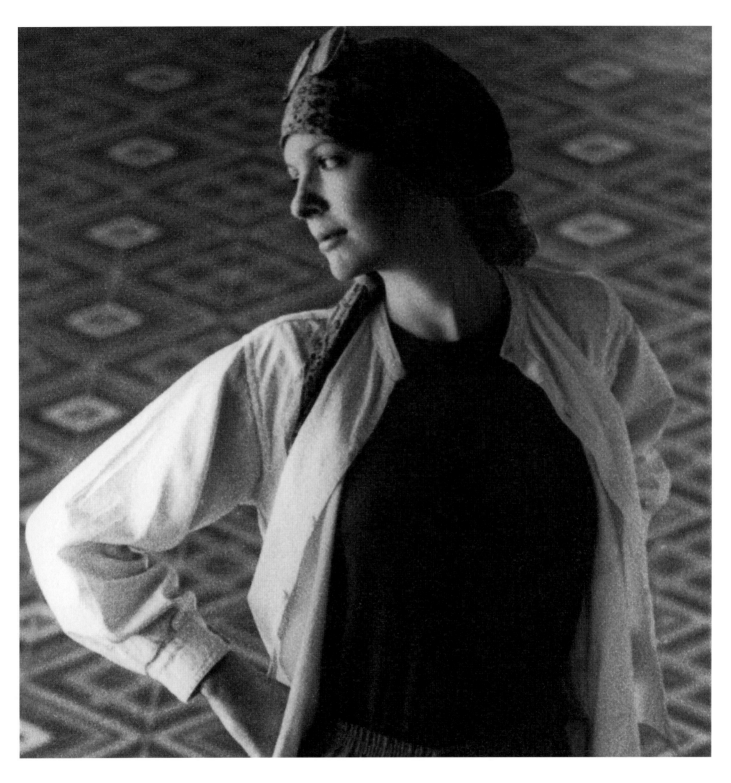

Headwraps were a way not to have to do my hair all of the time.
It was just a bonus that sometimes it looked chic.

This is horrible.

This is horrible.

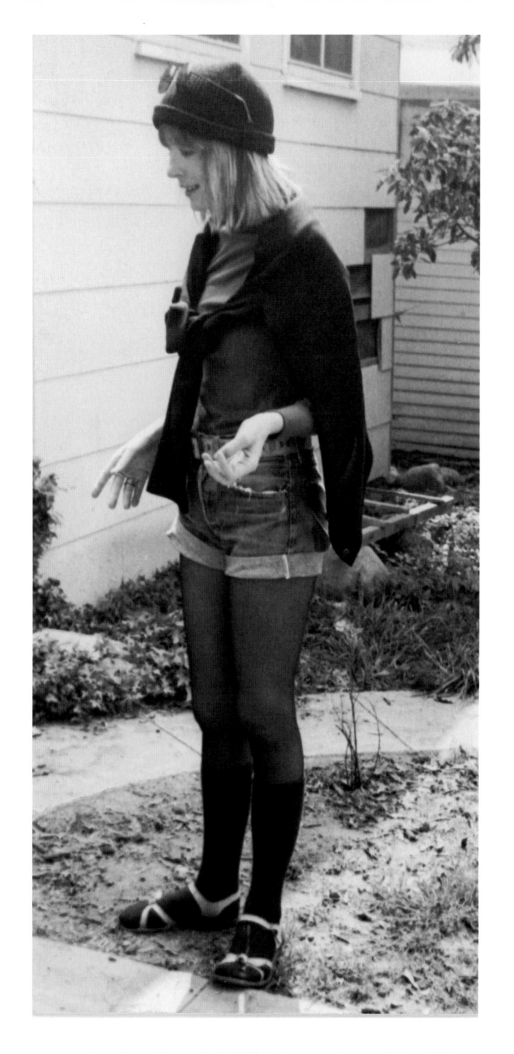

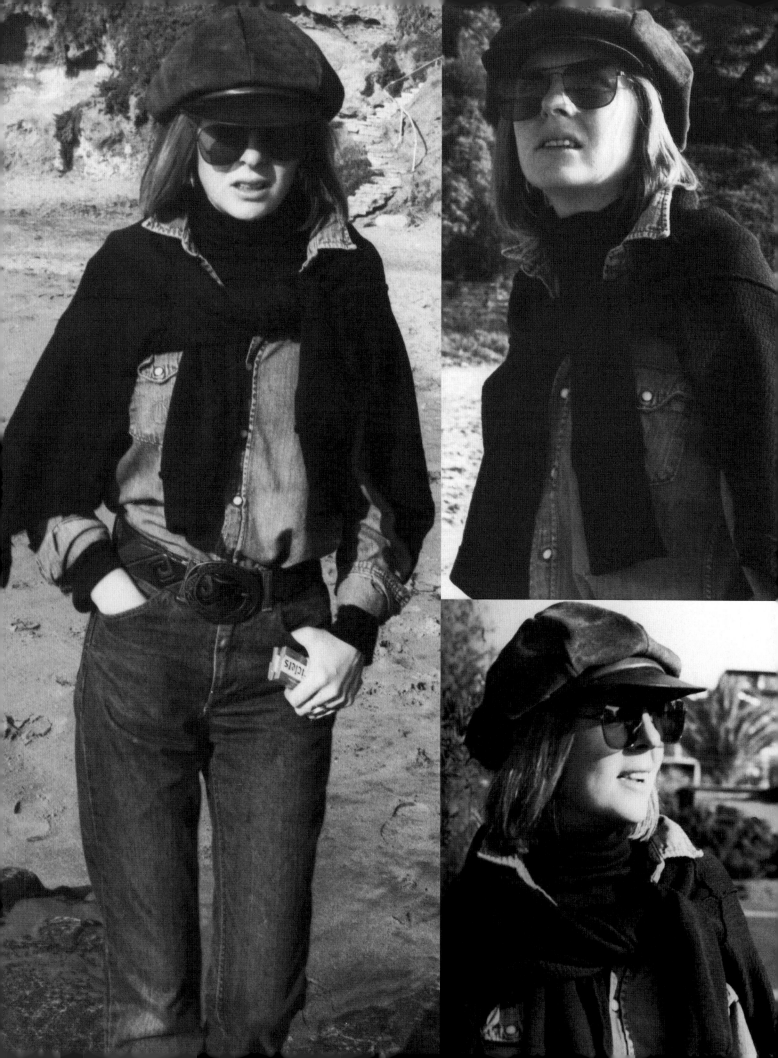

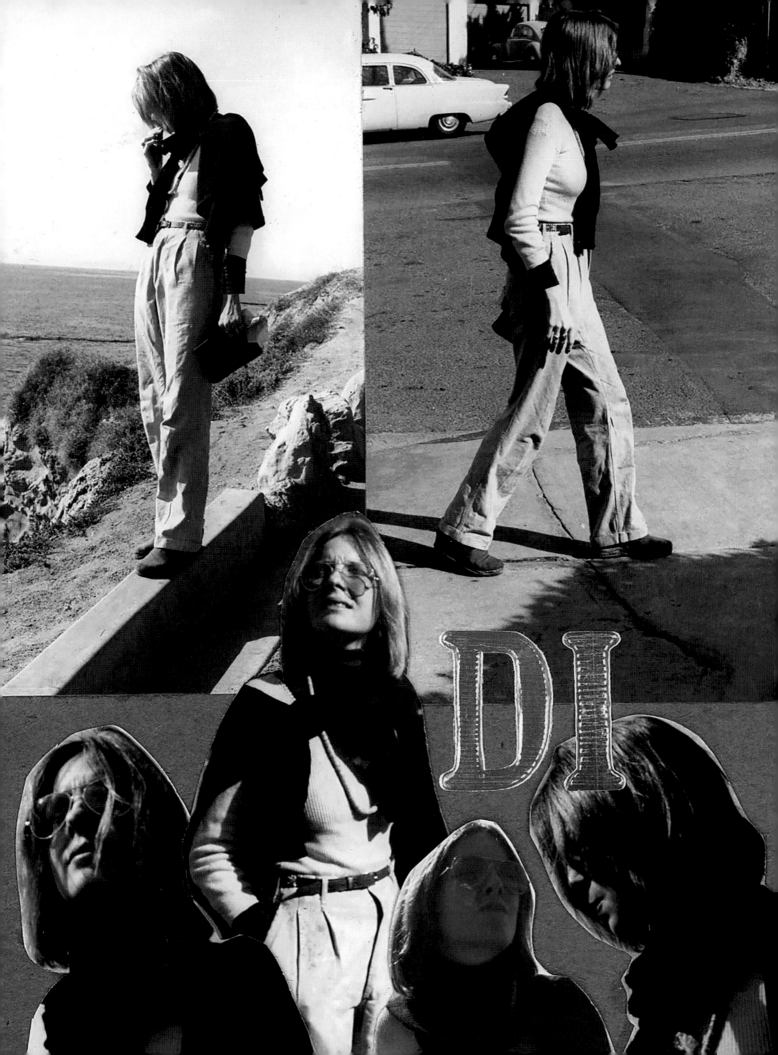

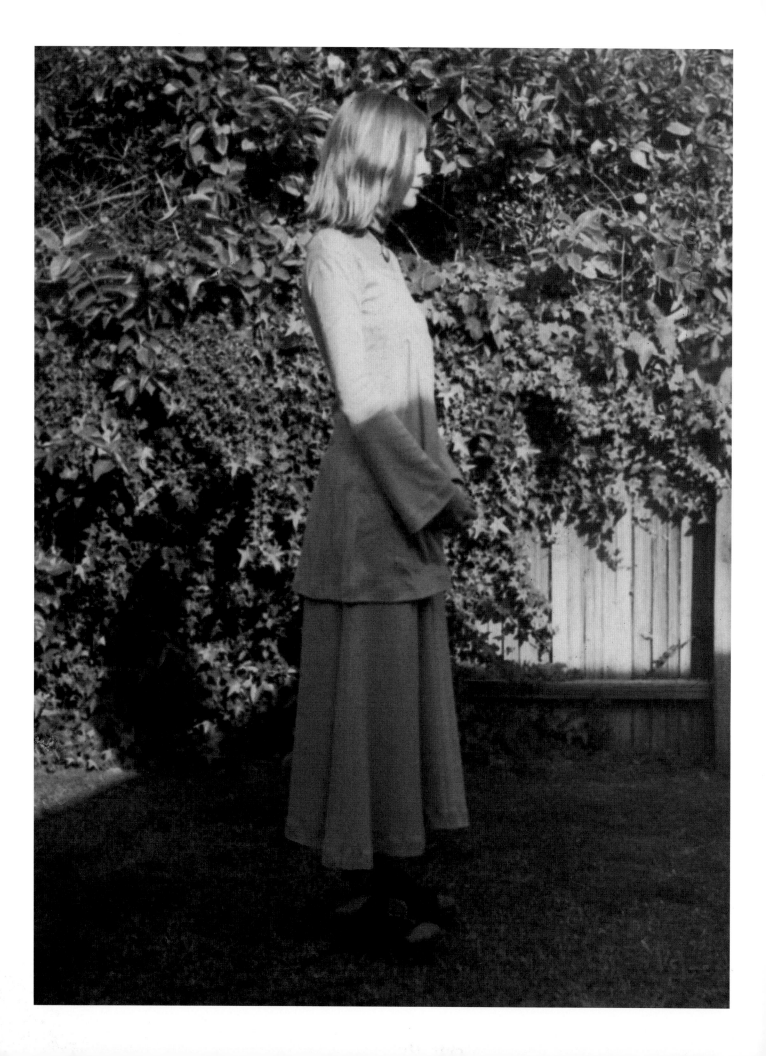

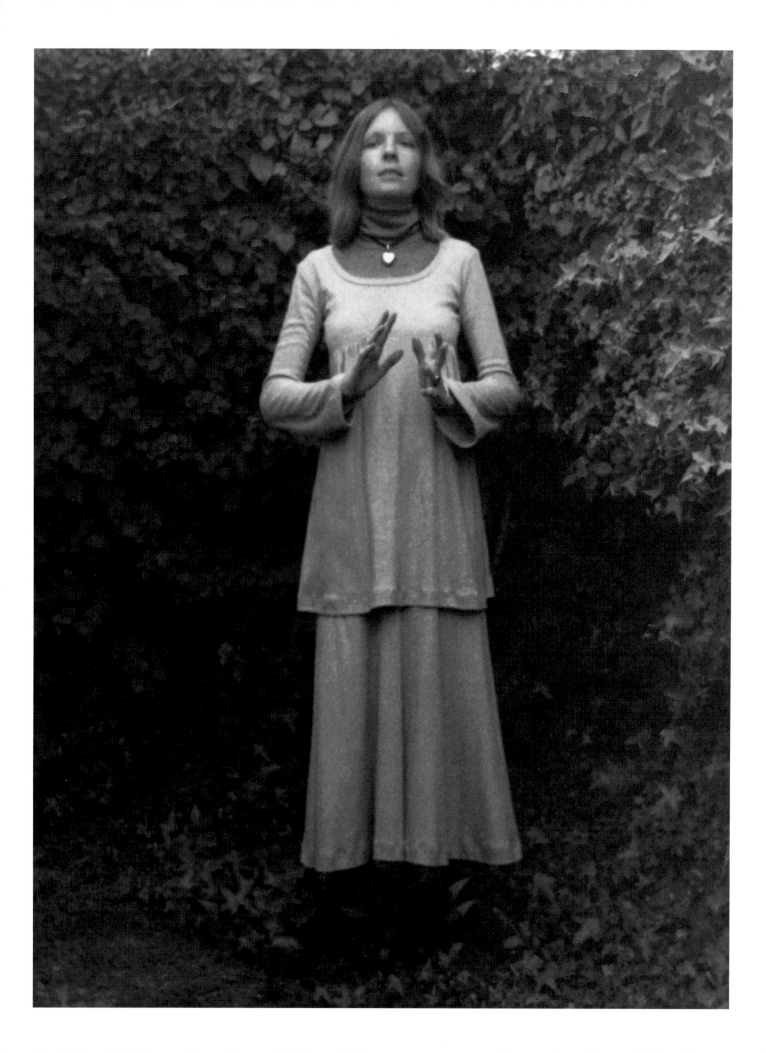

In 1974, I was lucky enough to shoot with the incomparable Neal Barr for *Harper's Bazaar* magazine. "Me? Are you sure?" I knew someone had made a mistake. I'd done *The Godfather* and *Sleeper*, but I wouldn't have called myself particularly desirable from a show business standpoint. But I went anyways, at the risk of being escorted off the premises because they had definitely gotten the wrong girl. How could I be so lucky? It wasn't until I arrived that I found out just how lucky I really was. I was going to be shot in the Diane von Furstenberg leopard print wrap jumpsuit. WHAT?! Have I died and gone to heaven? Everybody and anybody in the '70s wanted their hands on a Diane von Furstenberg creation. She essentially invented the wrap dress and thus gave girls like me the illusion of a waist. And here I was getting to pose in one of her best ever. I felt so lucky (and like I had a figure).

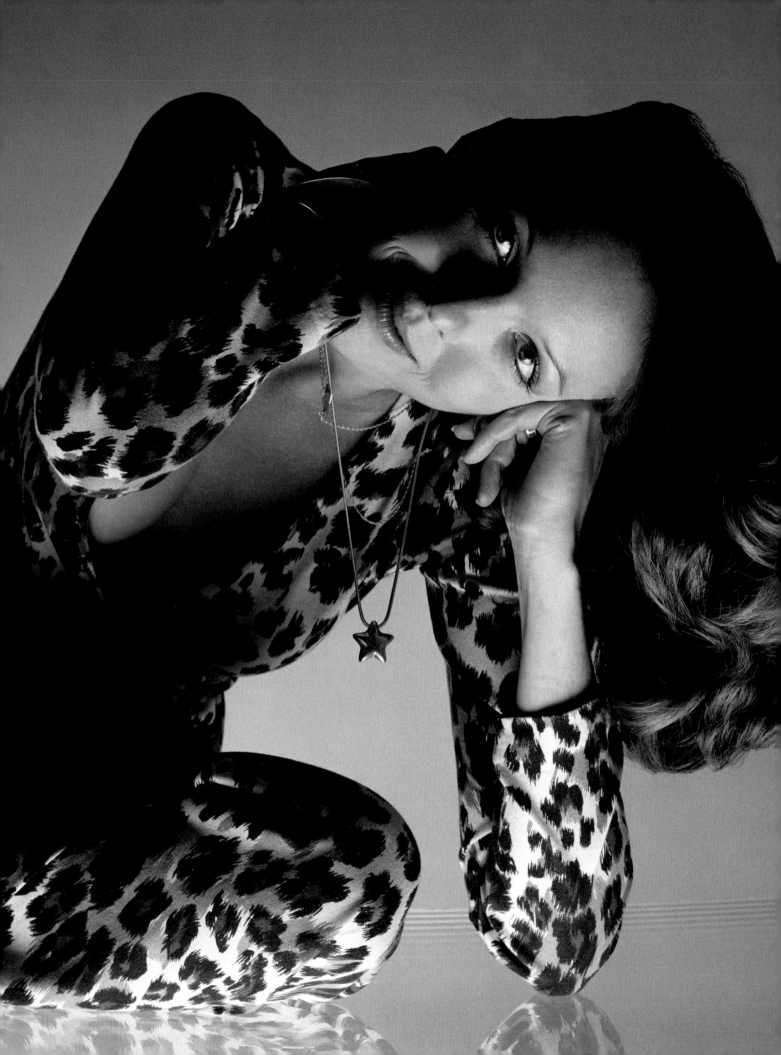

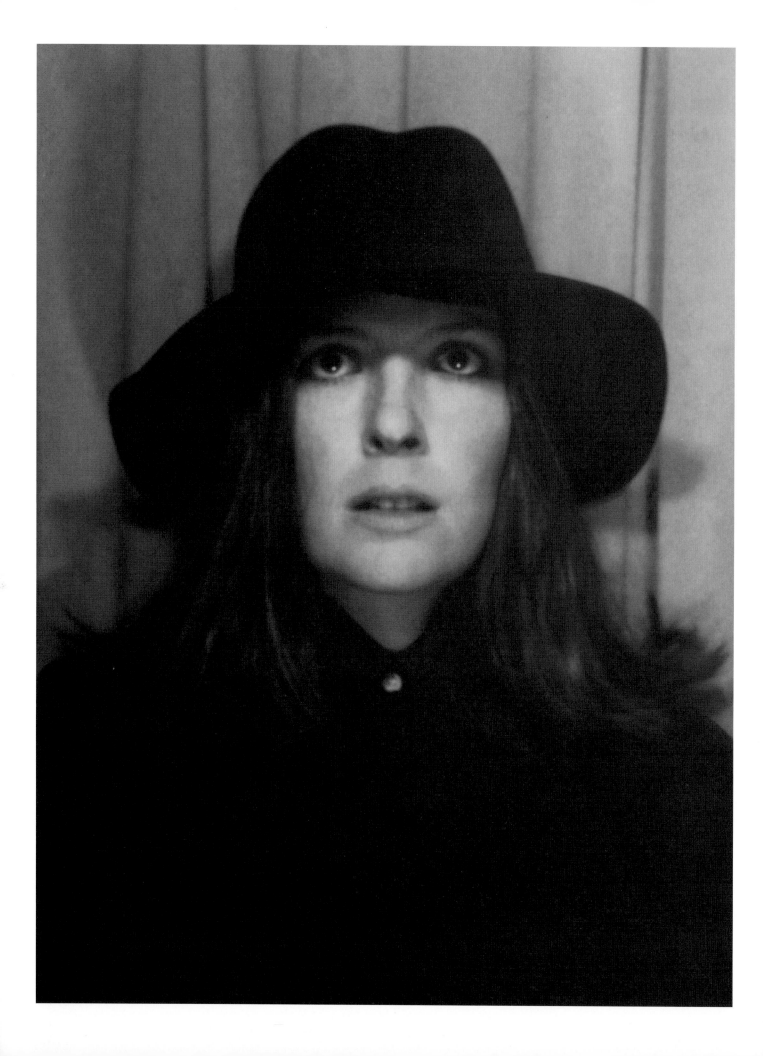

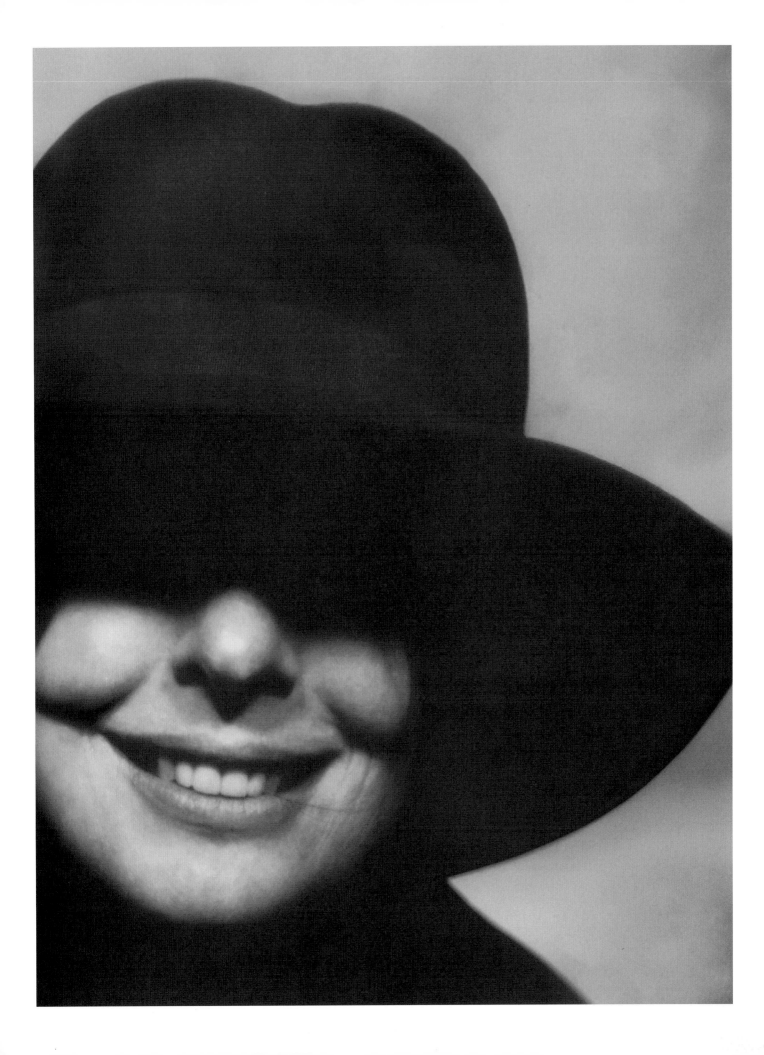

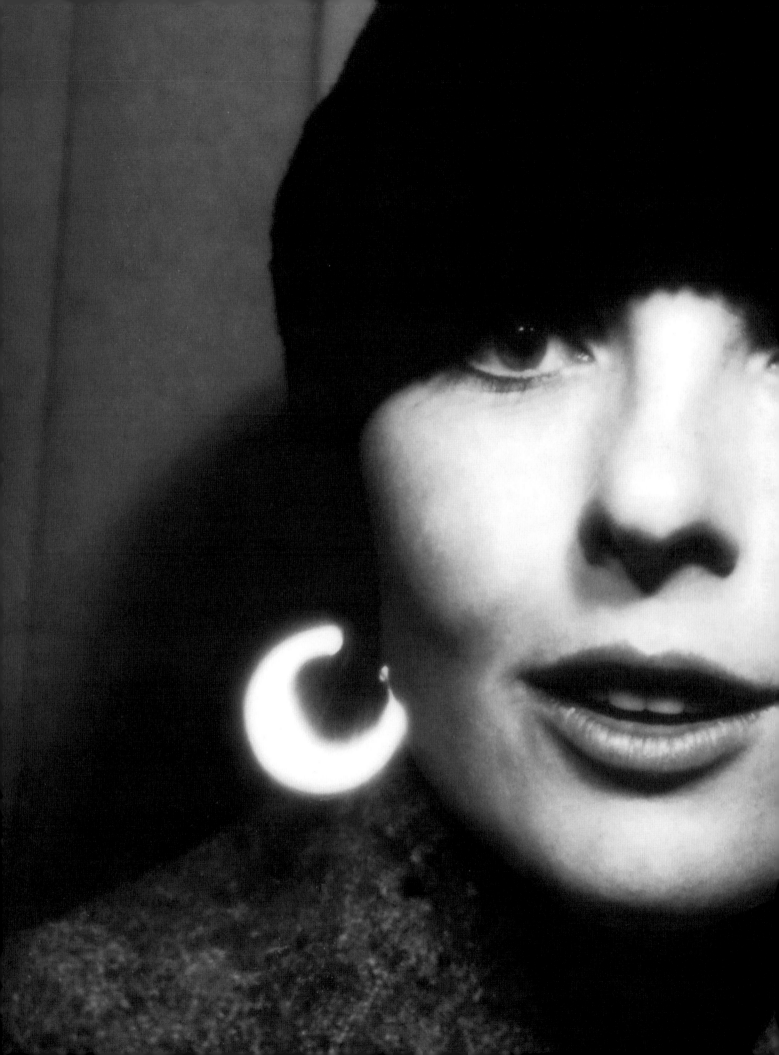

In the mid '70s, I decided it was time to be blonde. I wasn't blonde for long and, looking back, I can't believe I even did it. I wanted blonde hair to make my face look pretty. That was always the goal: "Let's try and look prettier, Diane." Mom and I ran down to Ohrbach's and bought the box that had the blondest woman on it and headed straight home. She slathered the white paste all over my head and, in an hour, I was blonde and could hardly recognize myself. It didn't look quite like the box, but it was still BLONDE and I was still pleased with what we achieved. It's true what they say: blondes have more fun—but not for too long because the upkeep is impossible. I gave up on it immediately.

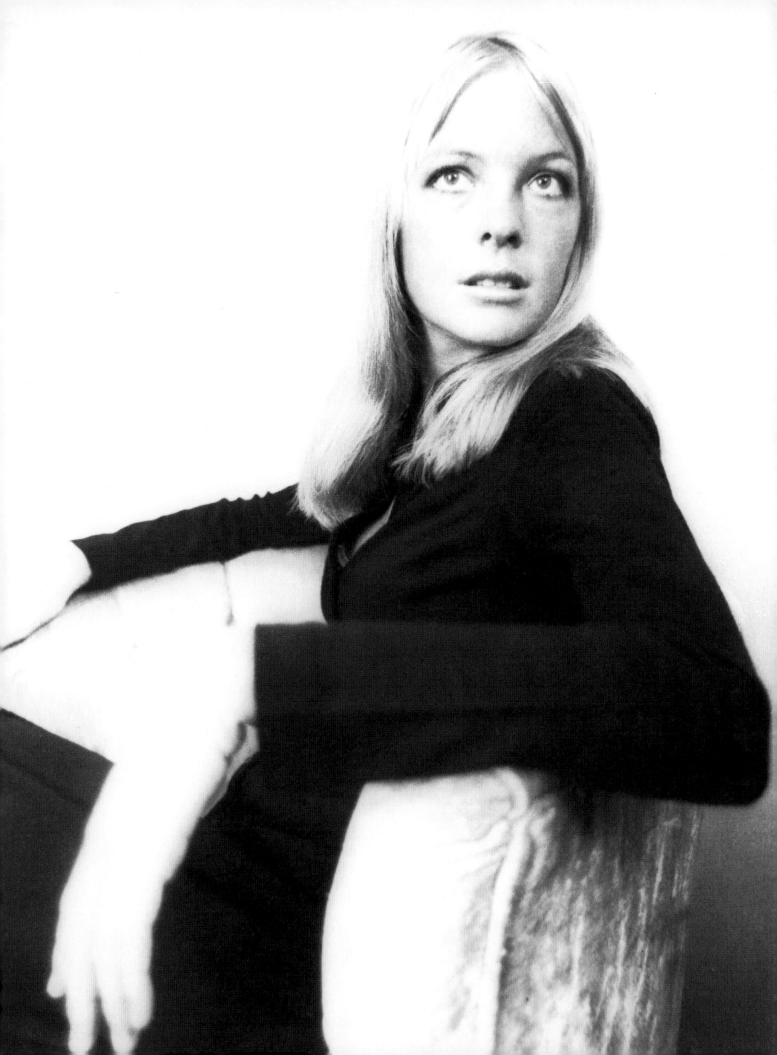

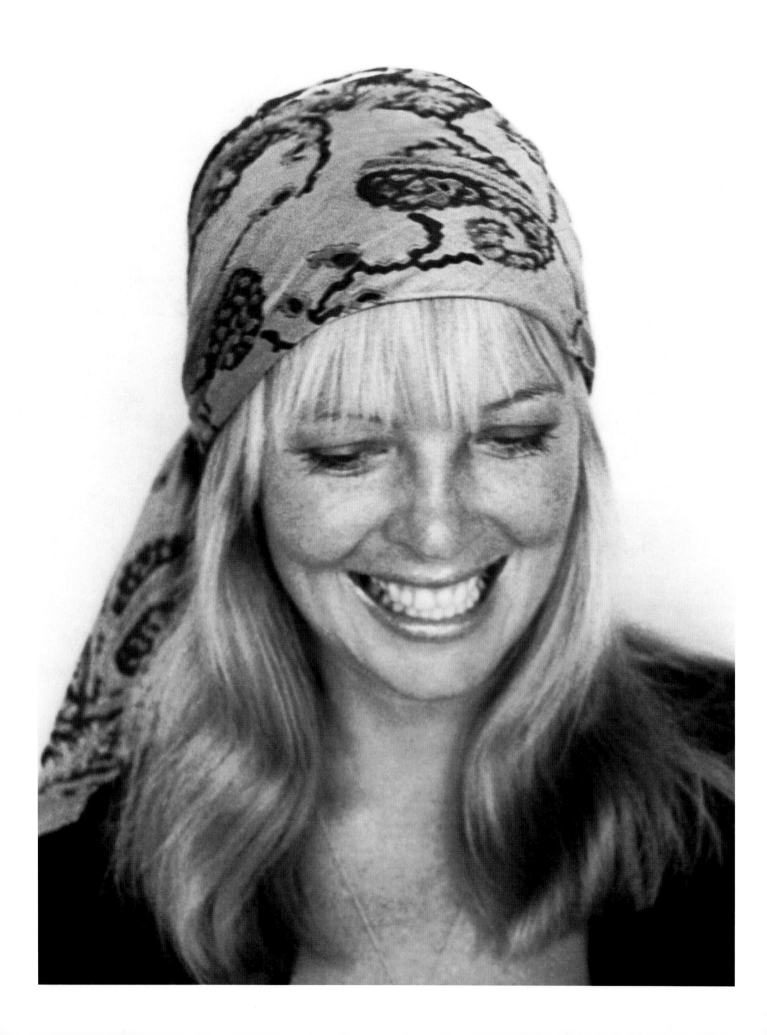

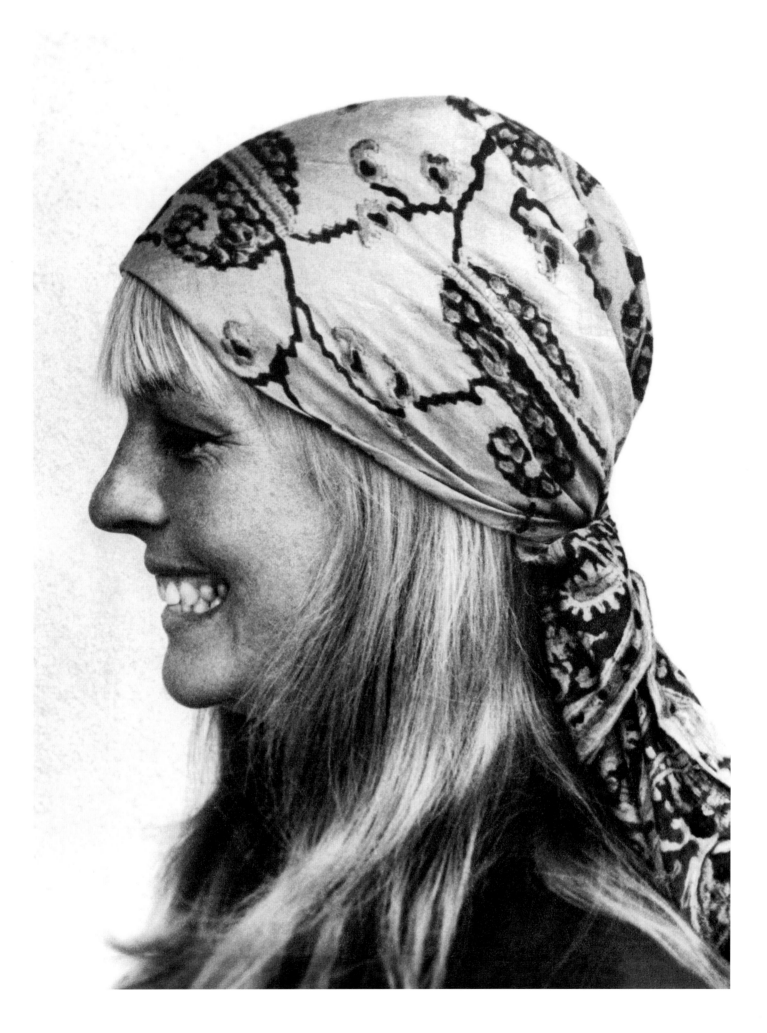

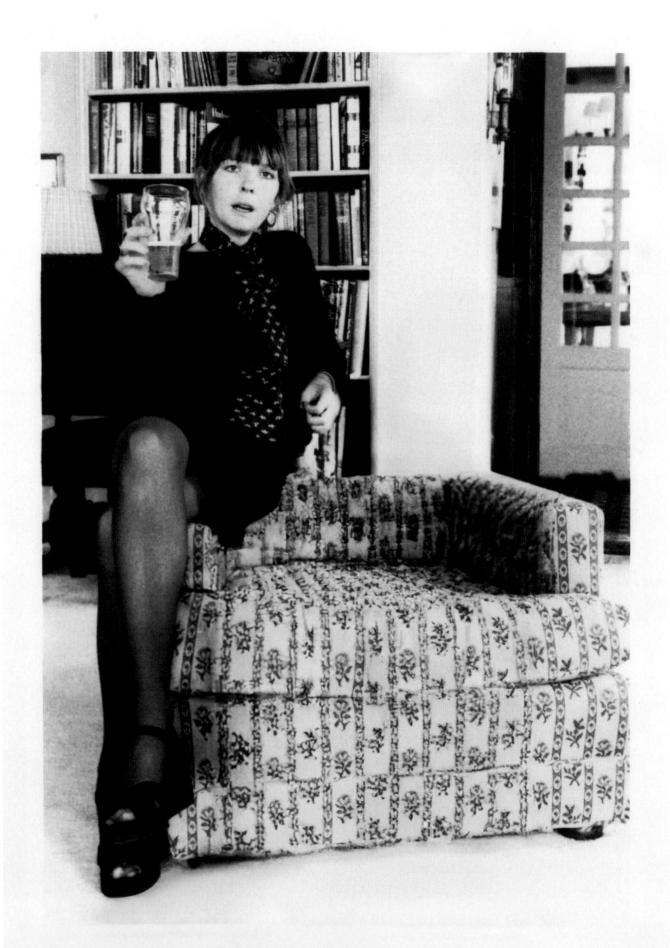

I loved this scarf.

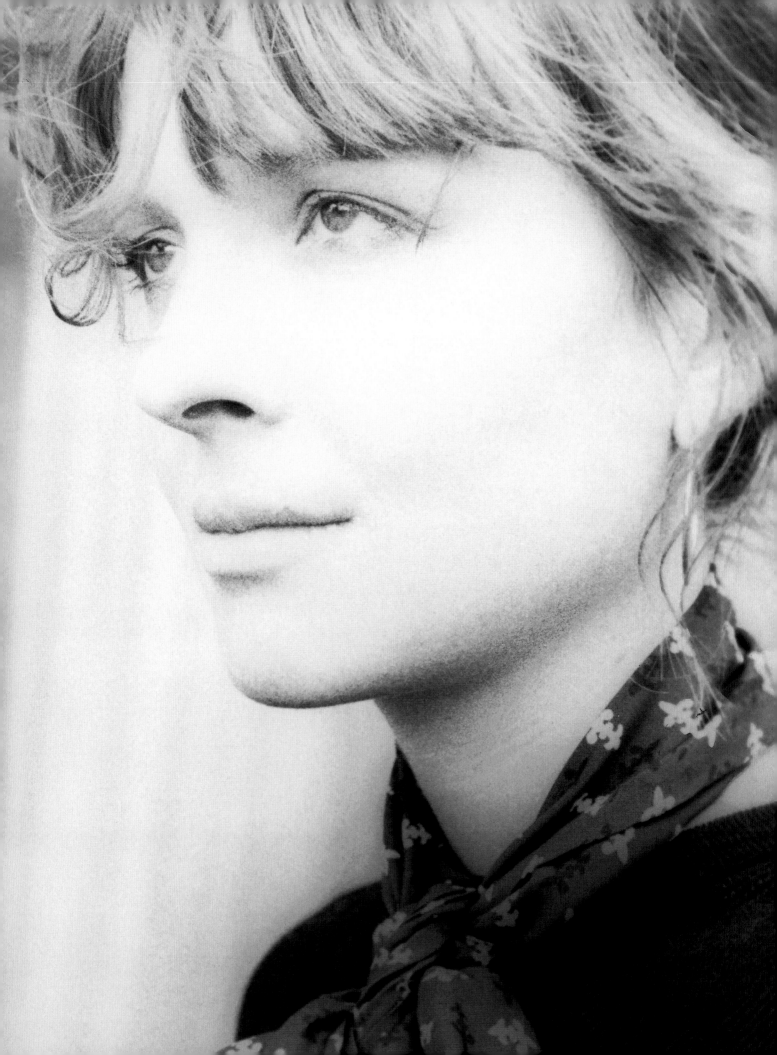

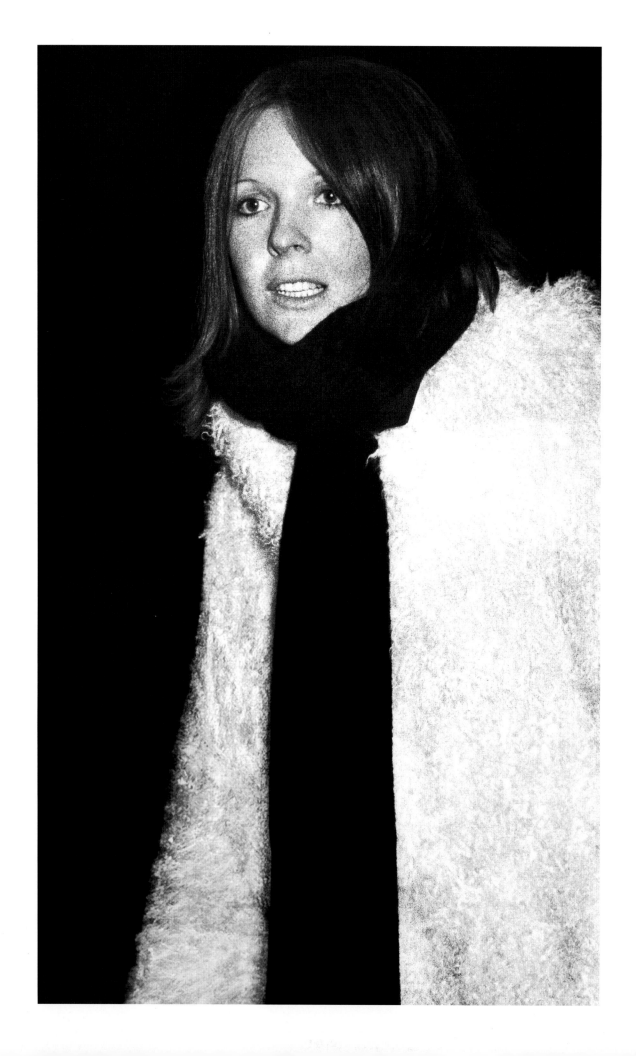

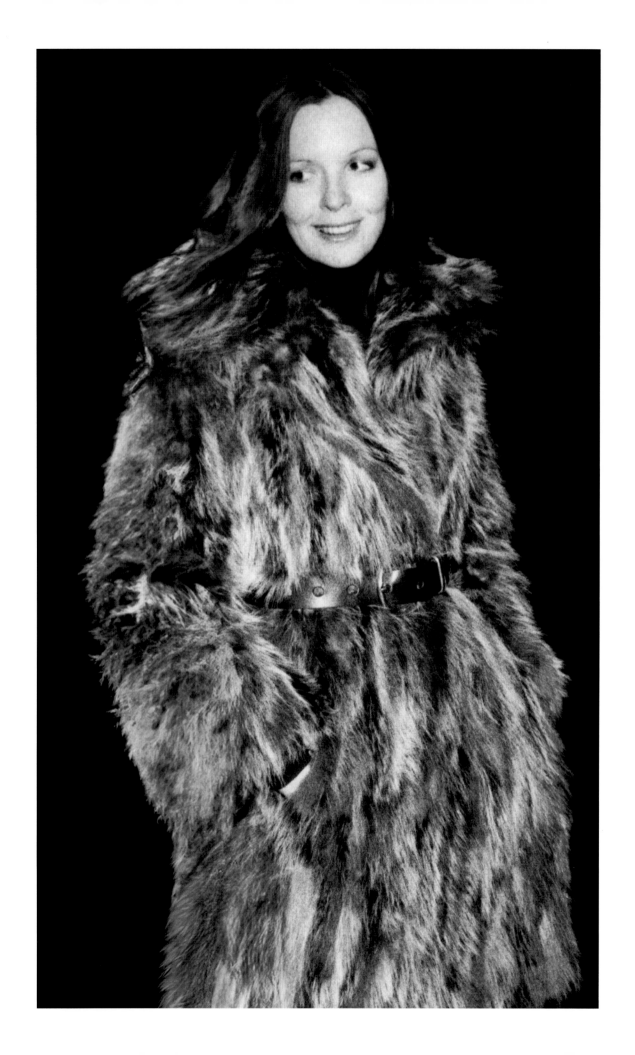

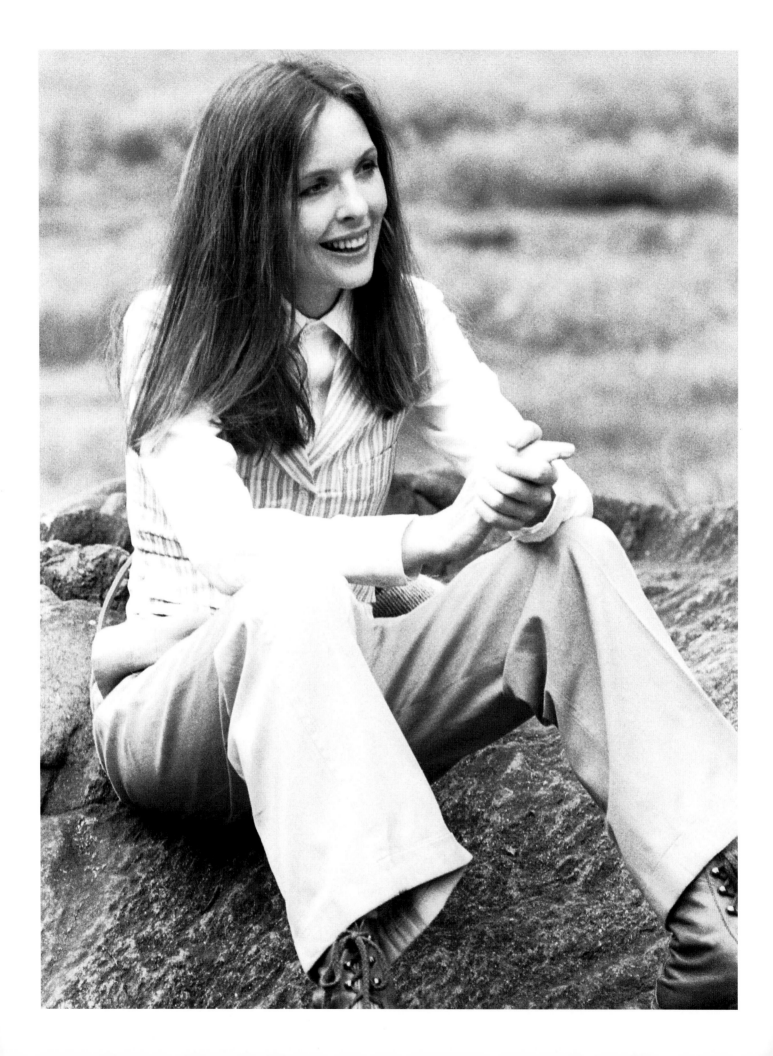

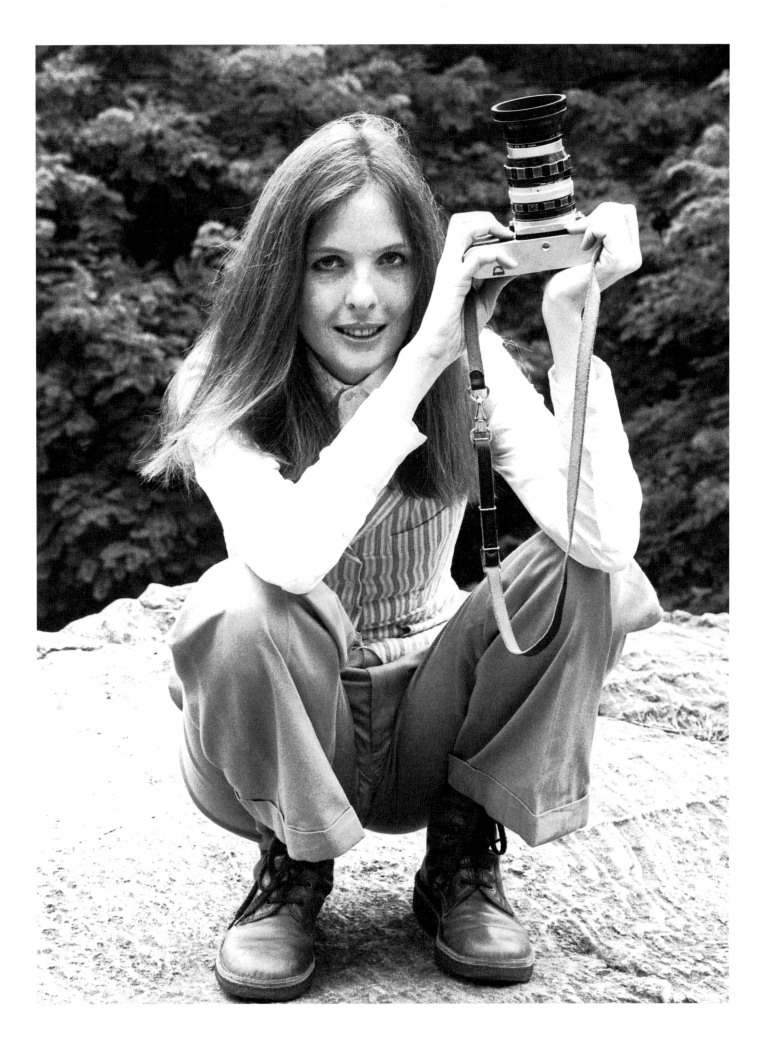

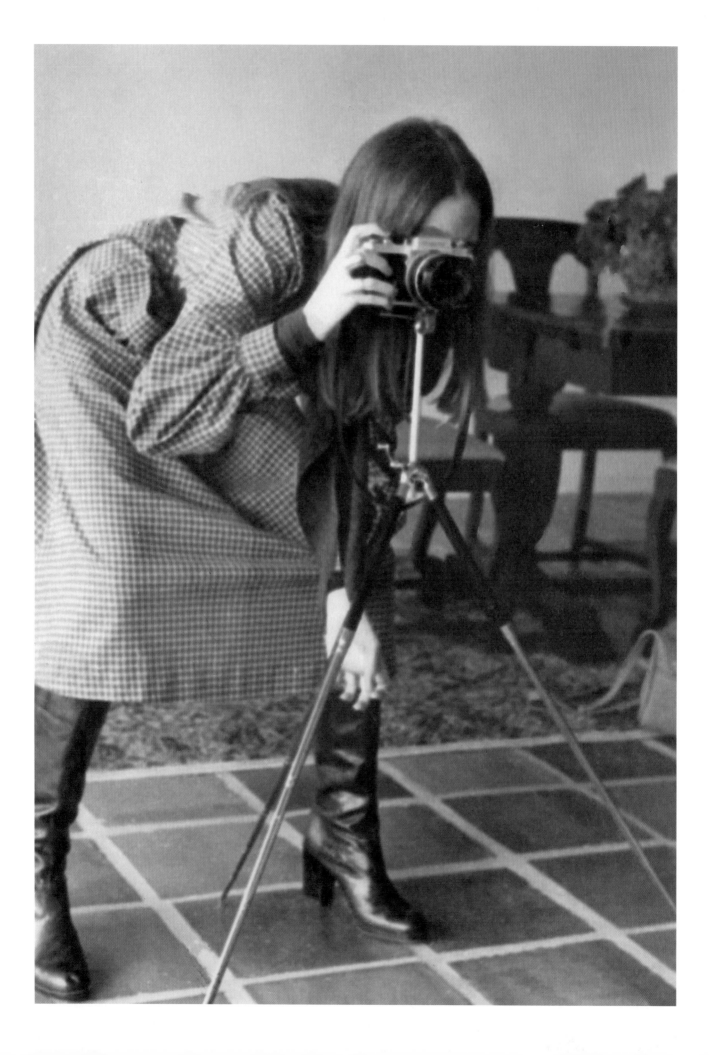

These boots were a thrifted find; I wore them with everything.

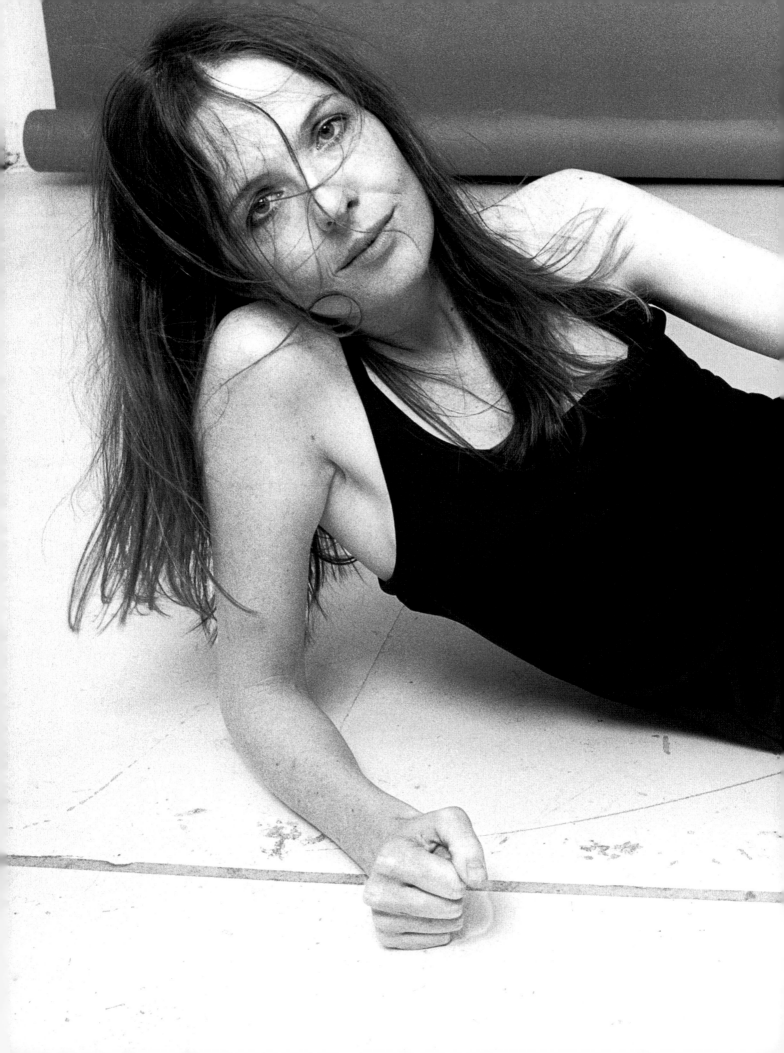

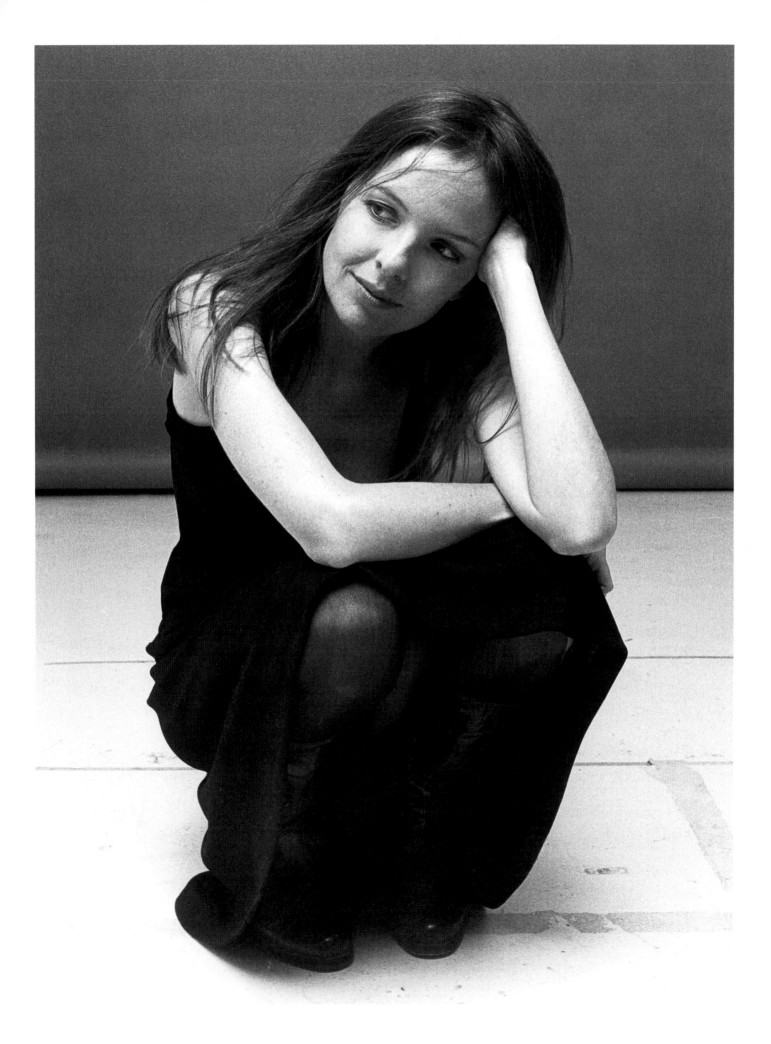

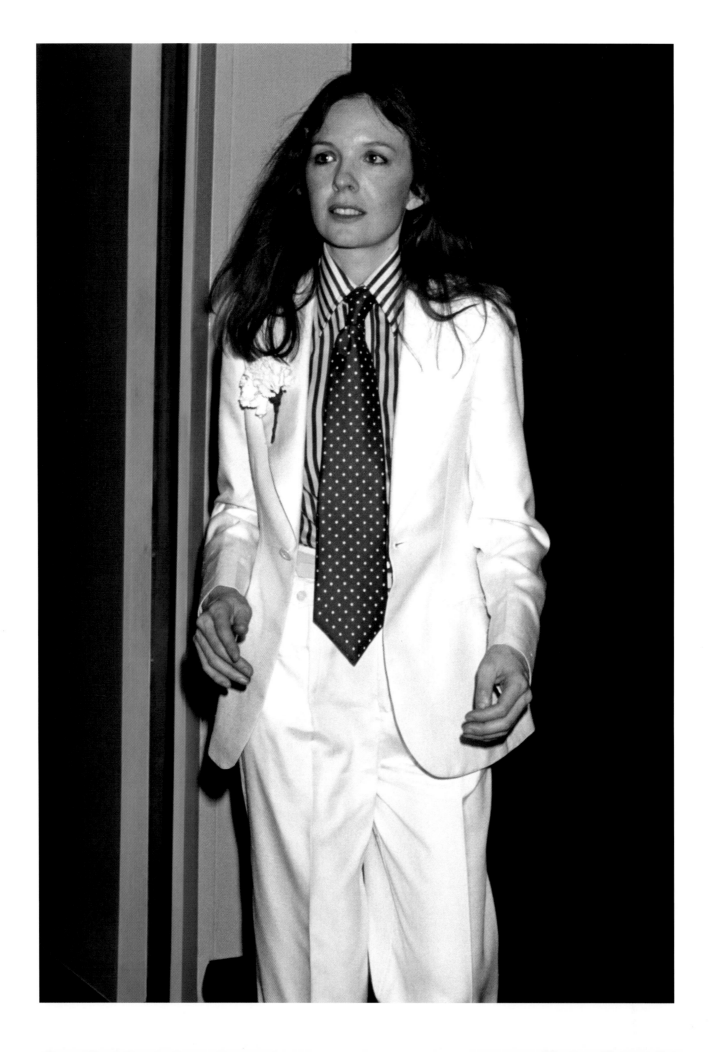

I was asked to present at the 1976 Oscars, which terrified me to my core. I am not one for public speaking, but I knew if I were to do it, I did not want to wear a dress. I wanted to wear a suit. It was not the norm back then for a woman to wear a suit in general, let alone to the Oscars. I am not sure how I gathered the courage but, to be honest, I think I just didn't care. I wanted to feel like myself, and wearing a suit was the only way. The brilliant Richard Tyler designed this white suit and tailored it to perfection. He was also on board when I told him I wanted to break another rule and pair stripes and polka dots together. We decided to choose a tie I already had in my wardrobe. (The same tie I wore in *Annie Hall*.) We pinned a carnation to the lapel and called it a day.

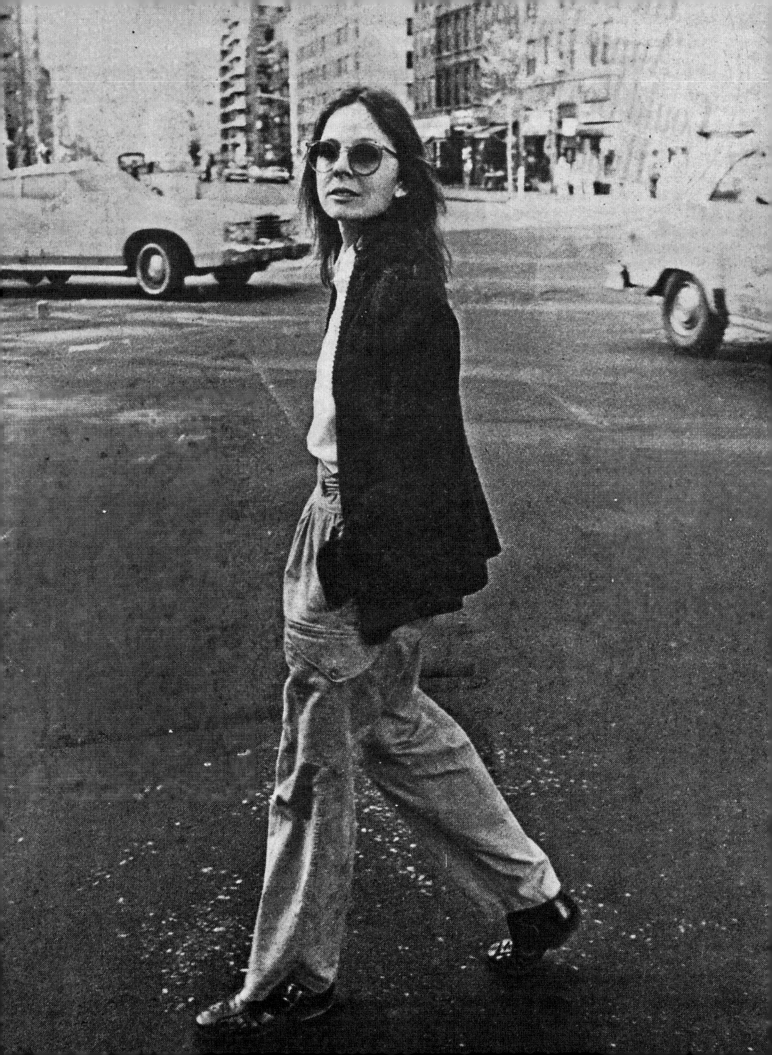

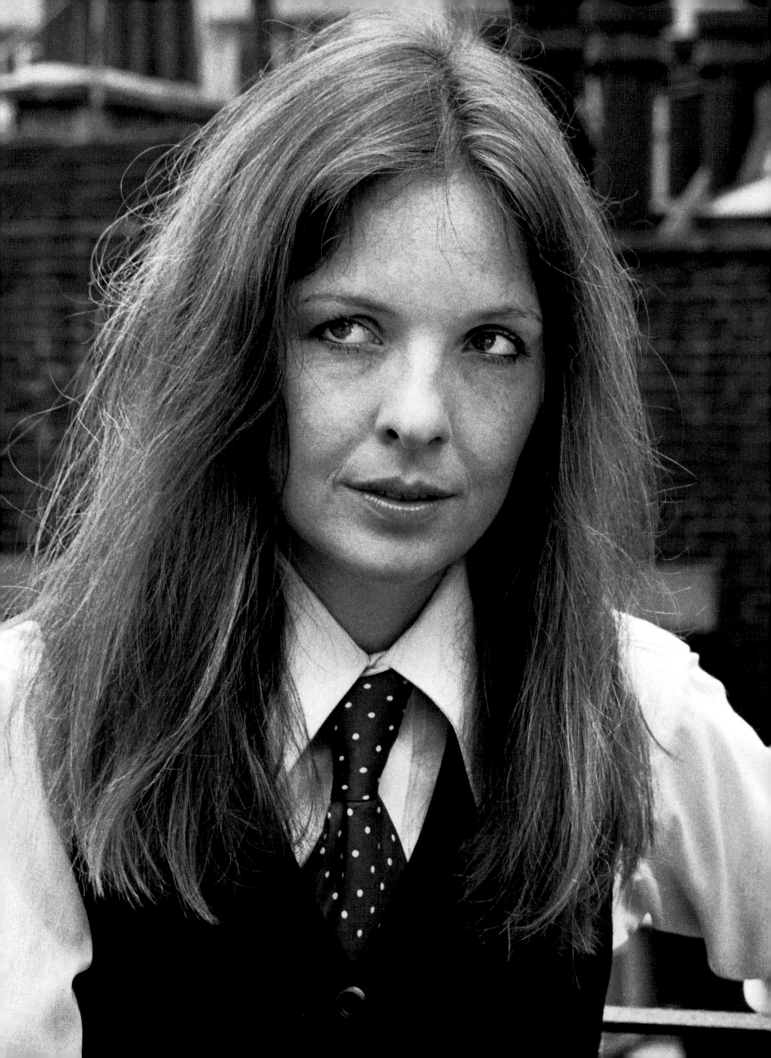

ANNIE HALL

Annie Hall was always a surprise to me. I dressed Annie as I would have dressed myself, and the response was beyond what I could have ever imagined. I always thought of myself as dressing a bit odd compared to the others out there in the movies. But when people seemed to like it, I didn't feel so weird. My style at the time was completely influenced by the cool-looking women walking the streets of Soho. I loved the effortlessness they conveyed: the oversized coats, a loose tie around a structured collar. It took me back to my infatuation with the incomparable Cary Grant who said, "Clothes make the man." I wanted my clothes to make the woman. I wanted my clothes to make Annie Hall.

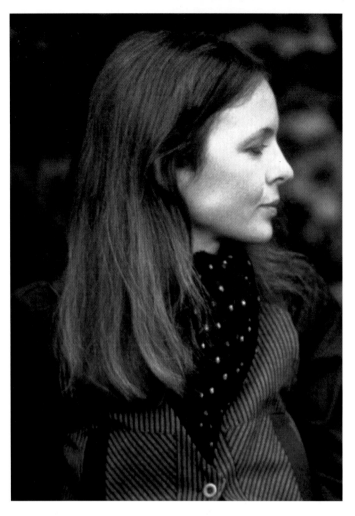
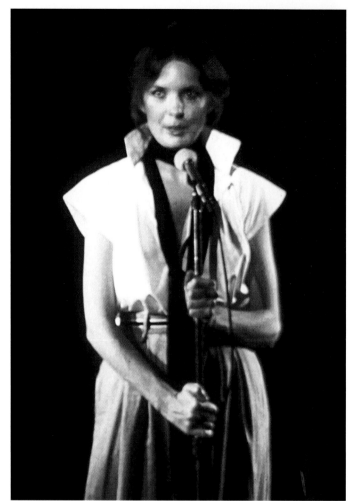
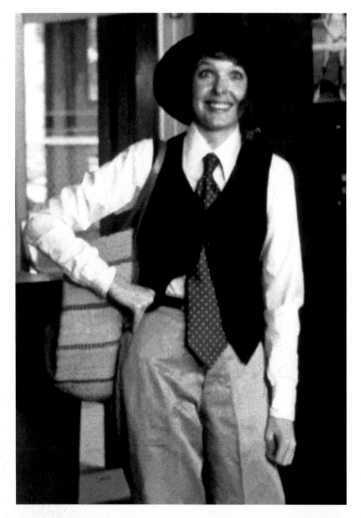
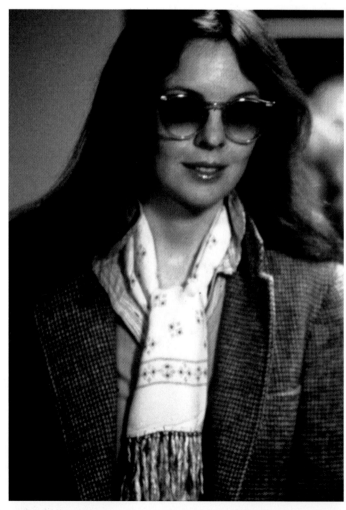

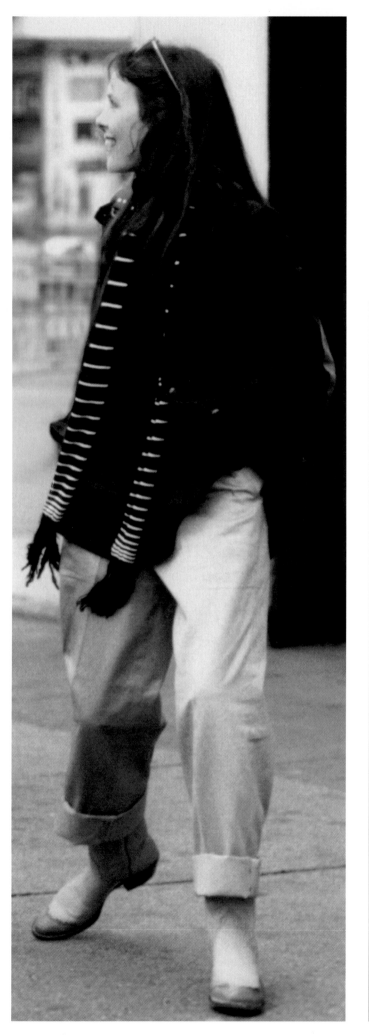
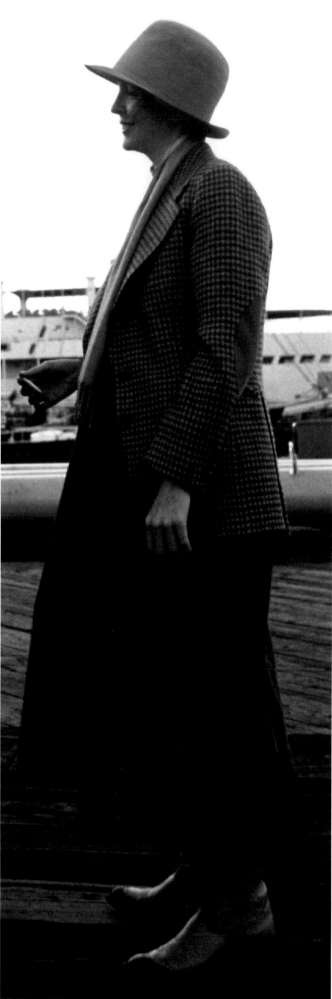

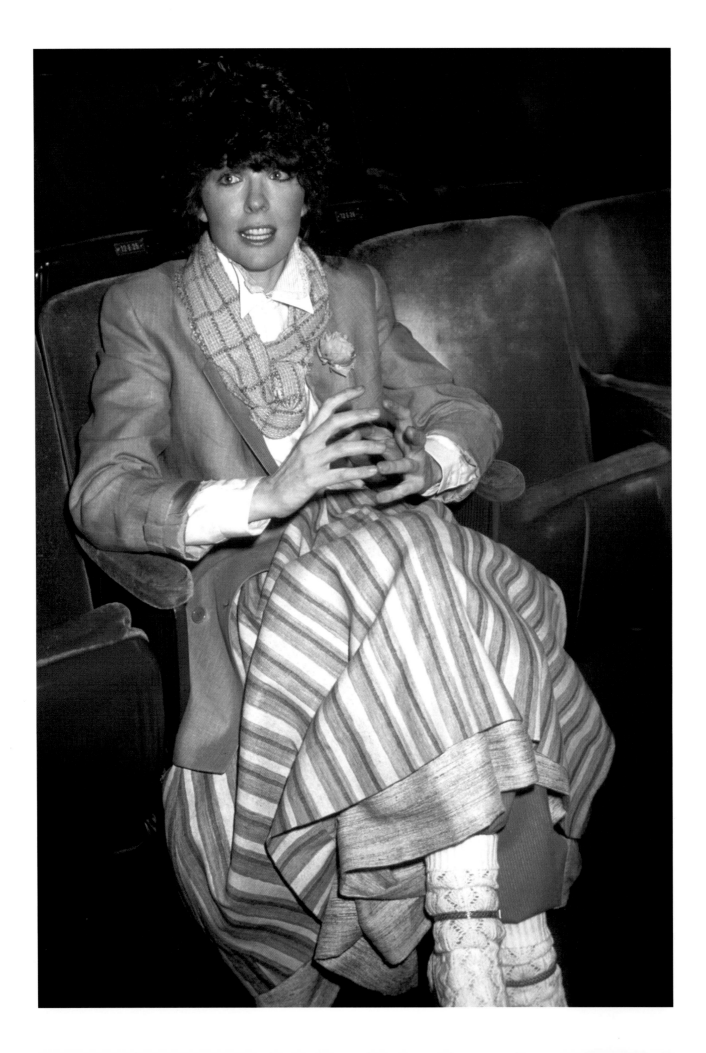

I still can't believe the genius that is Giorgio Armani designed my look for the 1978 Oscars. This was the year that I won for *Annie Hall* (which also shocks me to this day), and I am so lucky to have won in one of his designs. Giorgio gave me a look that honored my love for blazers and layers while also reminding me how much I adored skirts. (But maybe the socks I chose were just a little too '80s.)

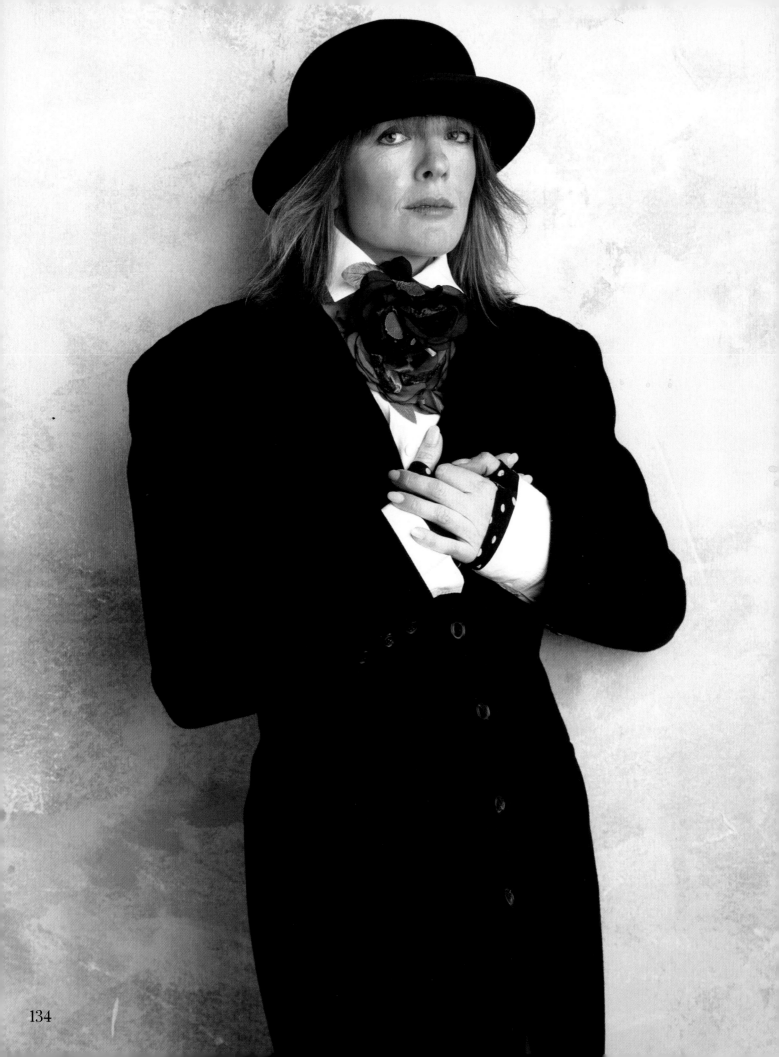

134

1980

These photographs will tell you more about the 1980s than I probably ever could. They say a picture is worth a thousand words, and it's never been more true. The bangs will be a dead giveaway that it was, in fact, the time of electronic dance music and the art of wearing one very large, very dominating earring. (What did we all do with the other earring?) The '80s were a time for shoulder pads, coats that were nine times your size, polka dots, perms, and pearls. Lots and lots of pearls. I beg of you not to judge this chapter too harshly, as I promise you, I was only following the rules of the time. Well, maybe I overexaggerated just a little bit. But I am me, so what did we expect? The flowers on the chest were perhaps a bit much, as well as the amount of different patterns I wore. I would be lying if I said I missed this time of fashion or the many obscure brooches I thought would be the cherry on top of my already unconventional outfits. The '80s were about patterns and shapes, and mixing them all together at once. And I did just that. So, let's look back fondly at these very bold choices together, shall we?

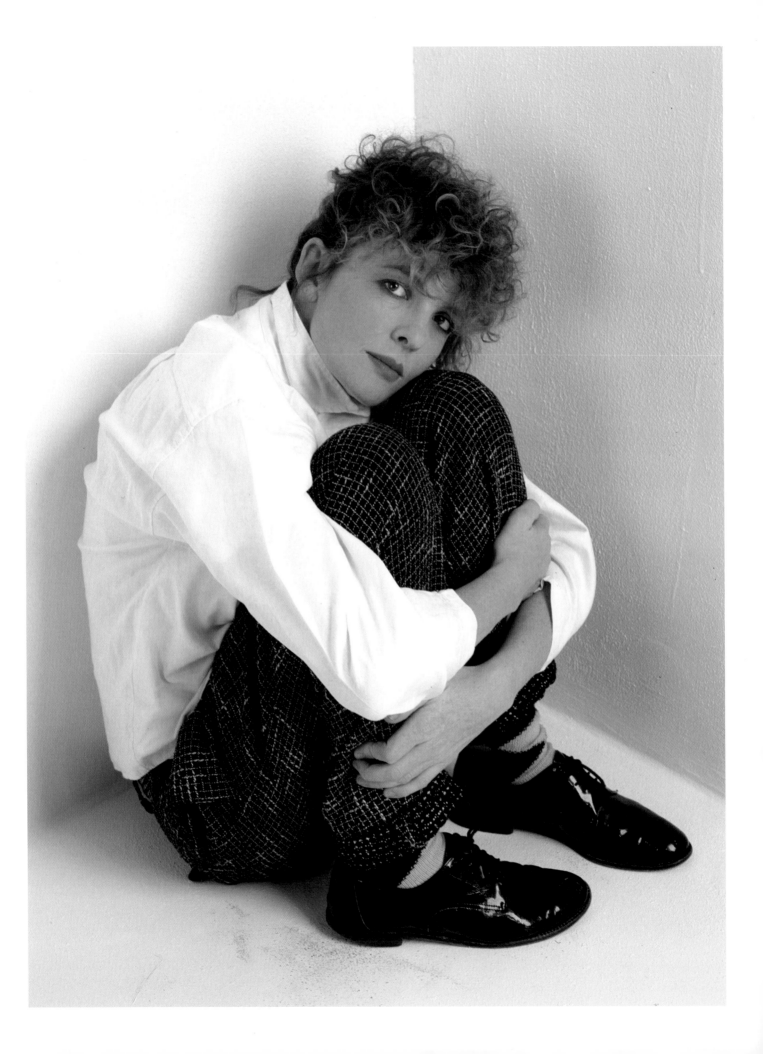

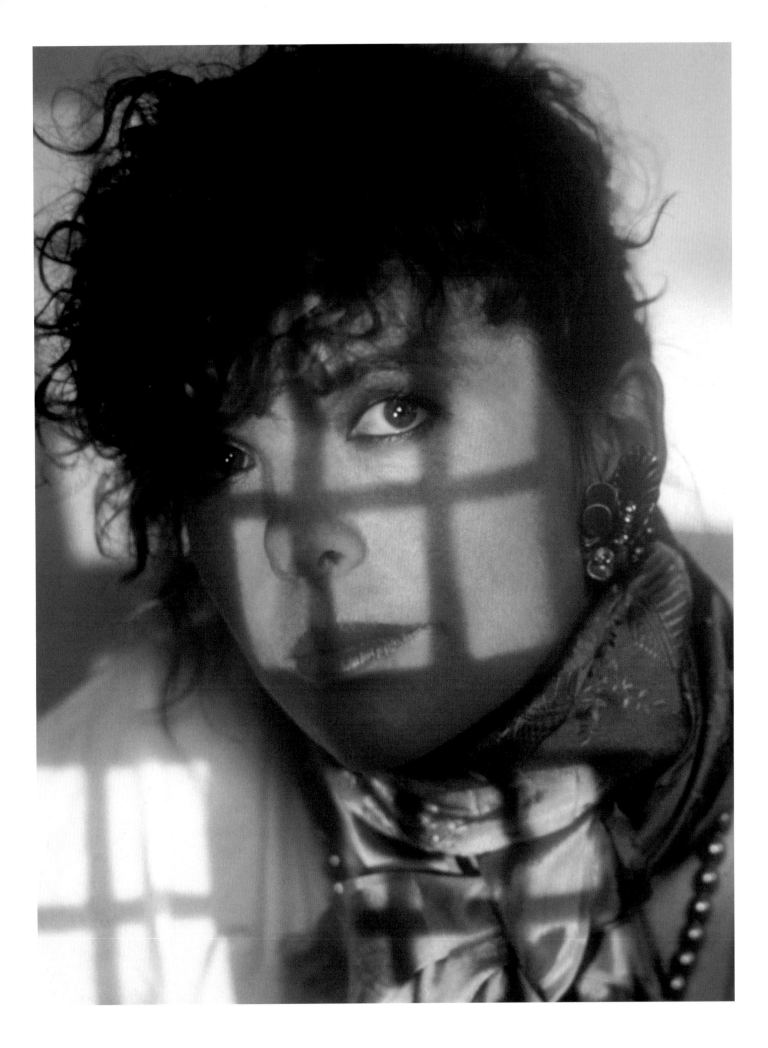

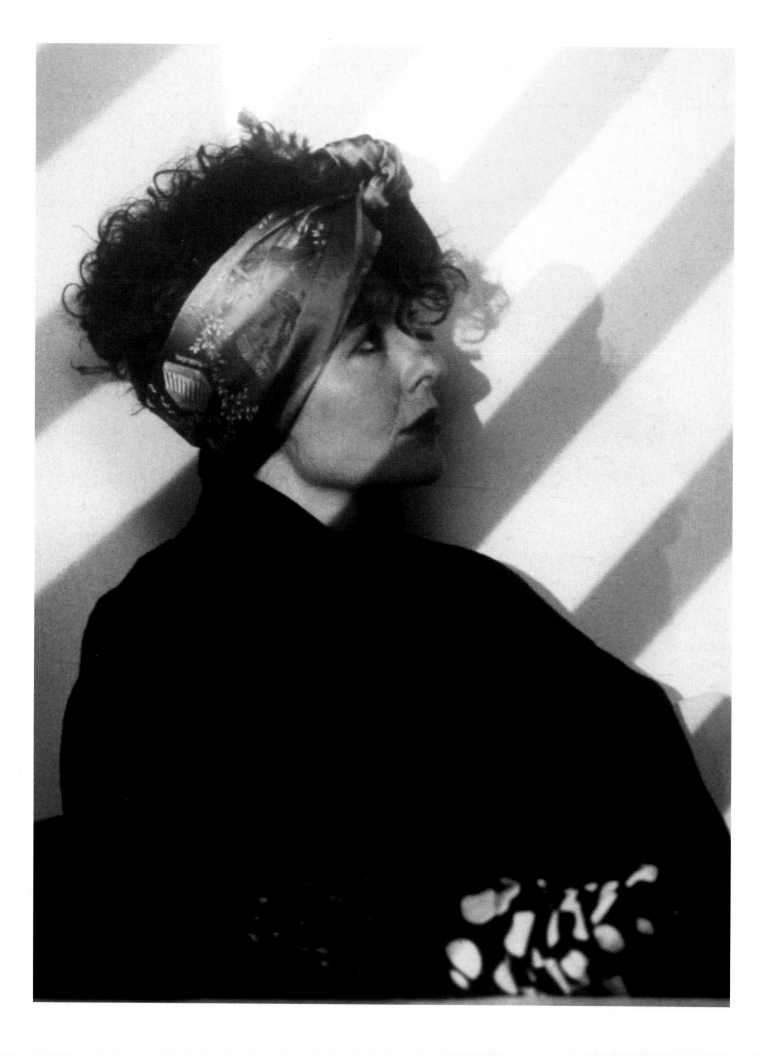

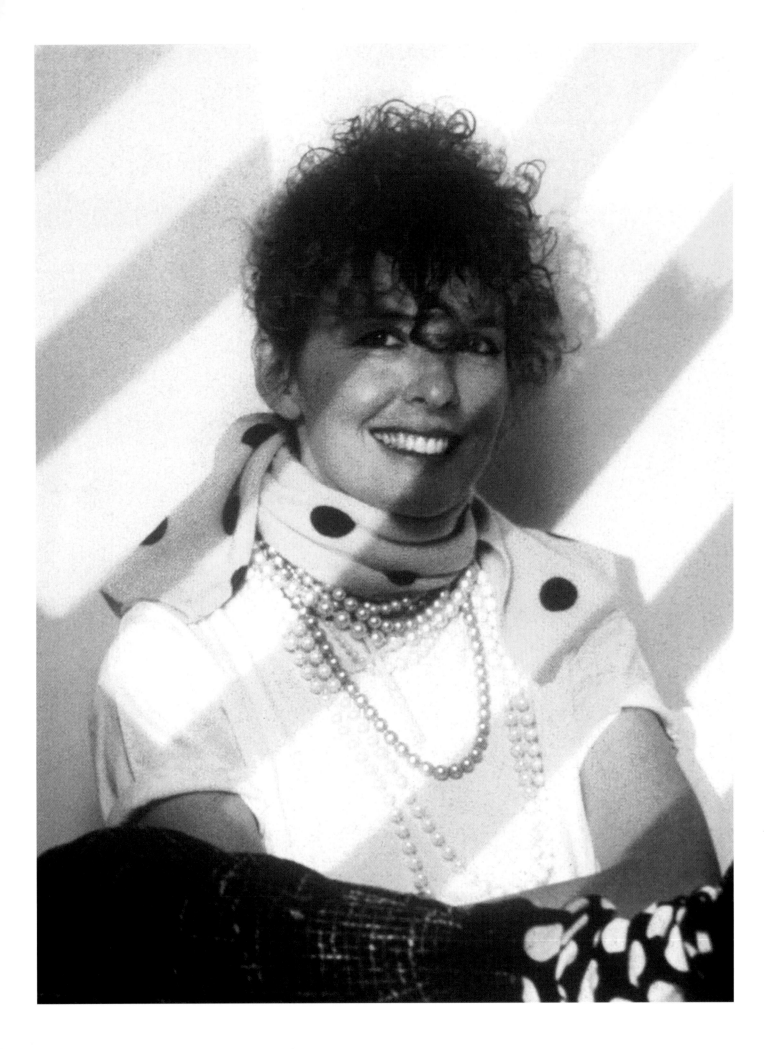

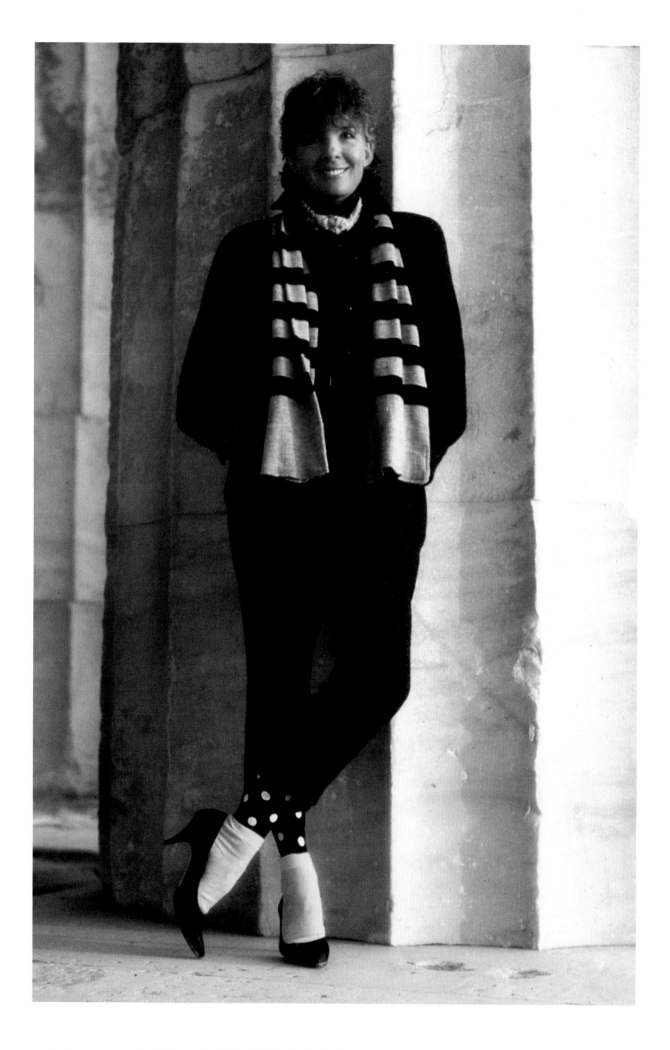

Don't forget to match your socks with your bandanna.

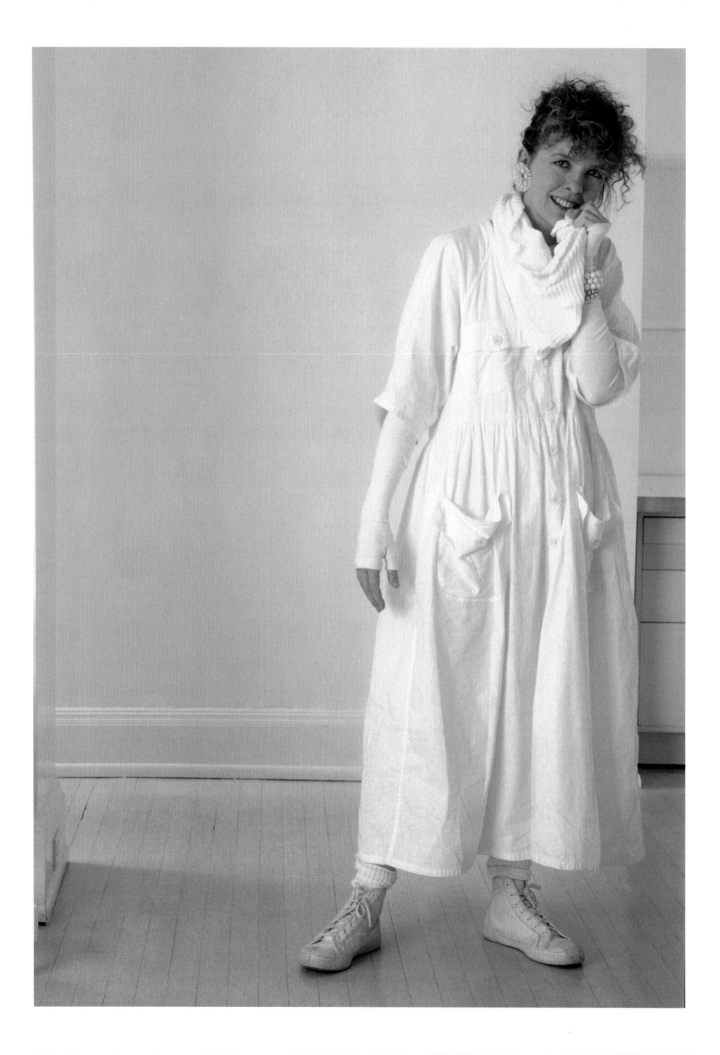

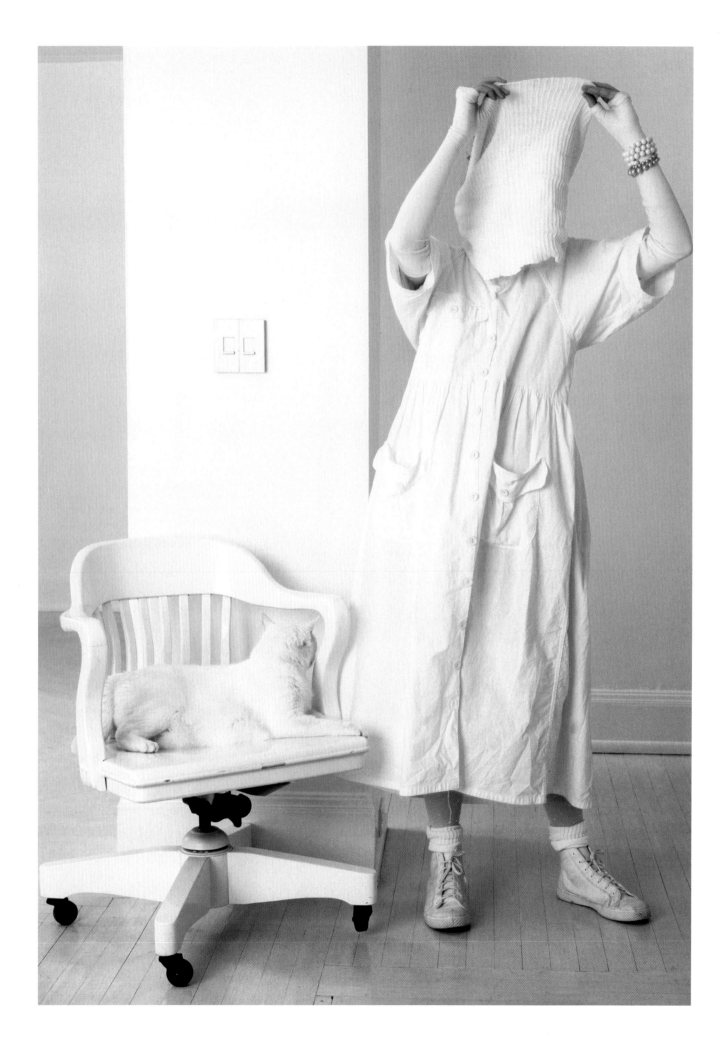

This is me on vacation somewhere tropical.
And, no, I am not kidding.

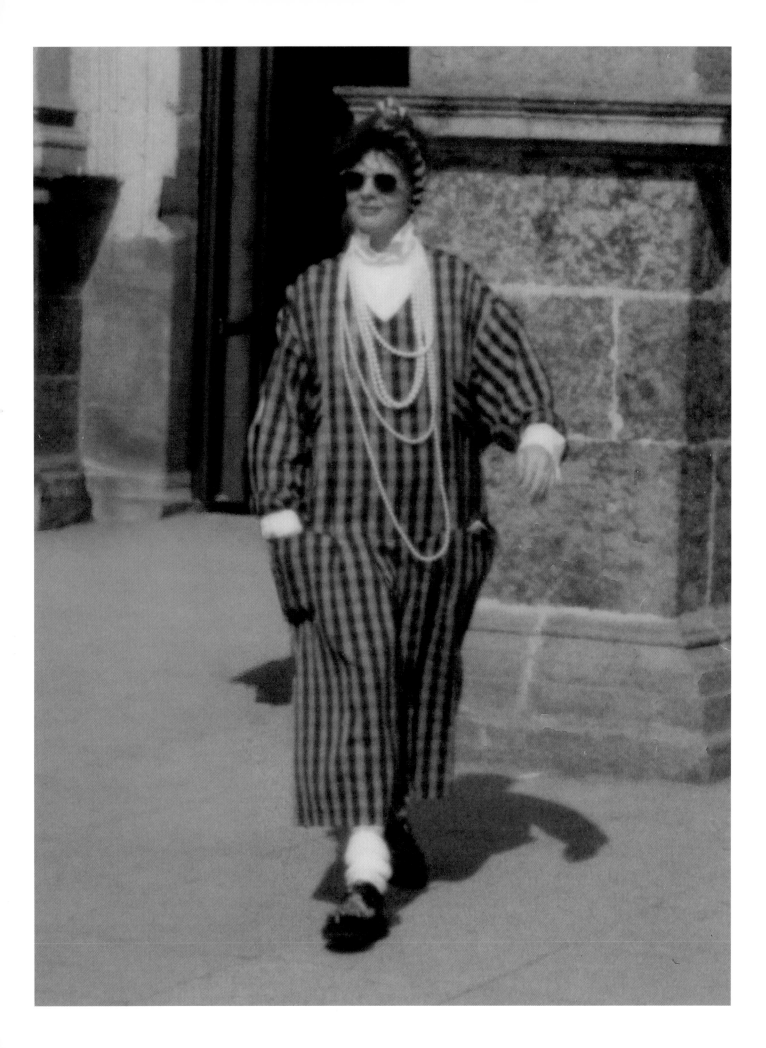

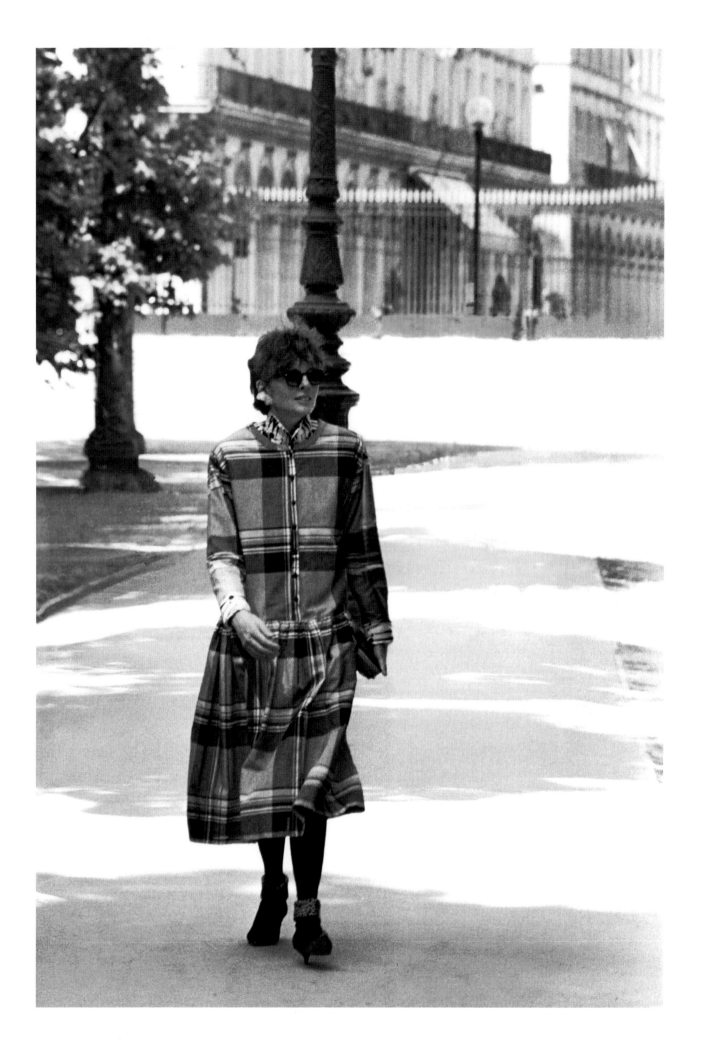

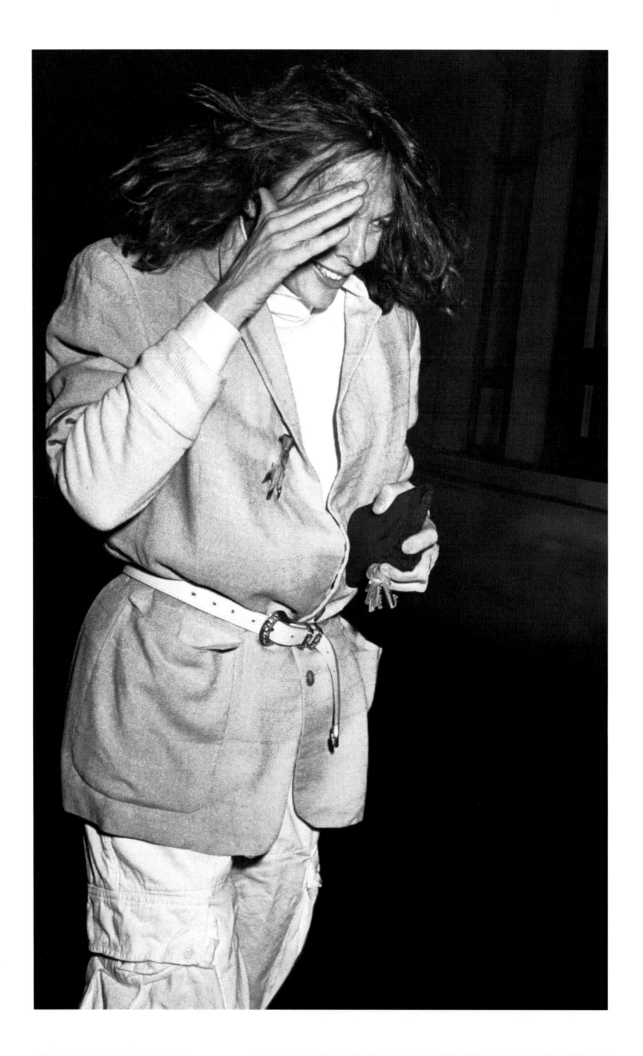

I got carried away with the chicken foot brooch.

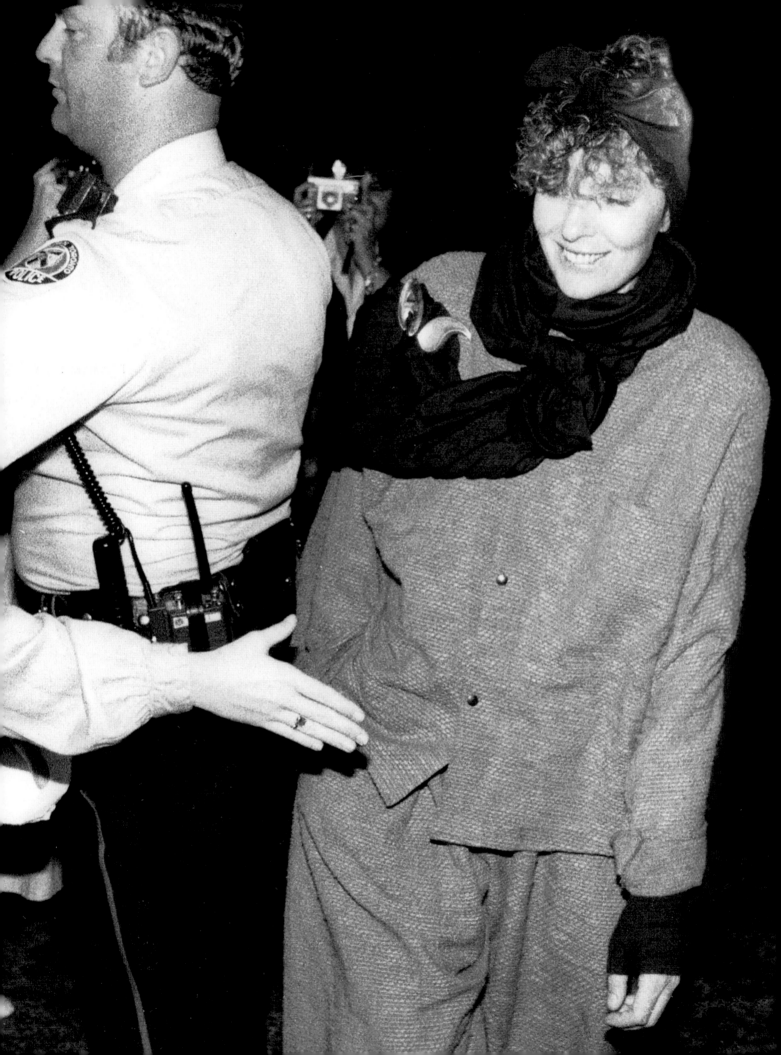

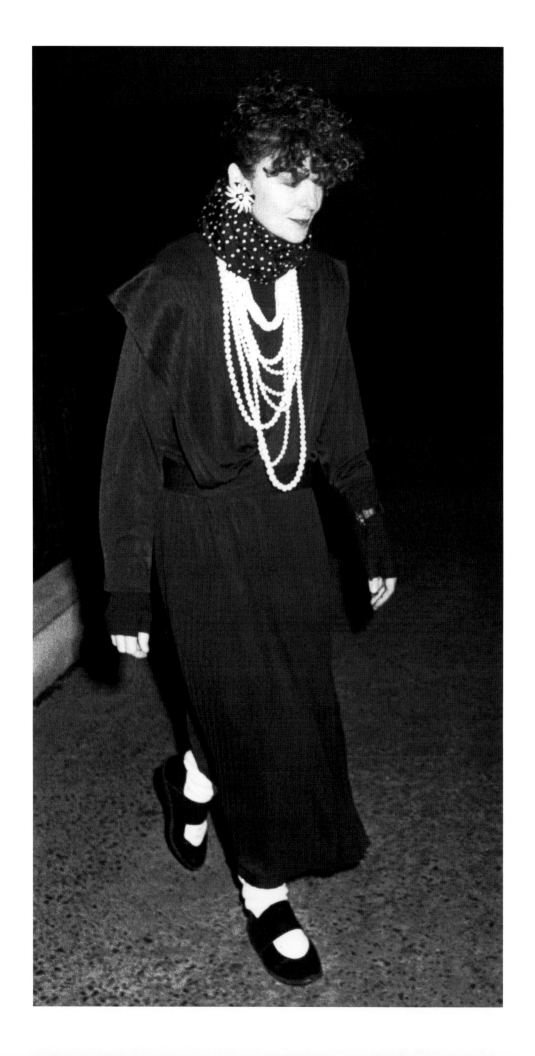

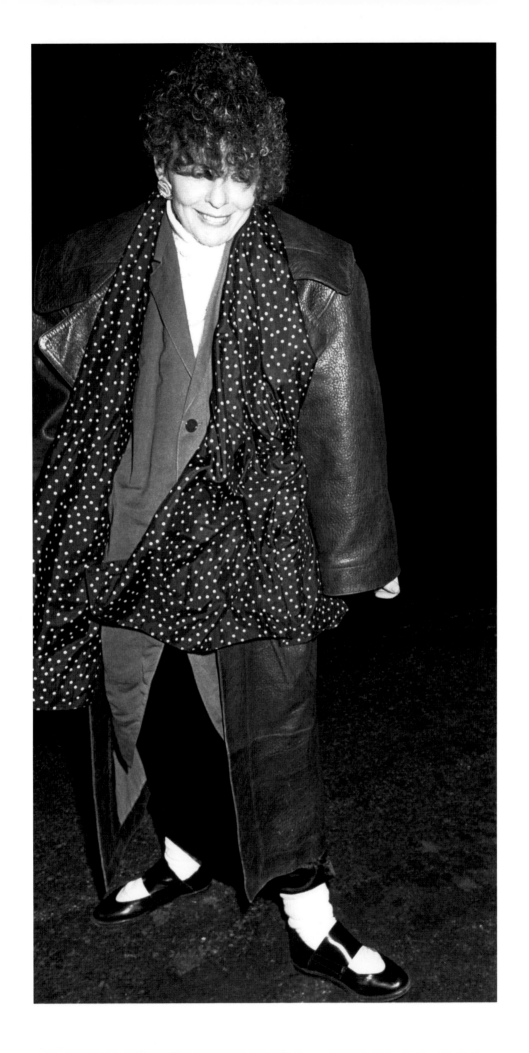

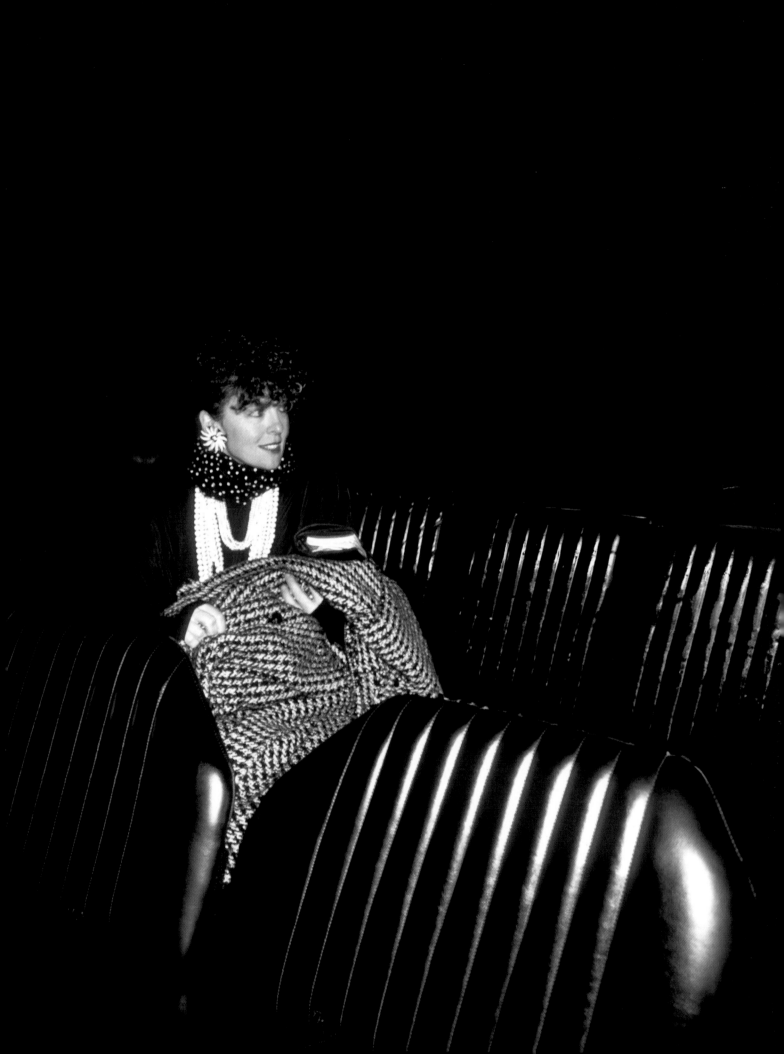

Do you think I am taking it a little too far with the pearls?

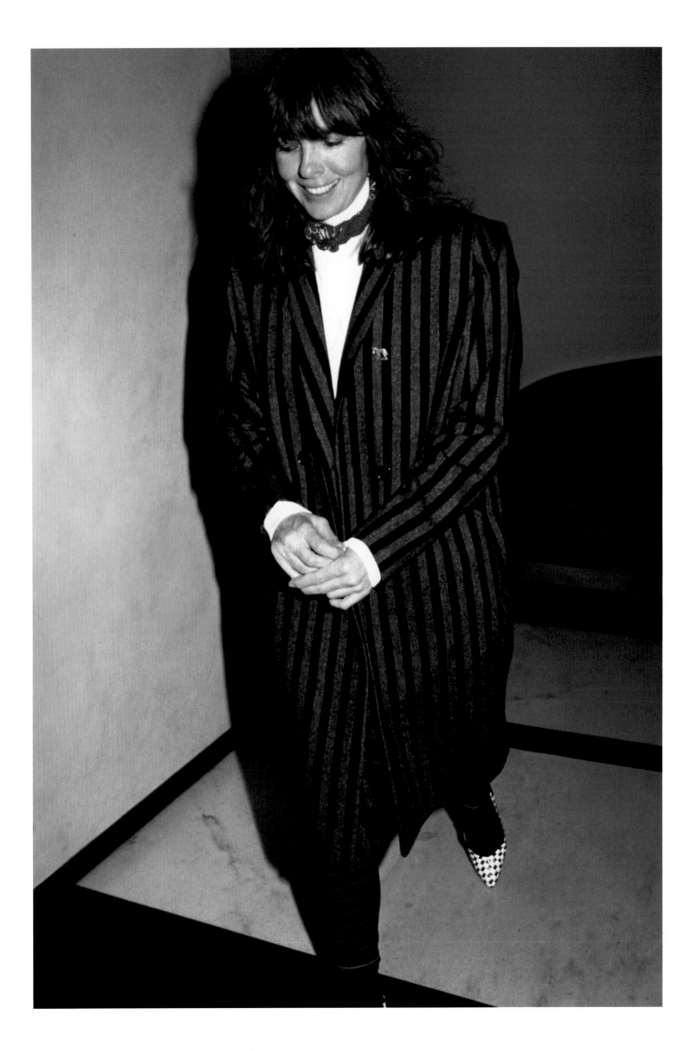

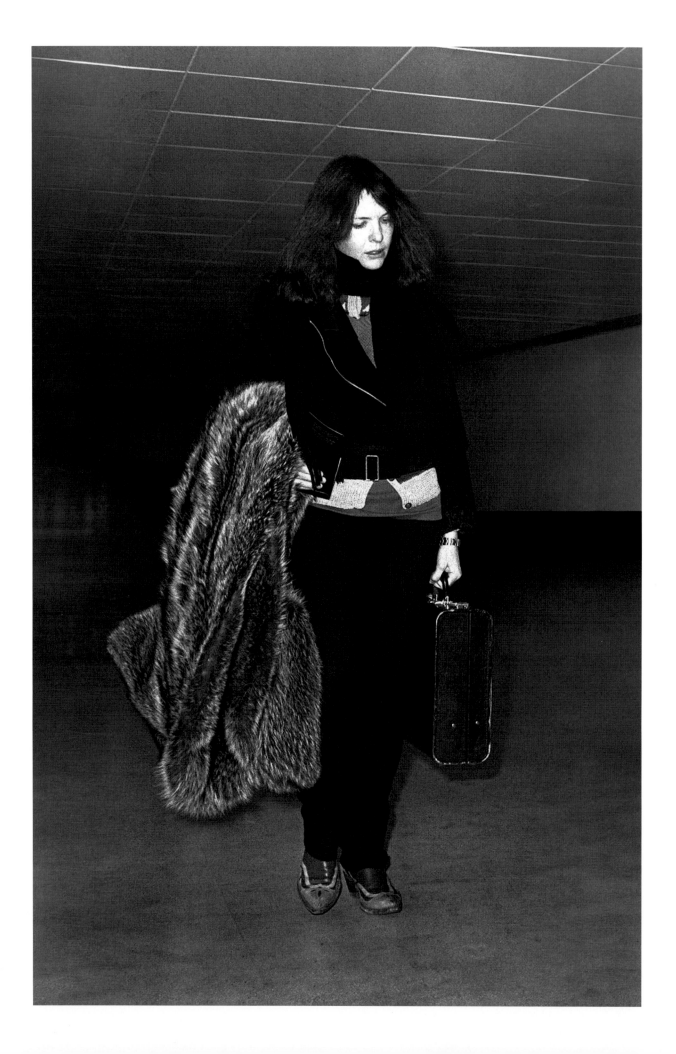

Uh-oh, the fur is back and went traveling.

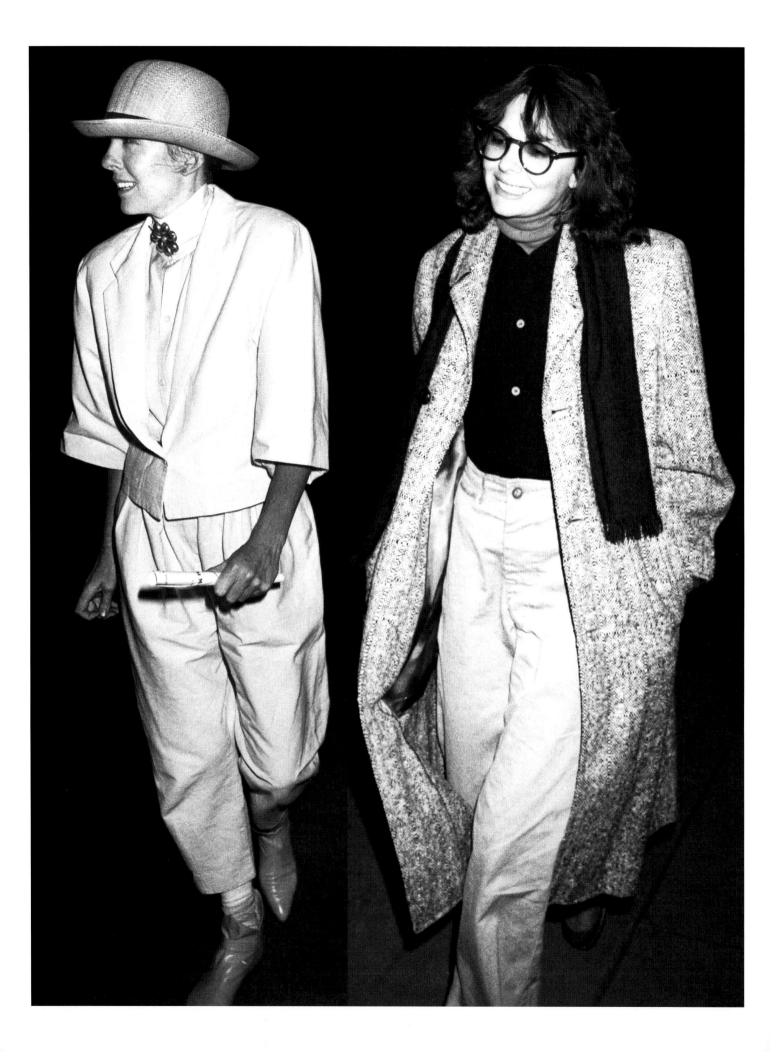

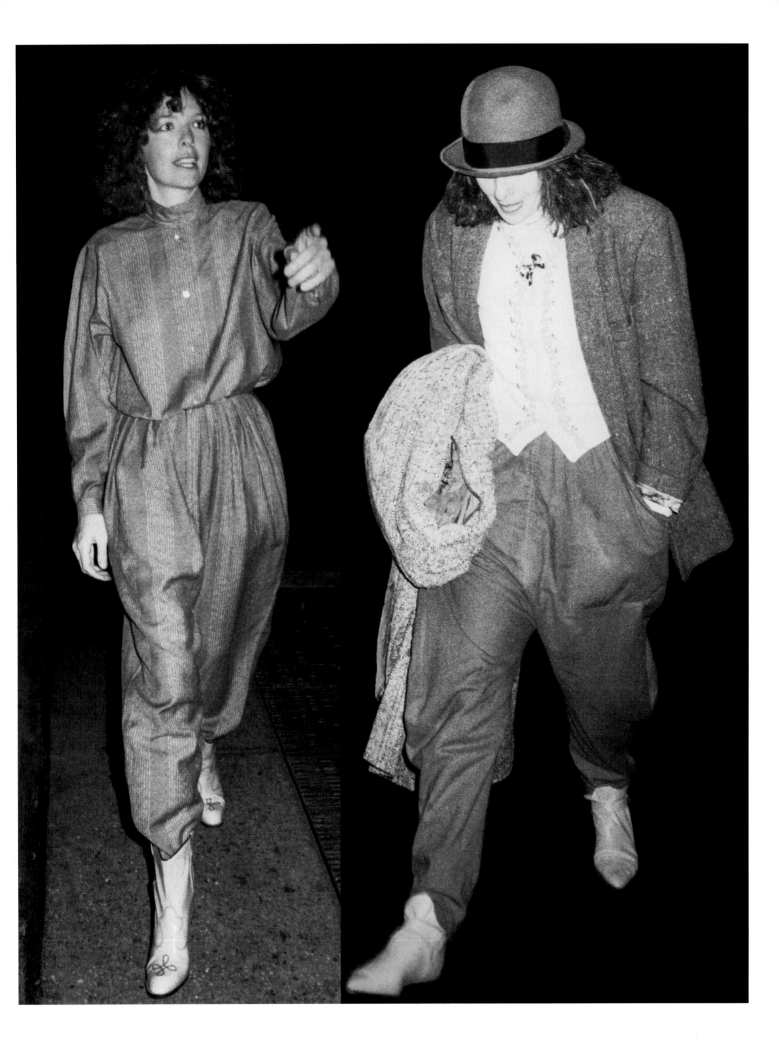

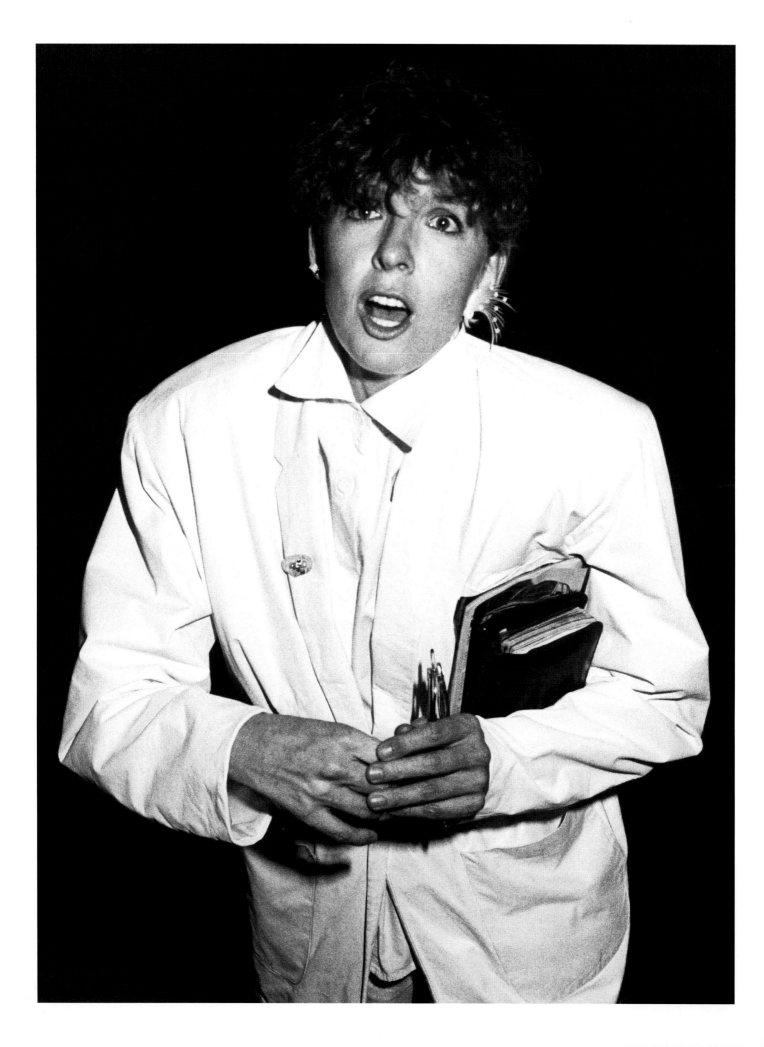

What should we discuss first? My jacket or my earring?

How about that zipper?

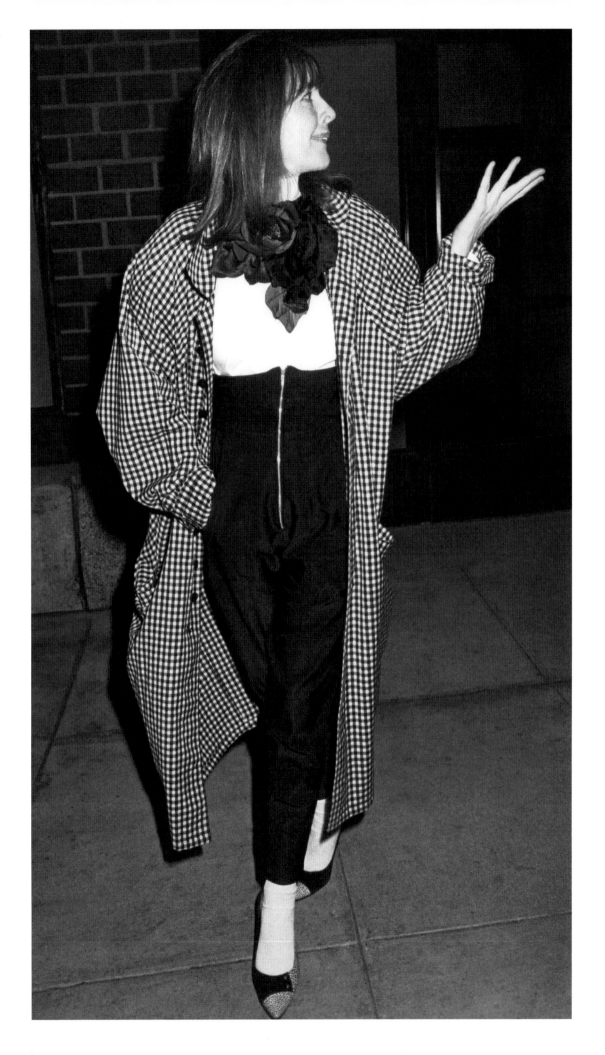

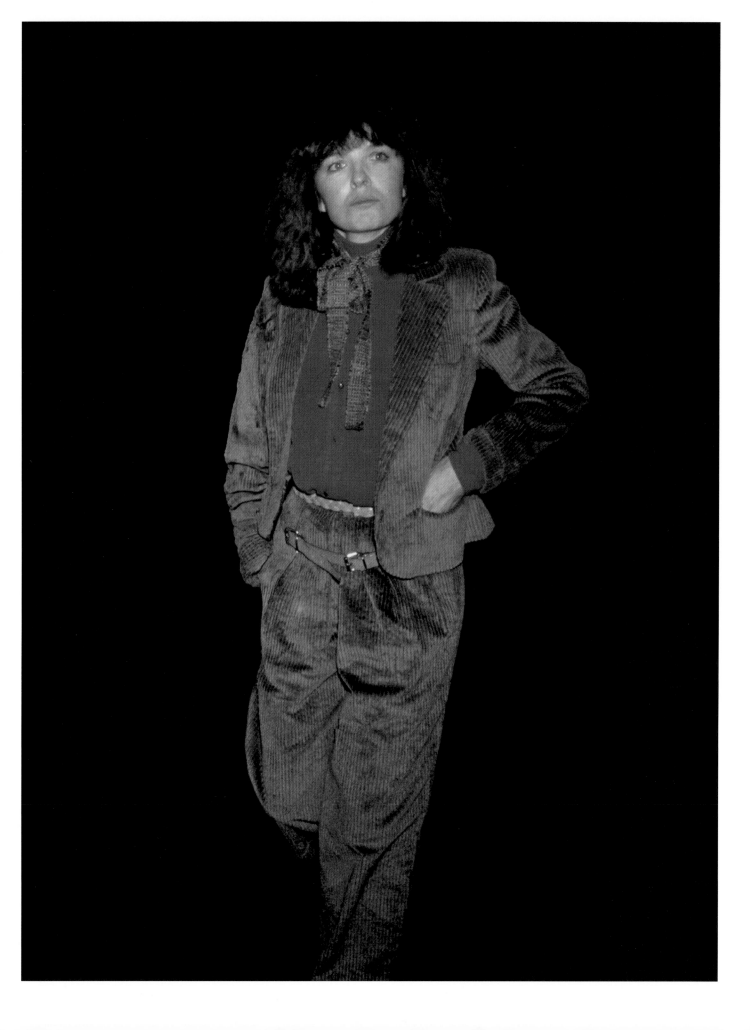

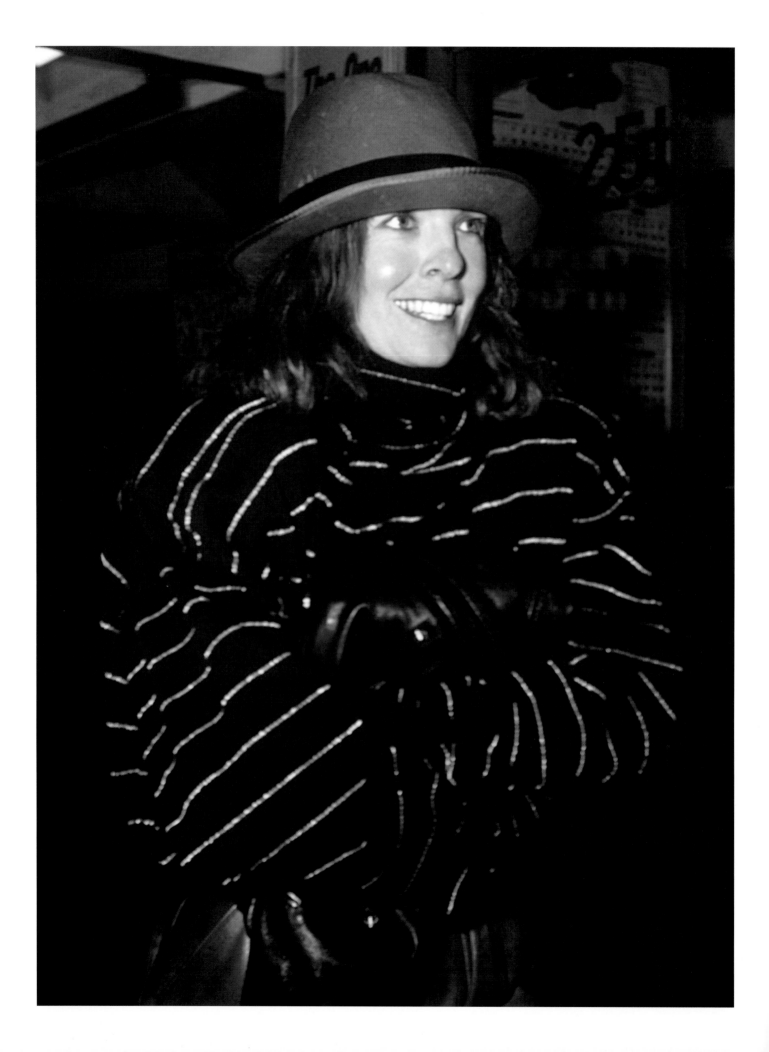

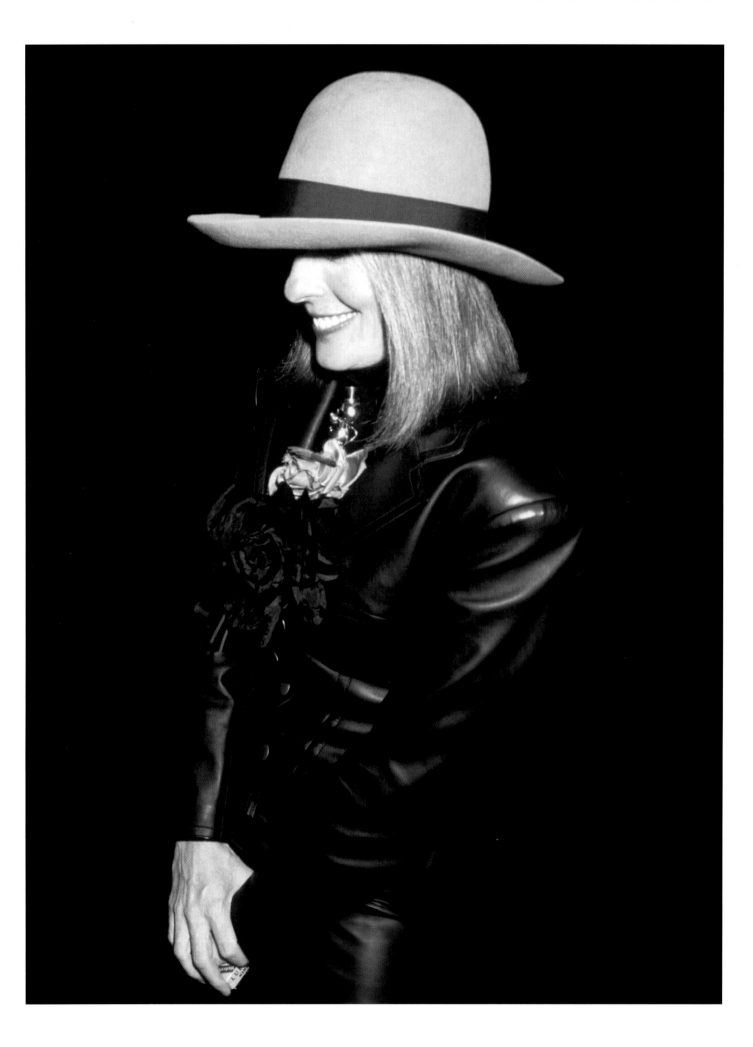

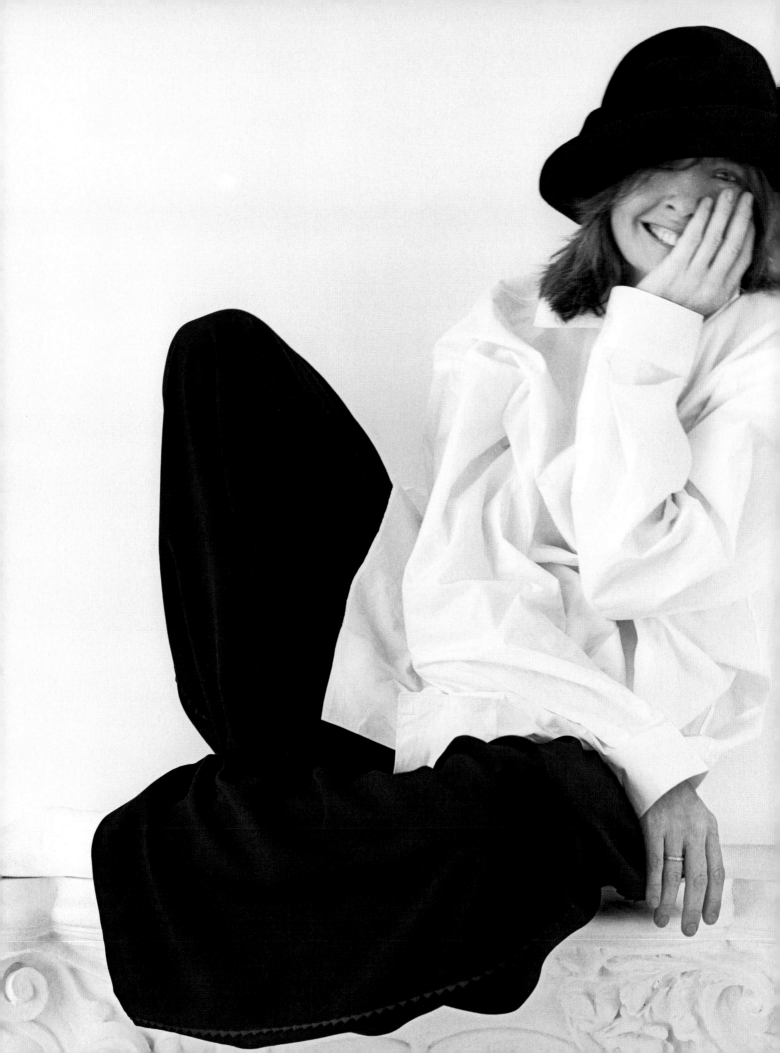

1990

By 1990, things were looking a lot different for me fashionwise. I ditched the polka dots (mostly), and I wasn't wearing that much yellow anymore (thank God). My hair no longer had that '80s curl, and hats had reentered the picture more frequently. I began to wear a lot more suits and also found an obsession with cross necklaces, typically layered upon one another like a very devoted nun. I was finding my own style more and more and gaining a settled kind of confidence in what I was wearing. These years were filled with big coats, thick boots, and wide brimmed hats. I was beginning to wear more jewelry, like silver necklaces and bracelets. I started to throw in some bow ties and pocket squares as my collars became smaller than the years before. The only thing that never changed was my longing to be covered up.

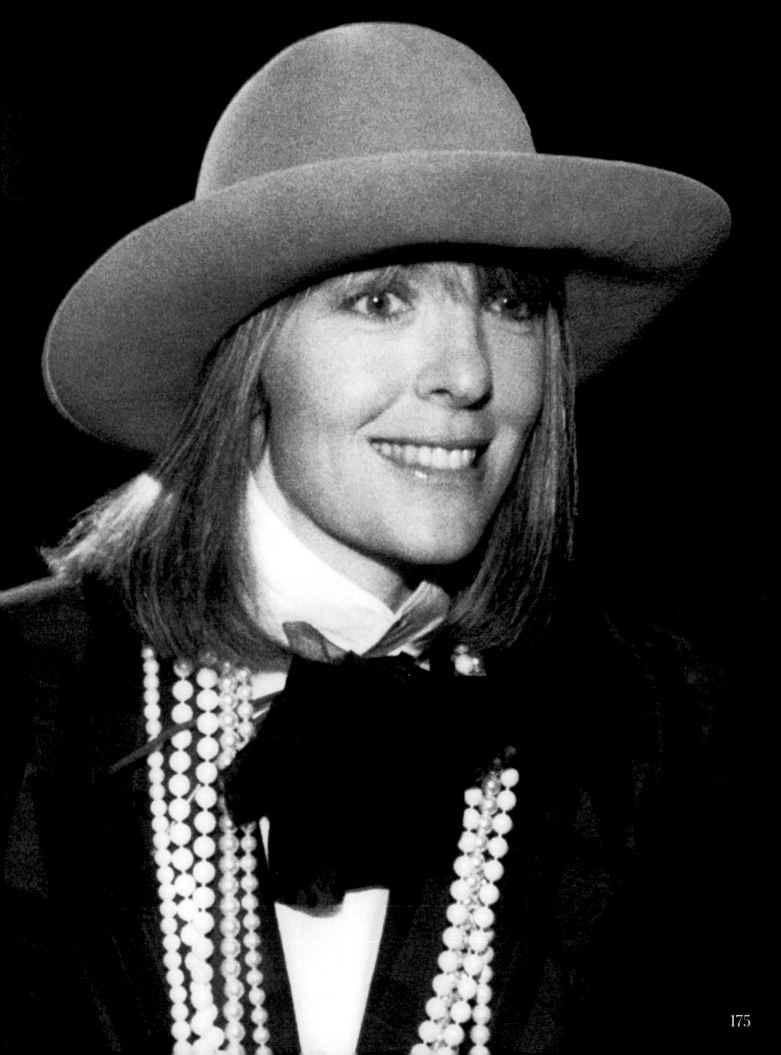

175

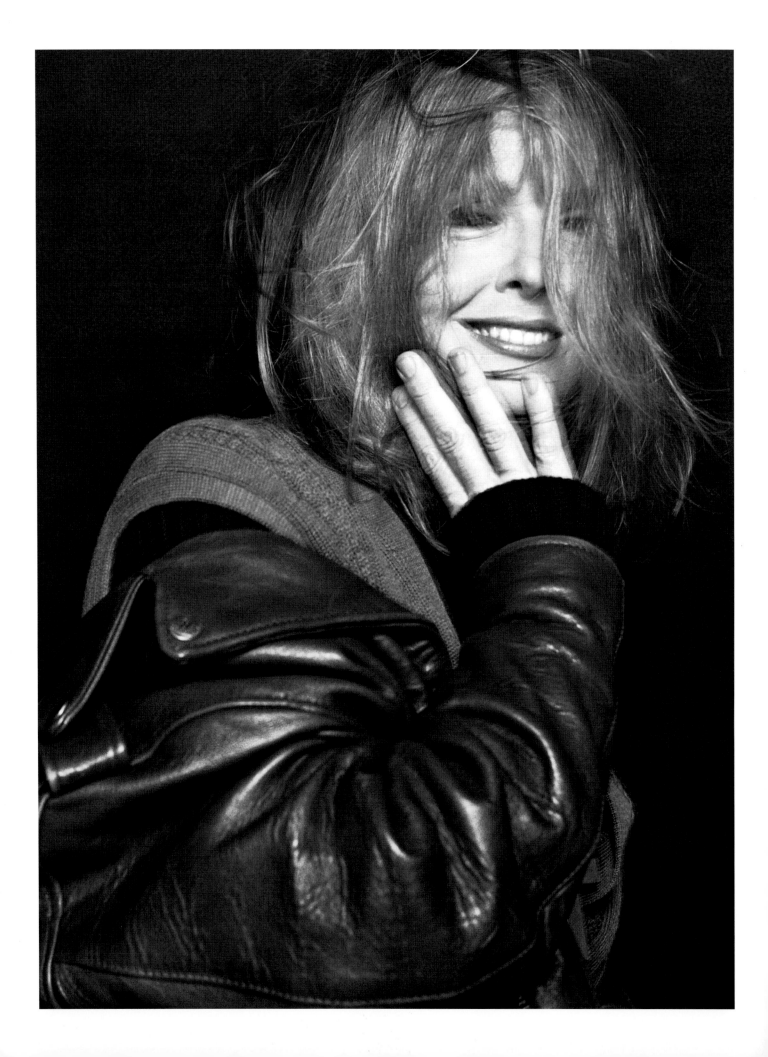

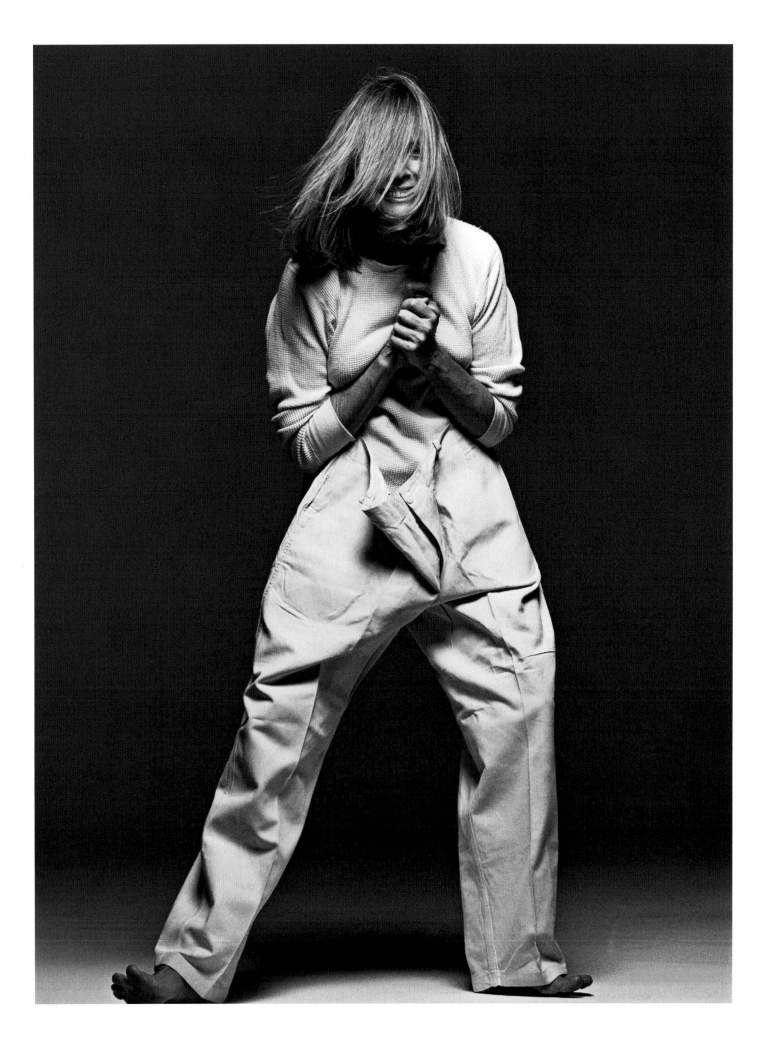

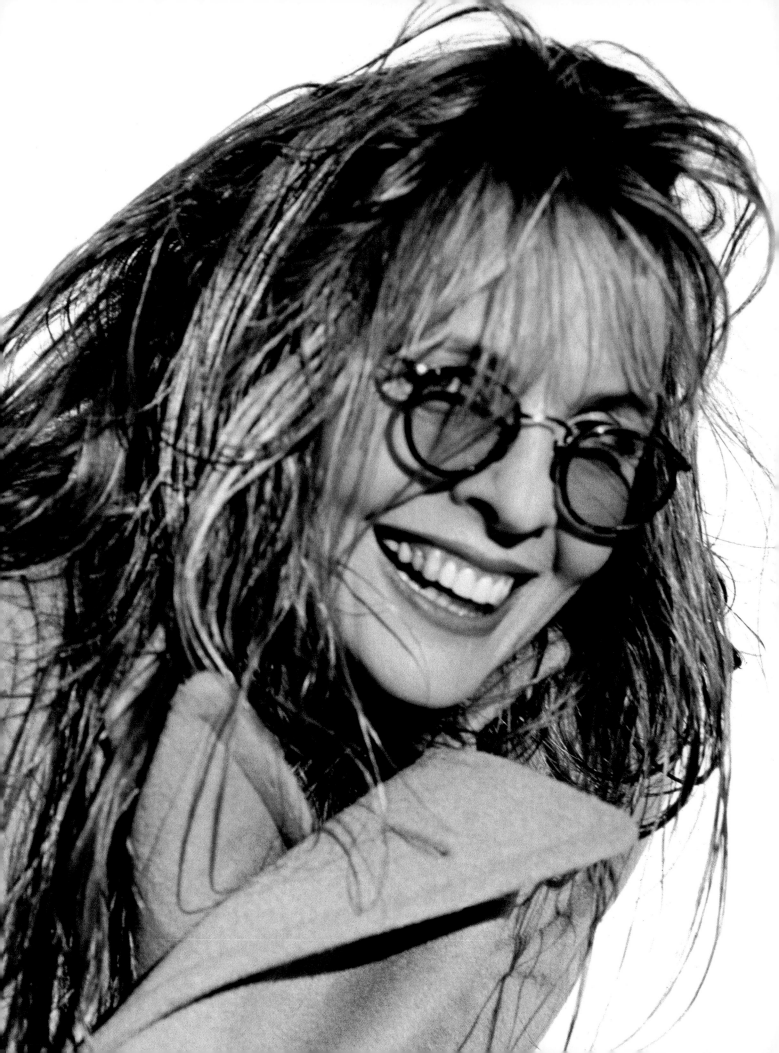

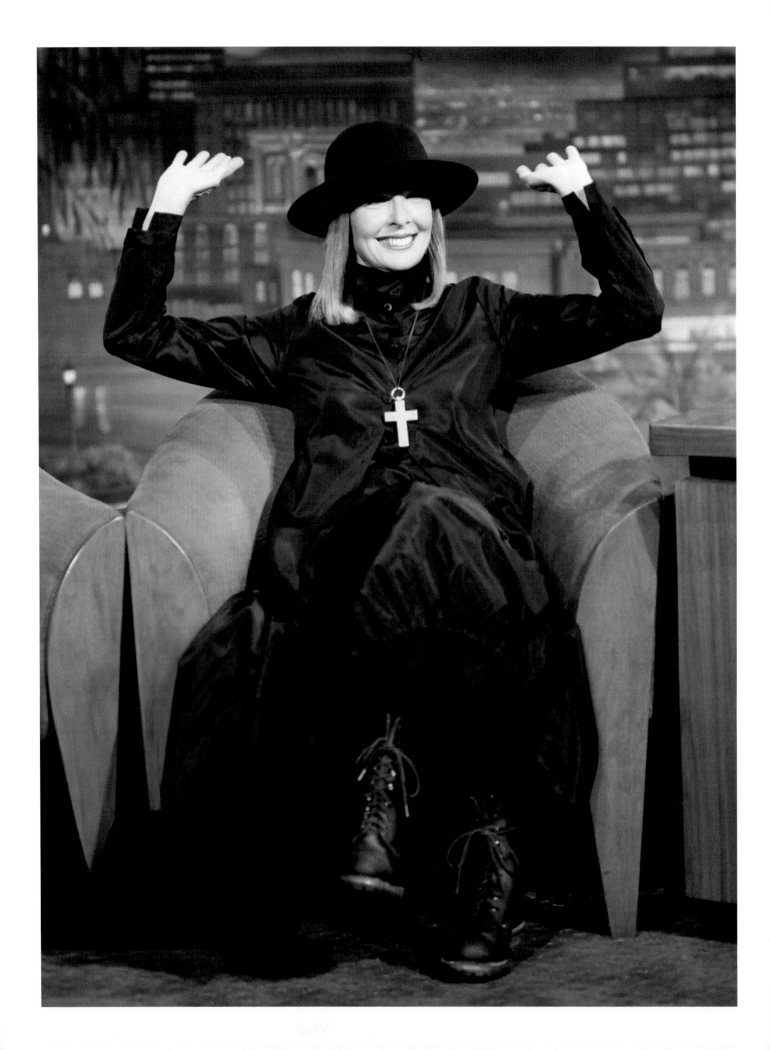

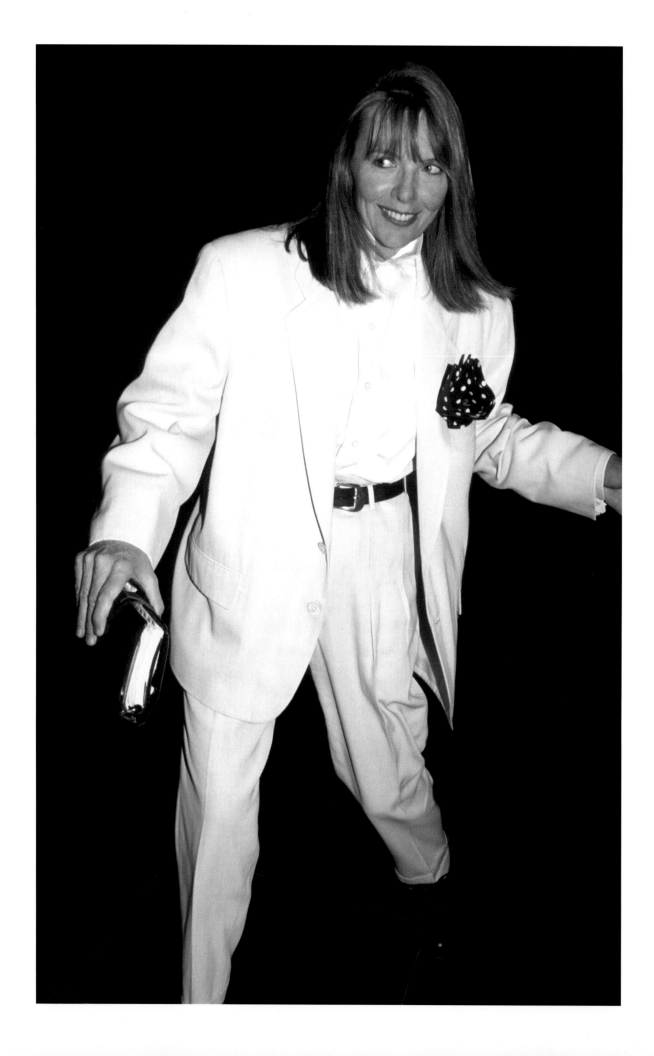

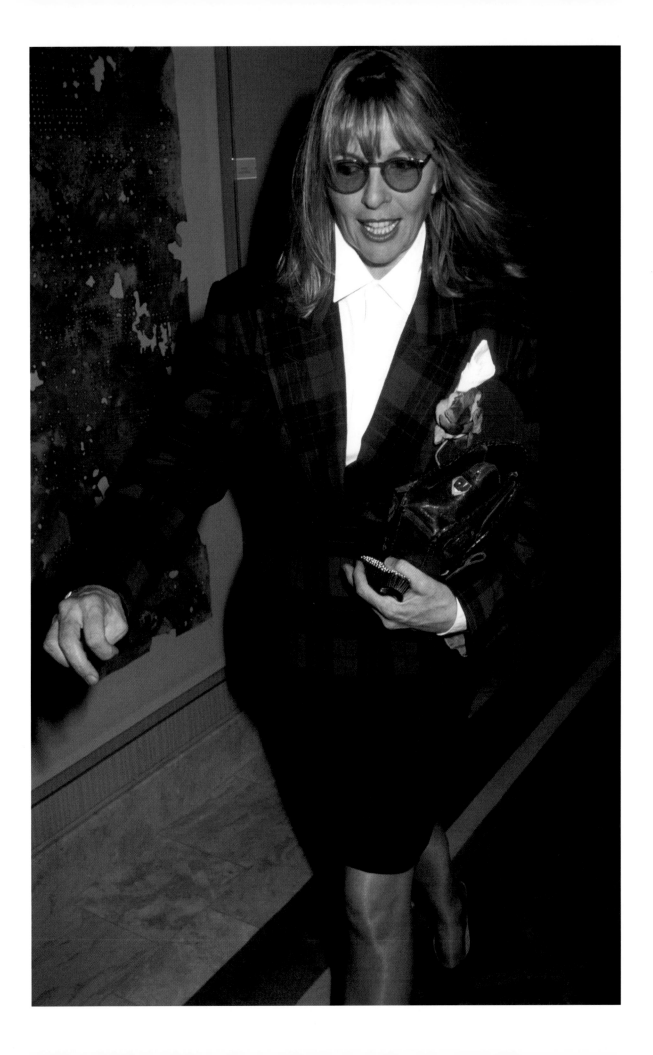

I like this outfit. I am a little curious about the shoulder pads and why I was long-
ing for bigger shoulders. Everybody was at that time. As for the matching orange
gloves and flowers? That was just me being insane.

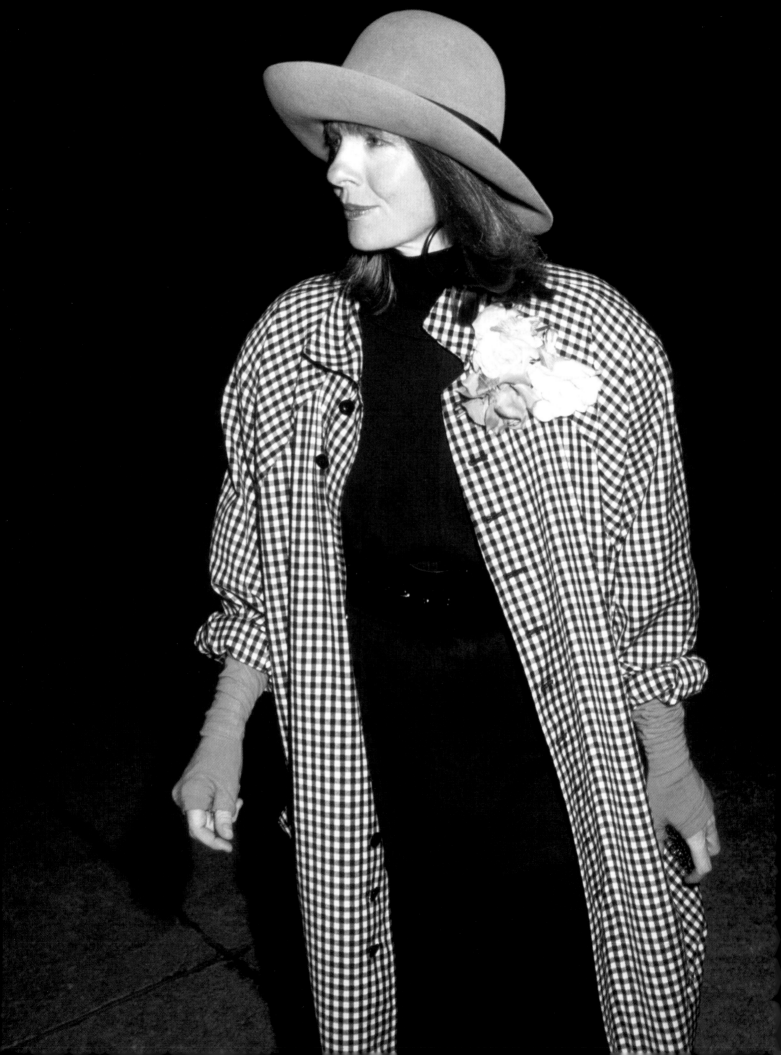

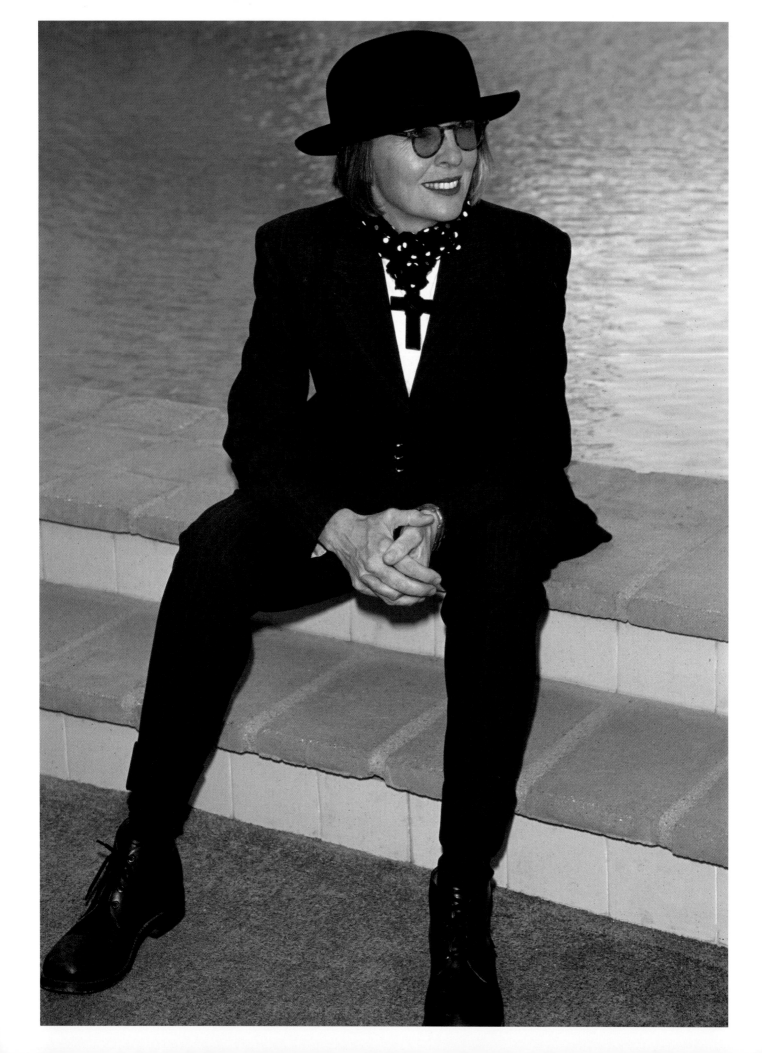

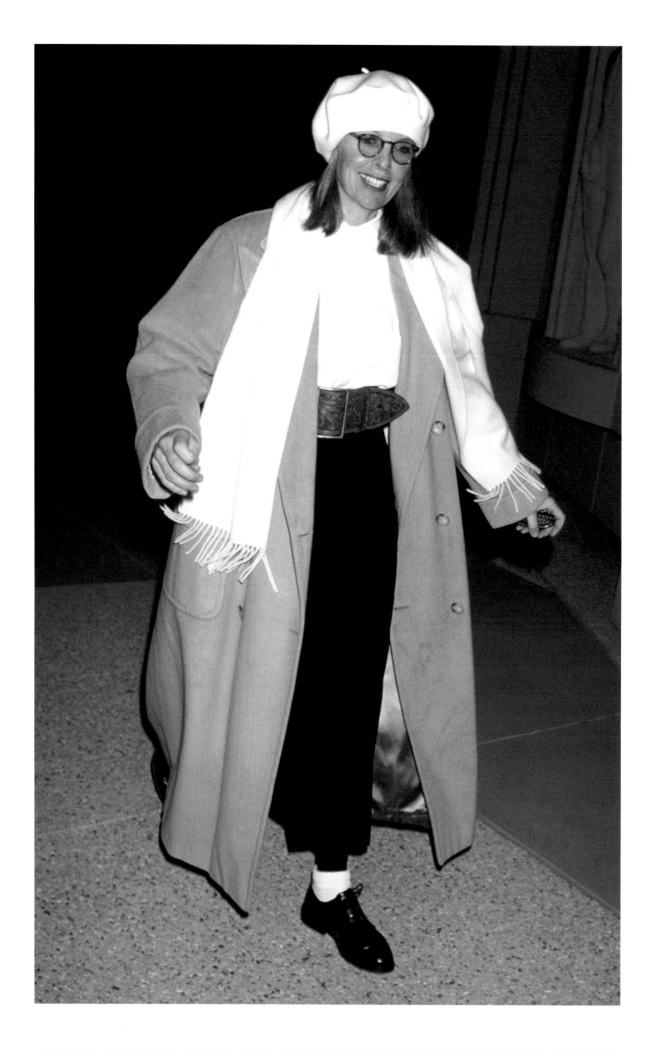

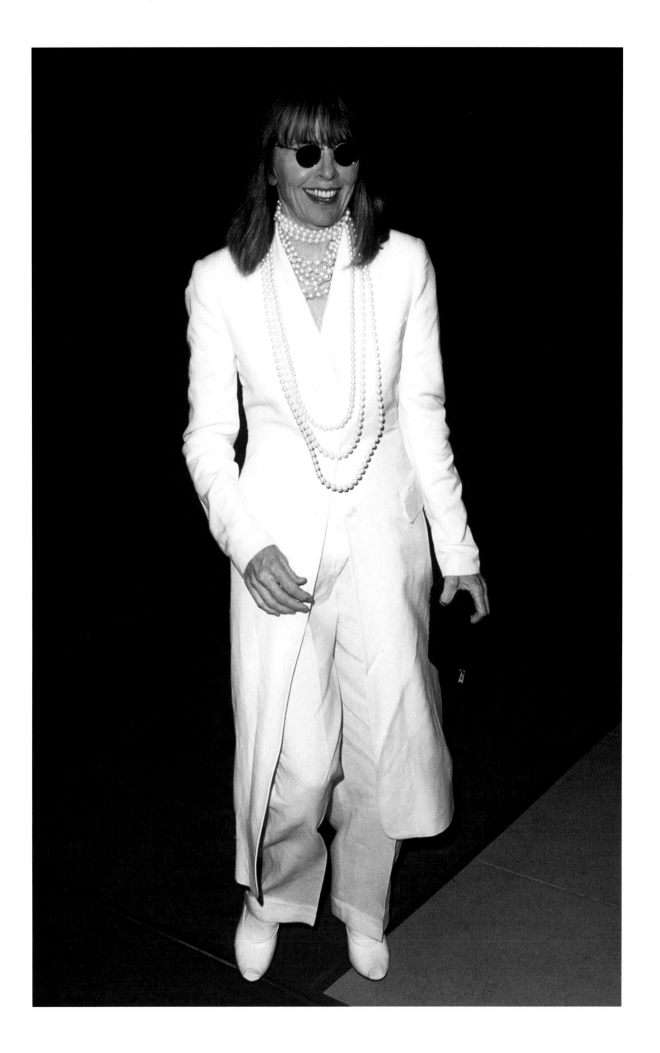

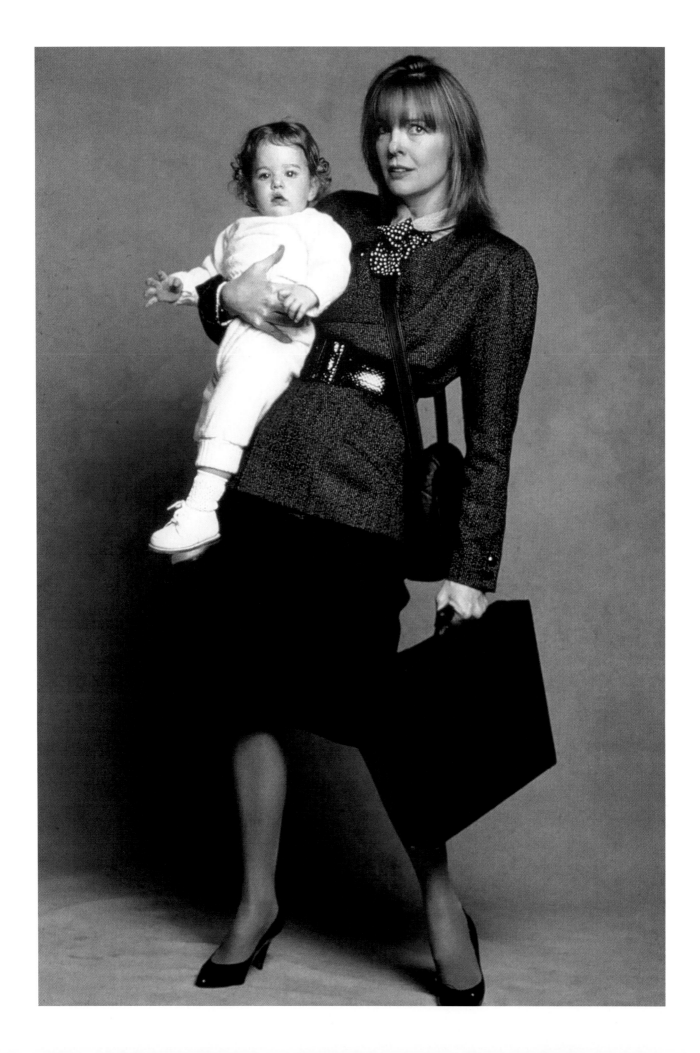

NANCY MEYERS

Diane dresses like nobody else. She also talks like nobody else, thinks like nobody else, and performs like nobody else. She is—as the Broadway tune says—a singular sensation. Before I knew her, I wanted to know her or be like her—or at least be her friend. I think all women did. *Annie Hall*, of course, was a brilliant movie, and Diane seemed to just pop off the screen and into my psyche. She was the movie star we were all waiting for. I remember going into Bullock's in the Sherman Oaks Galleria after the movie opened and seeing every single mannequin in the women's department dressed in khaki pants, ties, vests, and black hats. Everyone wanted to be her. And when *Time* magazine arrived at my house in 1977 and Diane was on the cover, I really wanted to find that black ribbon she had tied around her shirt collar. I went nuts for that. Had to have it. This was before the internet. I couldn't google "Diane Keaton ribbon on *Time* cover." But, somehow, I don't remember how I did it, but I found it and wore it with great pride. And then, of course, I got to meet Diane and work with her. Thrilling! Our wardrobe fittings were never hard. Not on any of our films. She looked great in everything. Her *Baby Boom* look created by Diane and Susan Becker was a knockout. I remember walking into our first fitting and Susie presented J. C. Wiatt in her belted wool skirt suit, crisp shirt buttoned all the way up, a cross body bag (ahead of its time), and heels. No notes! It was so perfect. It captured the moment but still felt so unique. It was an updated Katharine Hepburn look from *Woman of the Year*. Diane was on the first cover of *Premiere* magazine in October 1987, and she was dressed as J. C. Wiatt. She was holding the baby from the movie, sort of on her knees, losing her balance, in a pinstriped suit—her bare ankle slipping out of one of her heels. Again, a crisp white shirt. This time, at her neckline, she wore not a ribbon but a pin of mine: a black square with a tiny pearl in the center. She wore a couple of my things in *Something's Gotta Give*, come to think of it. I had an oatmeal-colored cashmere turtleneck that Diane wore, I think, with a suede jacket. Anyway, at the end of the movie, they gave me back my turtleneck in a plastic bag marked "Nancy Meyers Personal." The other tag on it said "Erica Chg #28 Sc. 109-110." It's still in the plastic bag they gave it to me in. I keep it in a closet with my dad's Air Force uniform, my girls' prom dresses, and the outfit I got married in.

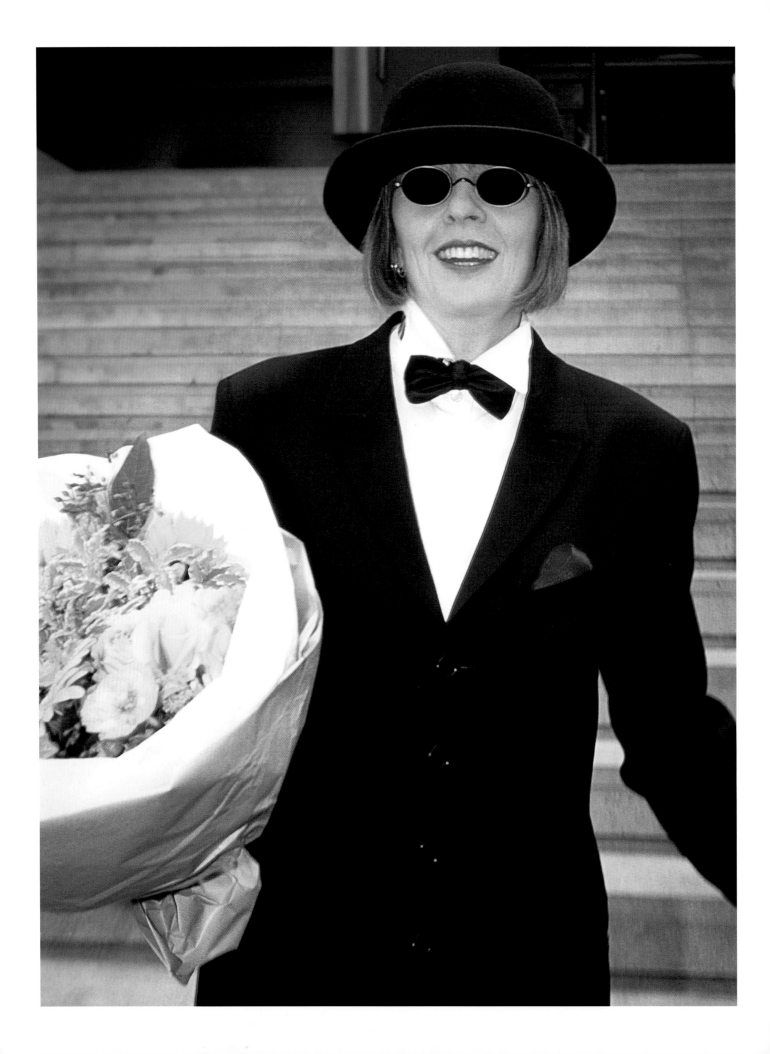

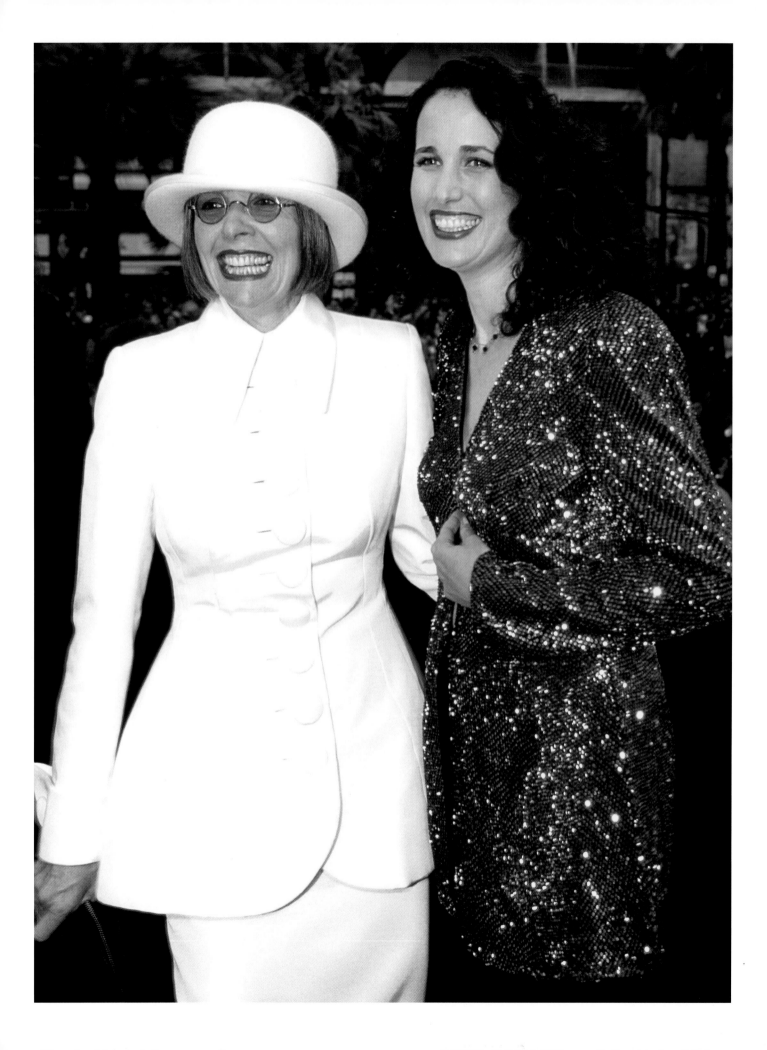

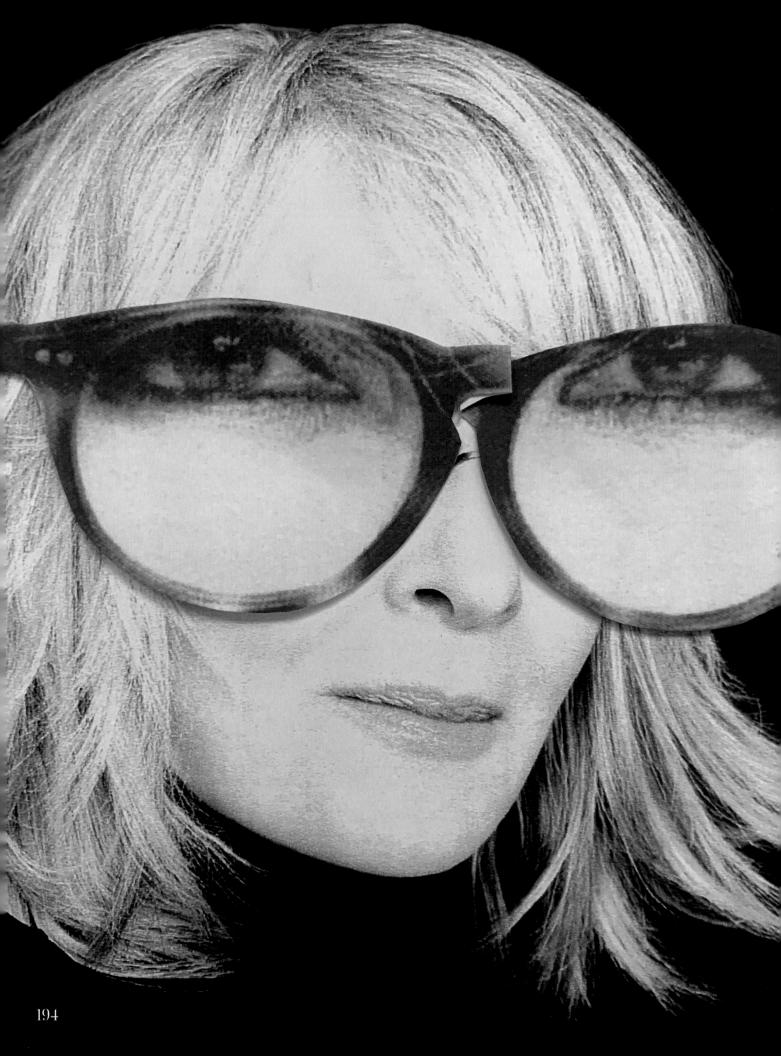

2000

The 2000s might be my favorite. These are all outfits I (mostly) still wear. I finally found my big, wide belts. I found the perfect coats. The best shoes. I even discovered some of my favorite suits. The 2000s were an accumulation of all the things I learned about fashion through the decades. I incorporated a tie or two from the '70s, some polka dots from the '80s, my cross necklaces from the '90s, and absolutely nothing from the '60s except for my black turtlenecks. There is a refinement to these years—a simplicity while also not losing the aspects of my fashion that make me me. I toned down the colors from the past and leaned into my instinct and love for black and white. I experimented with my hair, my glasses, my shoes, and my belts. I tried a few dresses but made them my own. I fell in love with Louis Vuitton, Thom Browne, Gucci. I remained infatuated with Ralph Lauren. I built the closet that I would use for the rest of my life, all while still managing to make my unusual (and necessary) mistakes along the way. There is a lot to cover in two decades, so I broke down my favorite things into chapters (with a little help from my friends).

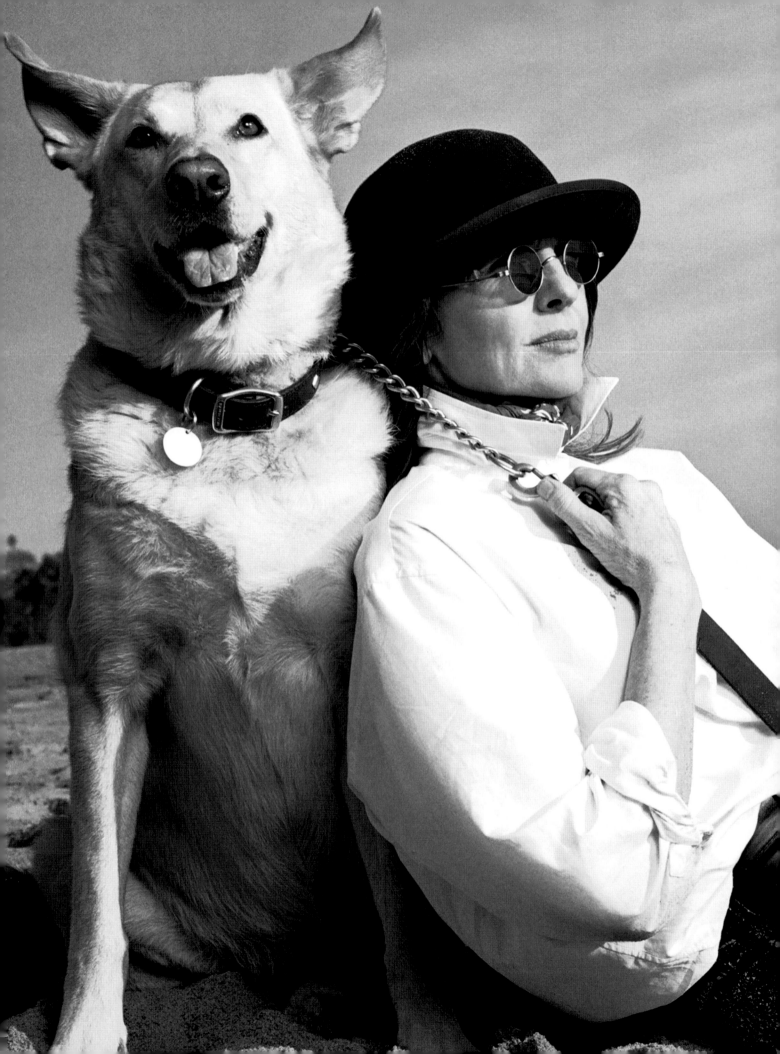

SKIRTS

I have always had a rough time with skirts, especially if they are too short. (My knees are ugly.) Even if they are below the knee, I don't really like them. But if I do like them, it's because I've put an obscene amount of tulle underneath it to make it wide. And I will never, never, never, never, NEVER wear one without a belt.

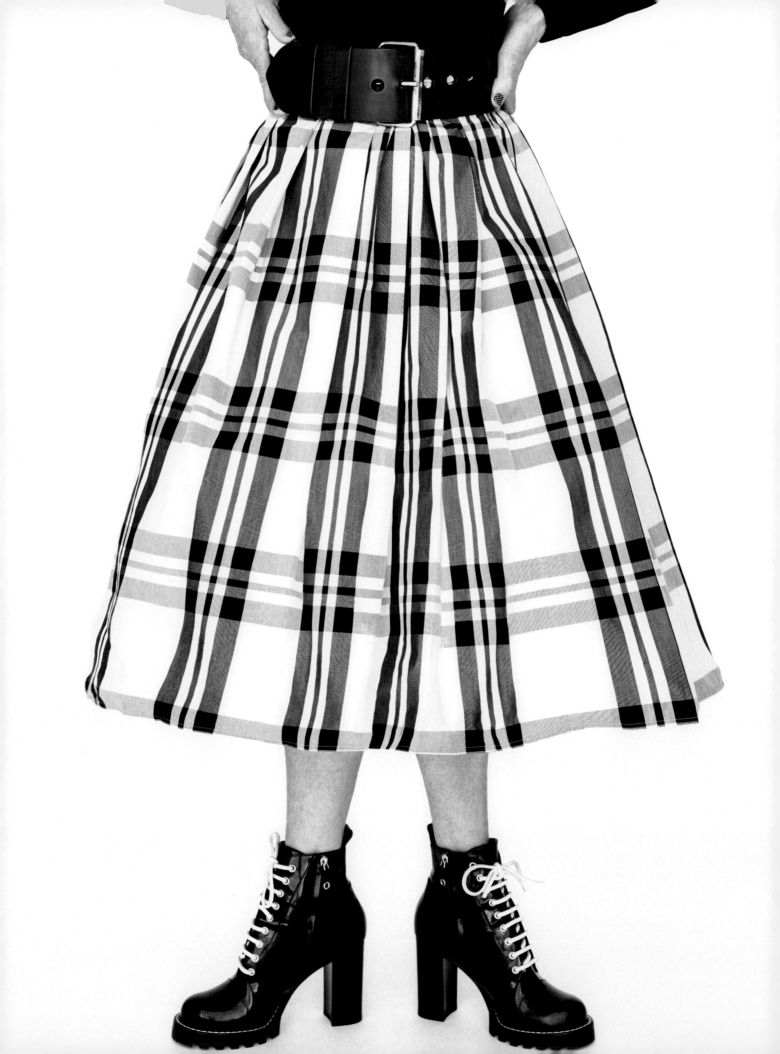

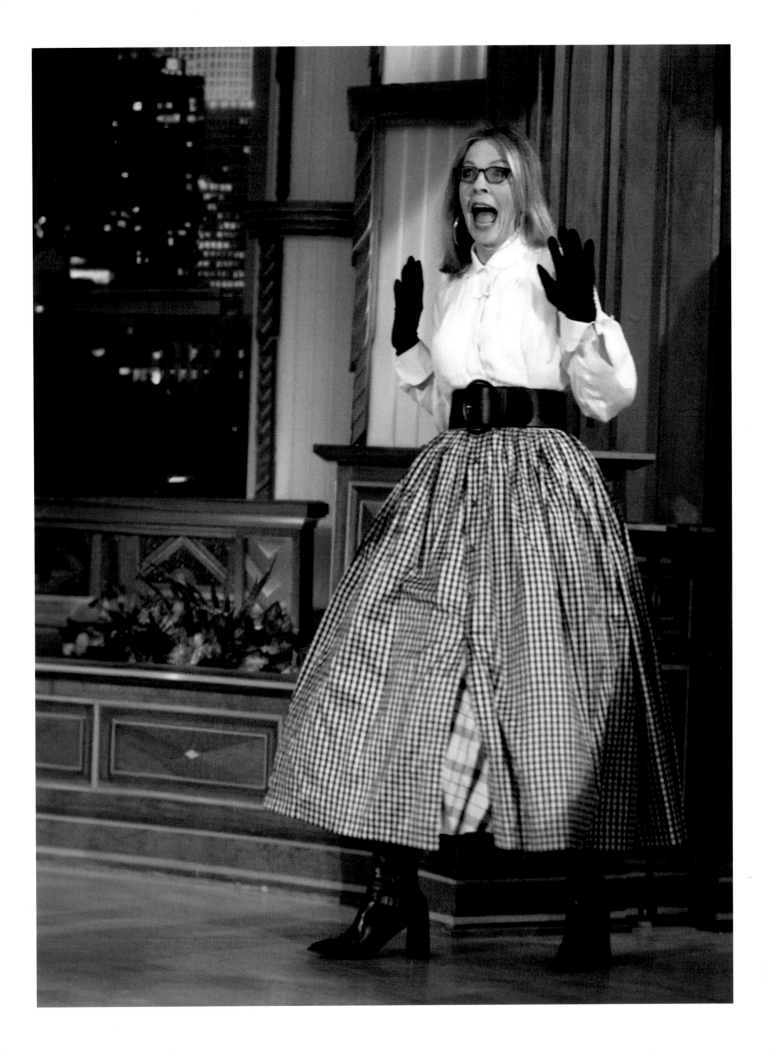

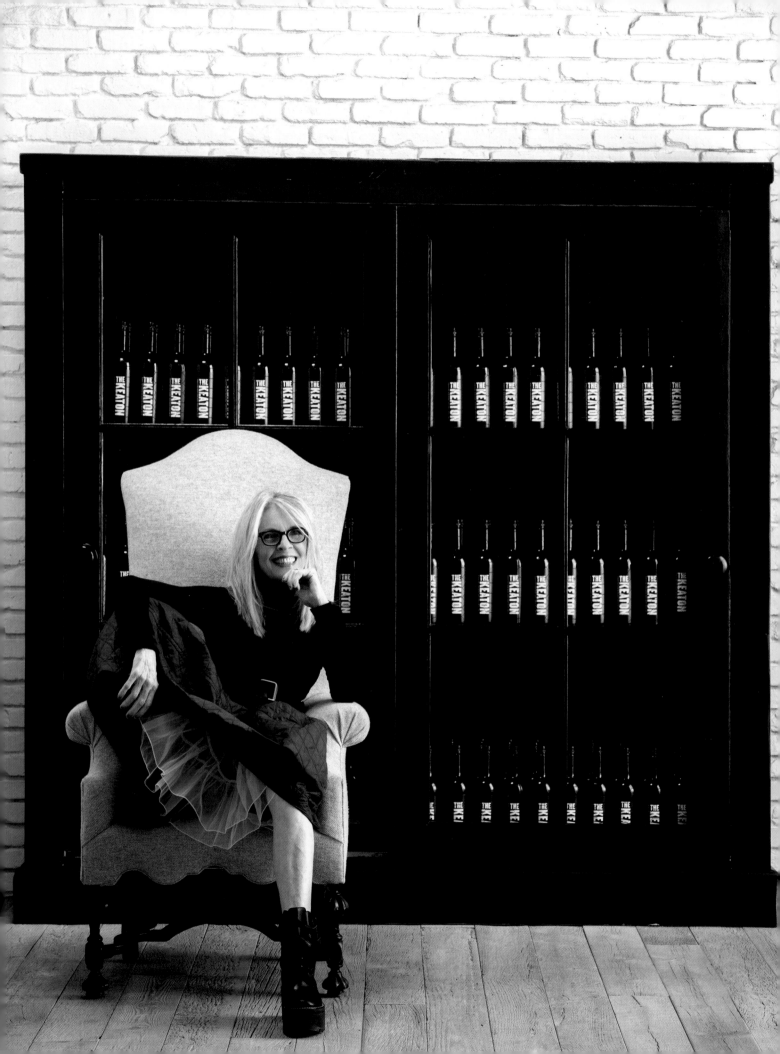

KRIS JENNER

Diane Keaton has been my style icon for as long as I can remember. She has al-
ways stayed true to her own style and personality, which I admire so much. She is
an inspiration to me and so many others! What I wouldn't do for an hour to play

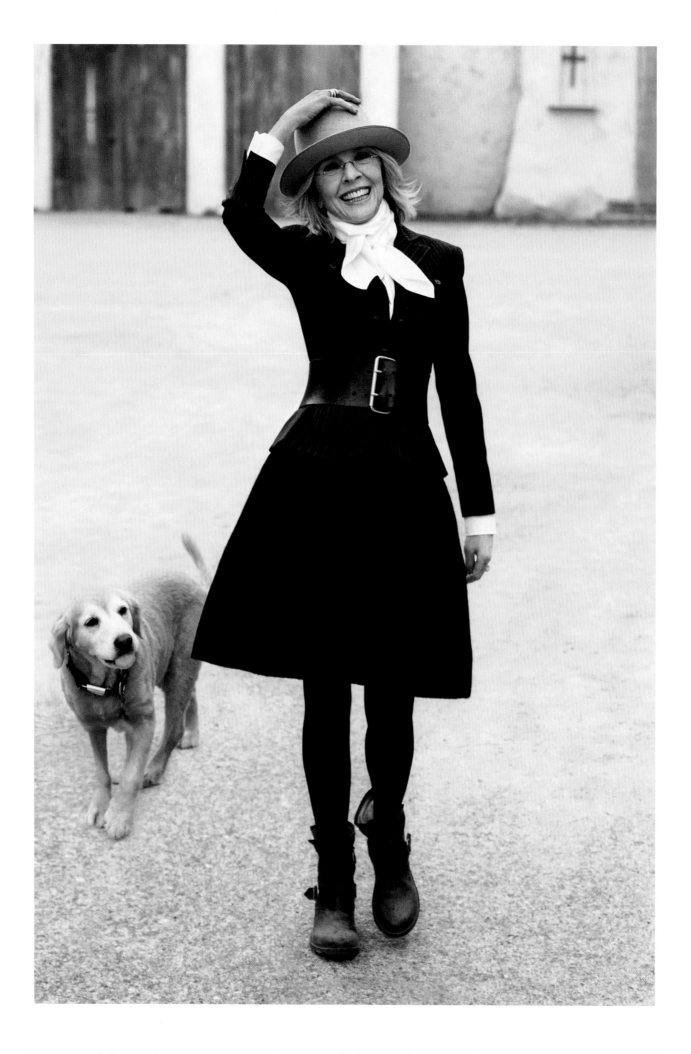

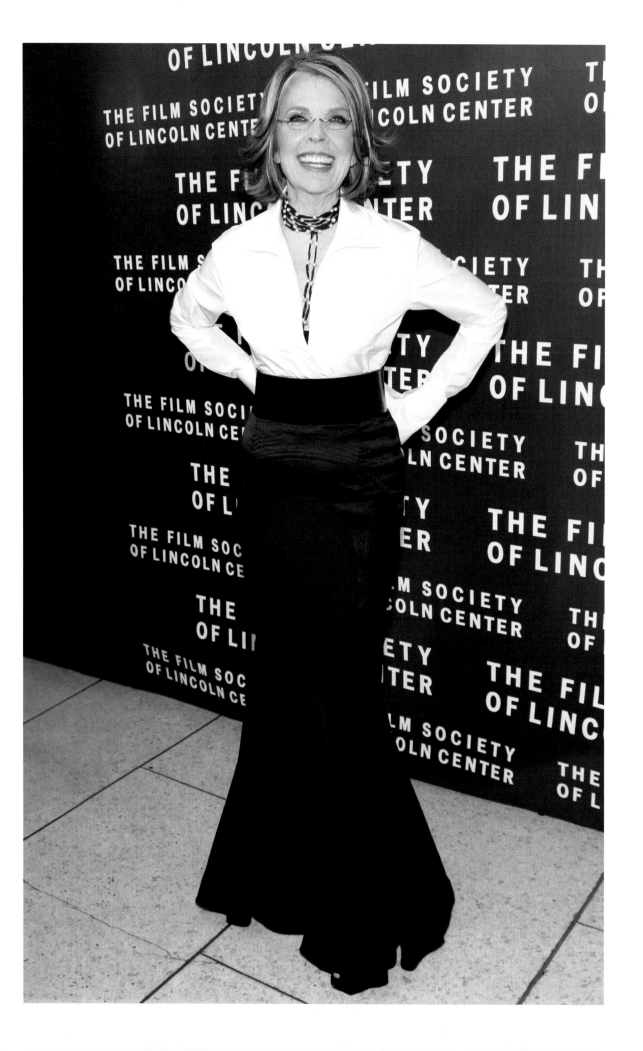

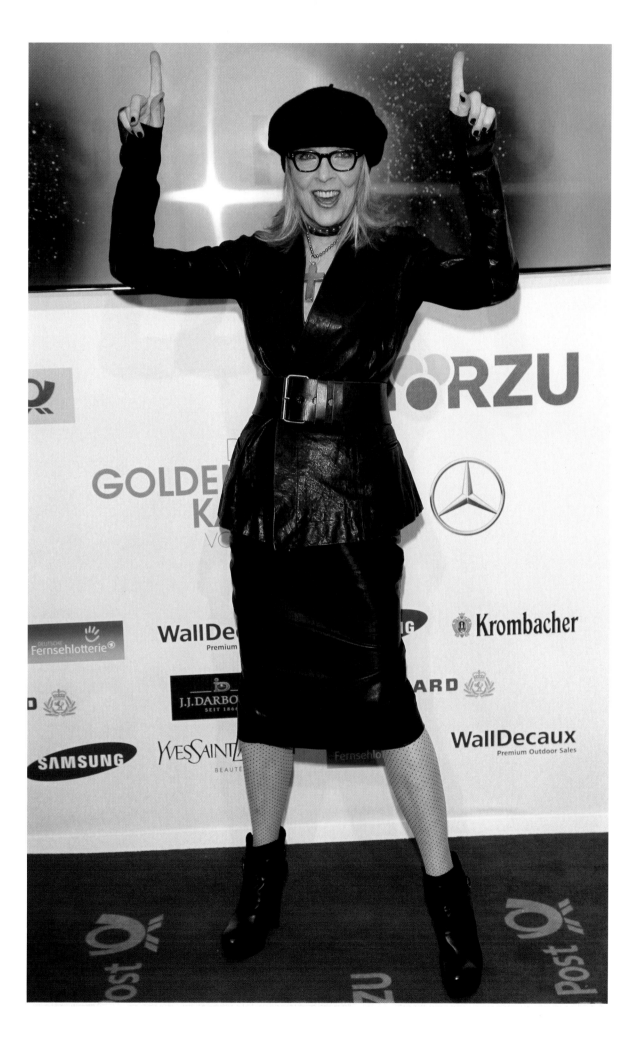

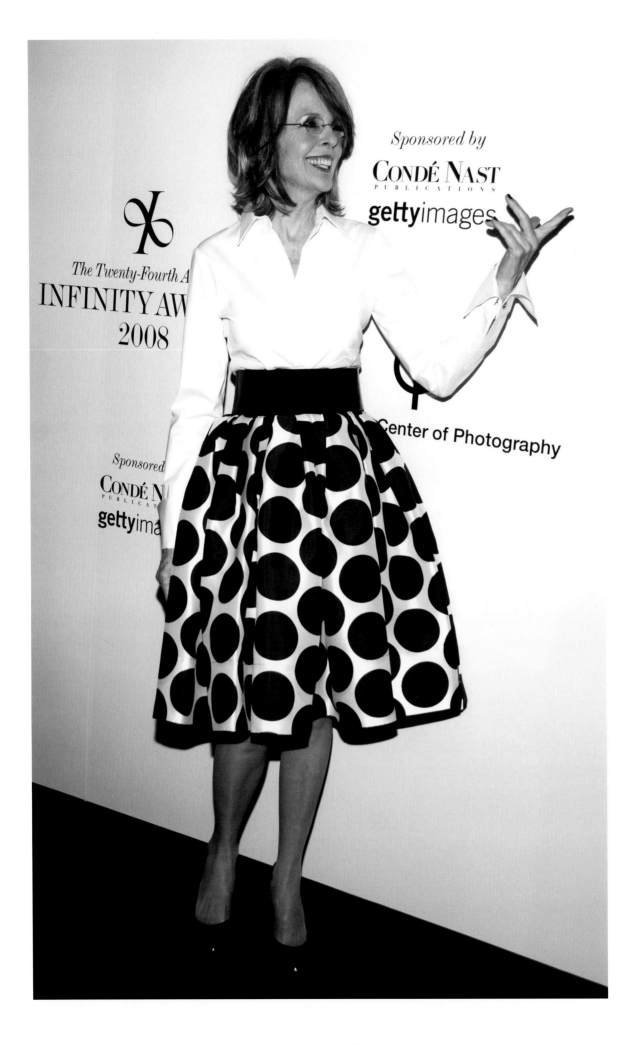

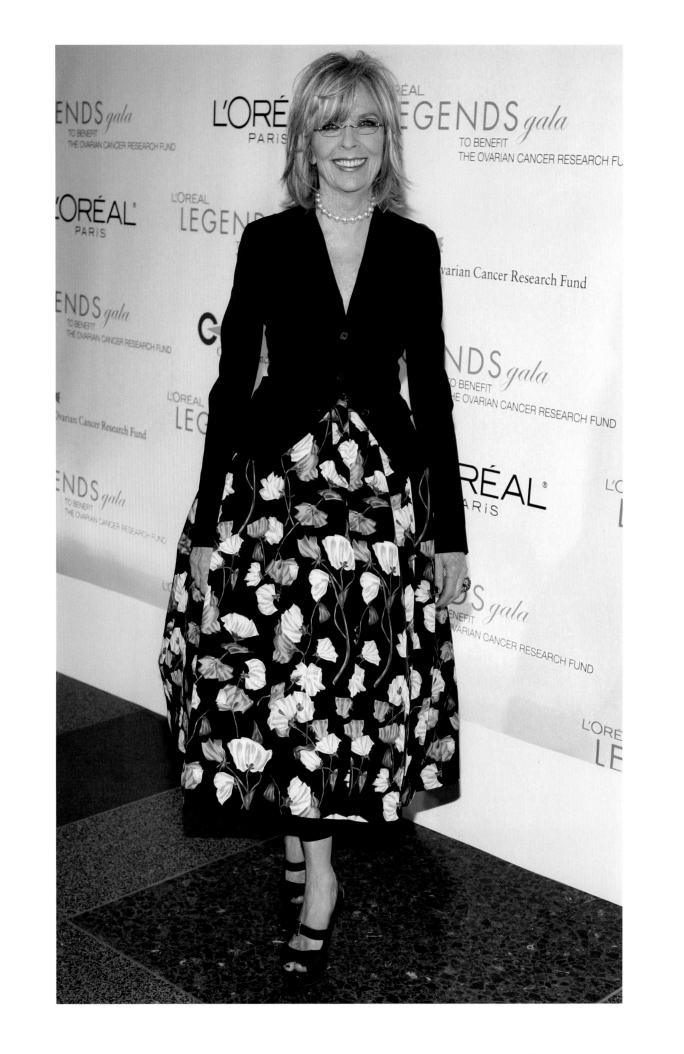

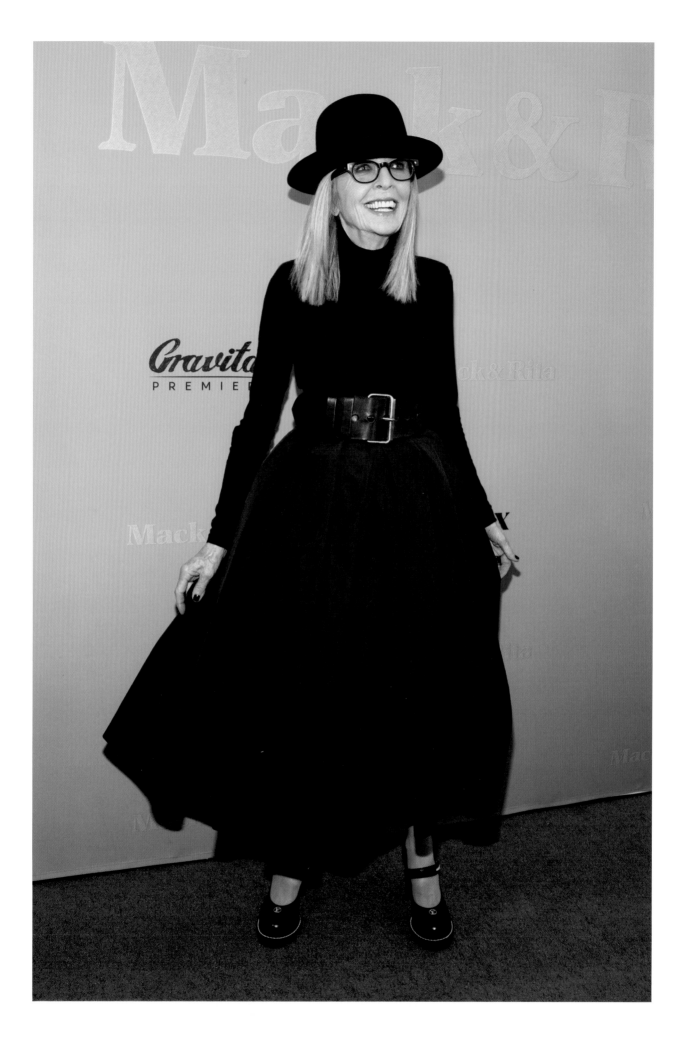

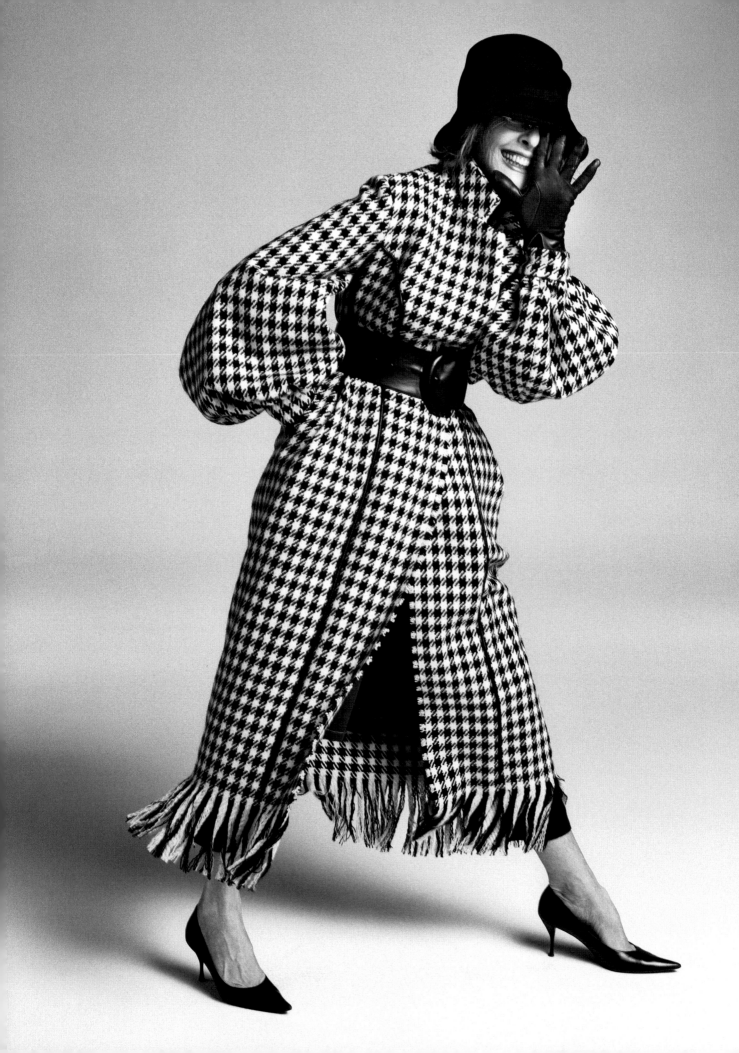

COATS

A coat is my version of a ballgown. A coat is perfection. It is like a cellar. I am hidden. I can relax in a coat, which is a blessing for a person like me who tends to be anxious and worried most of the time. A coat gives me the opportunity to make my own decision about how my waist will look. I lock myself in with a nice big belt, and I finally feel like I actually have a figure...but don't count on it.

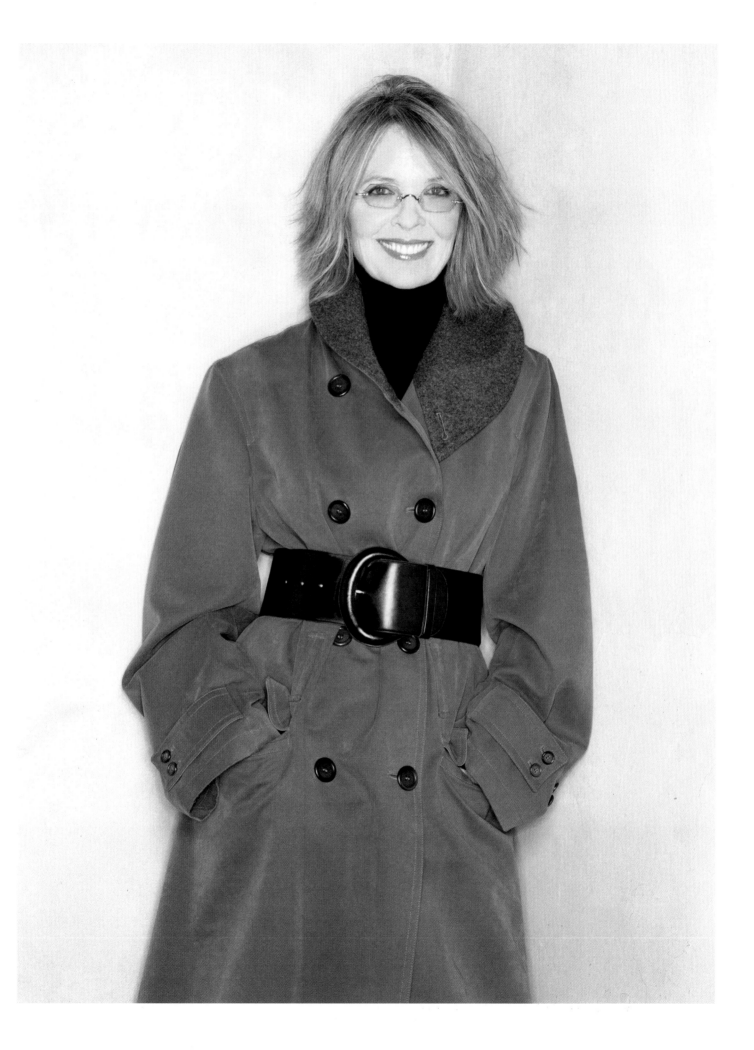

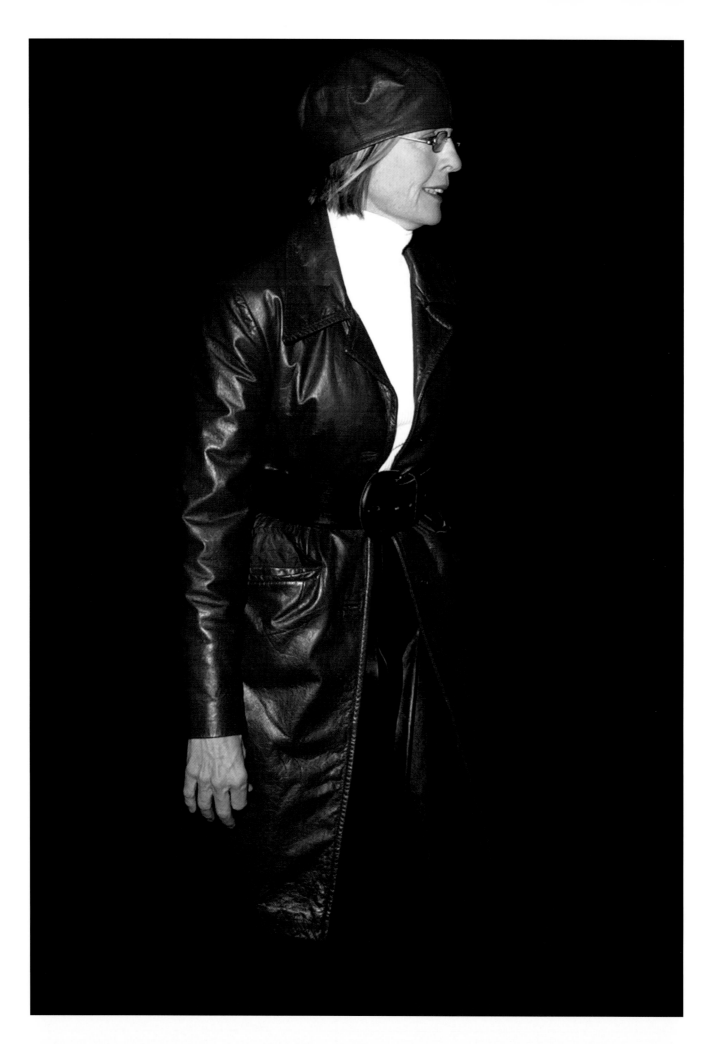

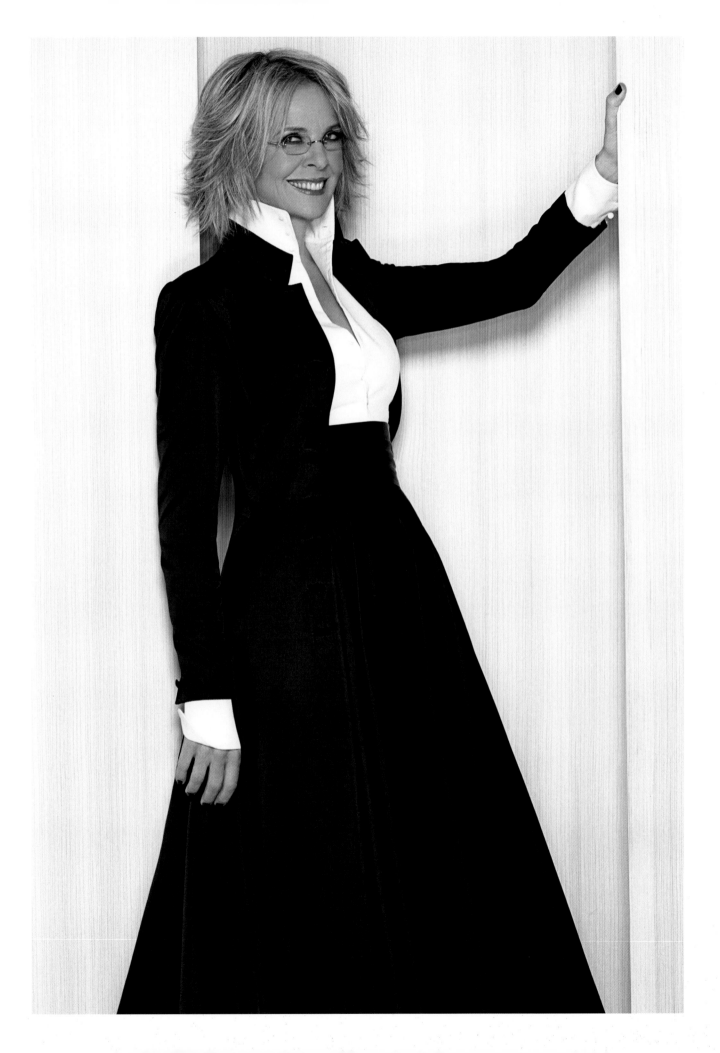

SARAH JESSICA PARKER

You can define Diane as inspiration. You can define her as a surprise. A classic. And, indeed, you can define her as a true icon. She brings celebration and commitment to her relationship with every dress, trouser, suit, skirt, hat, belt, and pair of gloves. Having a record on paper to study and recall is a gift to the many millions who adore her work on-screen and have for decades admired her singular style. In our lifetime, she is arguably one of the most influential people in American fashion and has been to me and countless others.

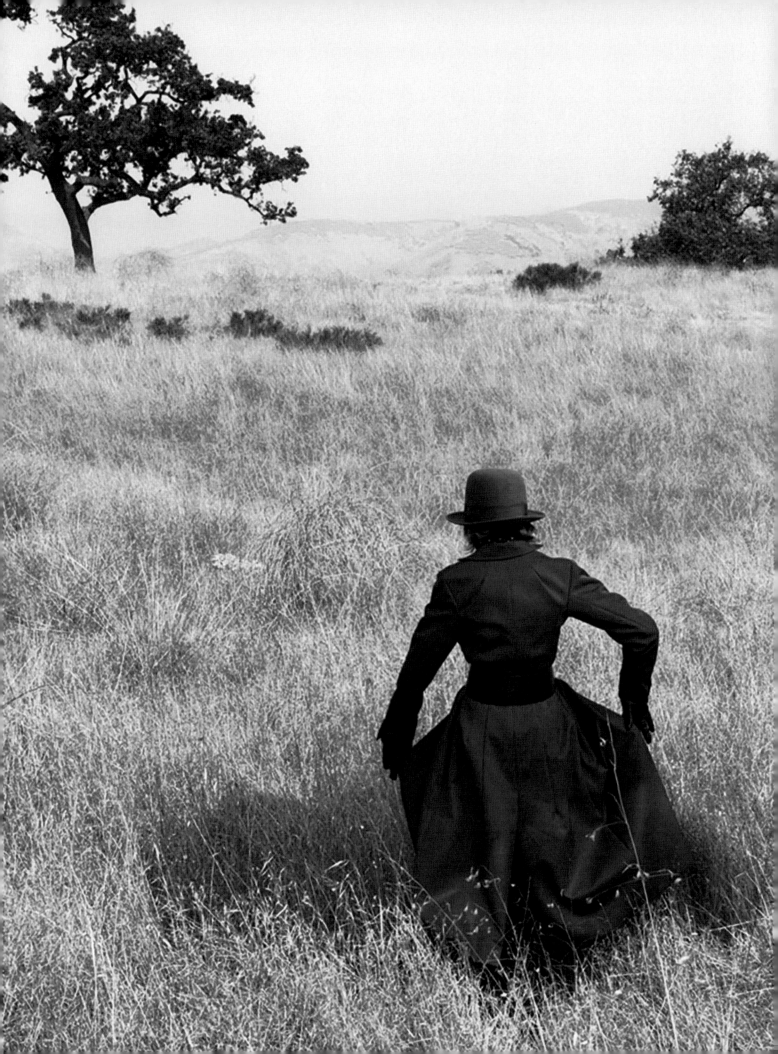

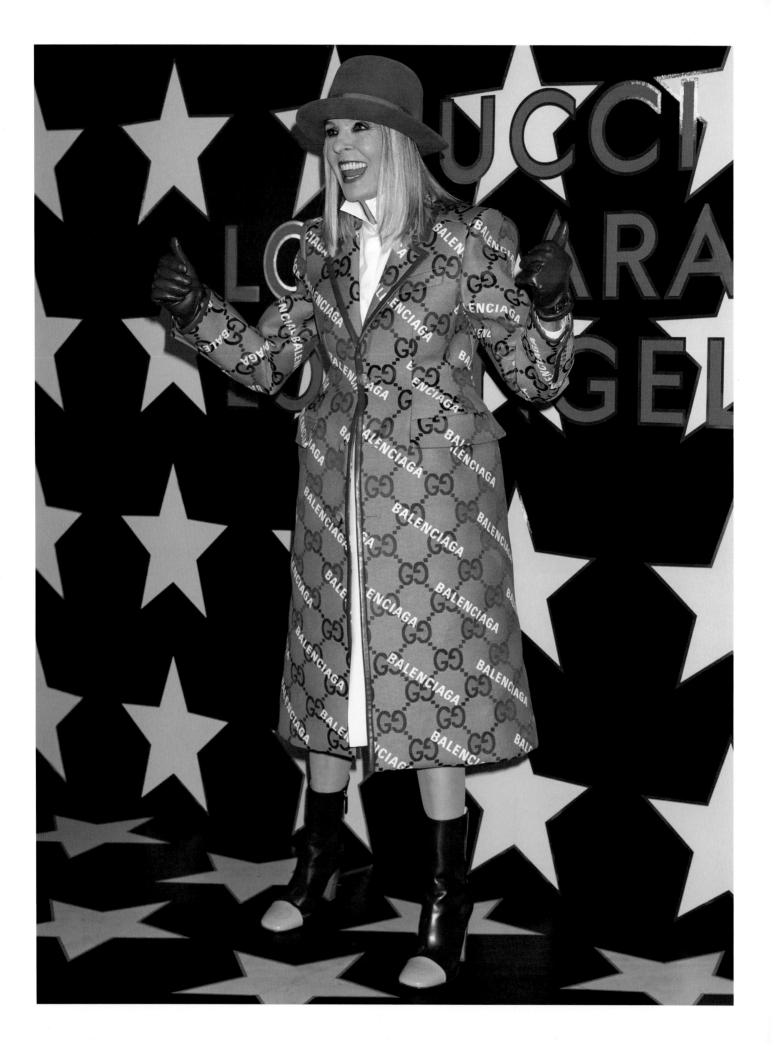

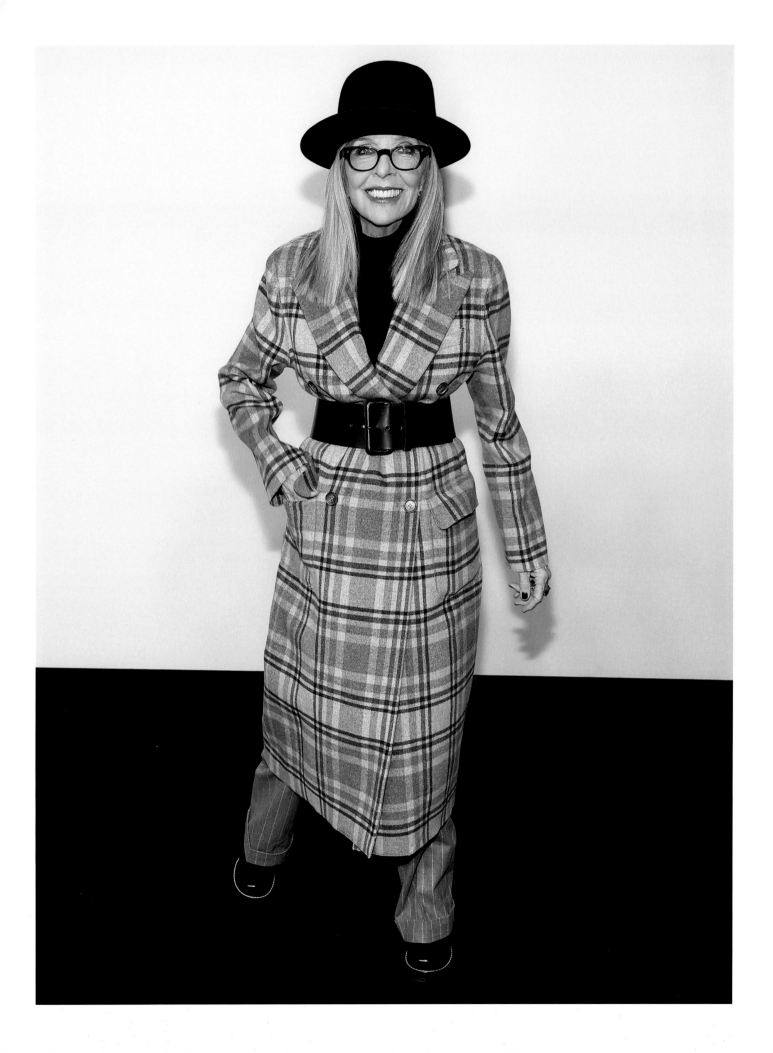

This is my favorite coat of all time. I love the way the coat flairs a little, making it sort of look like a dress. The long sleeves are genius and allow my hands to only squeak out just a little bit. The belt is the only thing that I have to allow me a small waist. I keep the belt high and wide; it makes me feel so secure.

MILEY CYRUS

Diane Keaton is the epitome of style, grace, uniqueness, and fearless fashion. The world she creates for herself is just as divine as she is. Her essence oozes into the fabrics she's surrounded by, whether that's in her home or on her body. She is charming and loveable. Even with her immaculate style, she always feels inviting and warm. I couldn't adore her more than I do. She is my role model, and it's a gift of a lifetime to call her my friend. I don't ever want to know what the world would be like without the oversized belt and tie combination originated by this goddess.

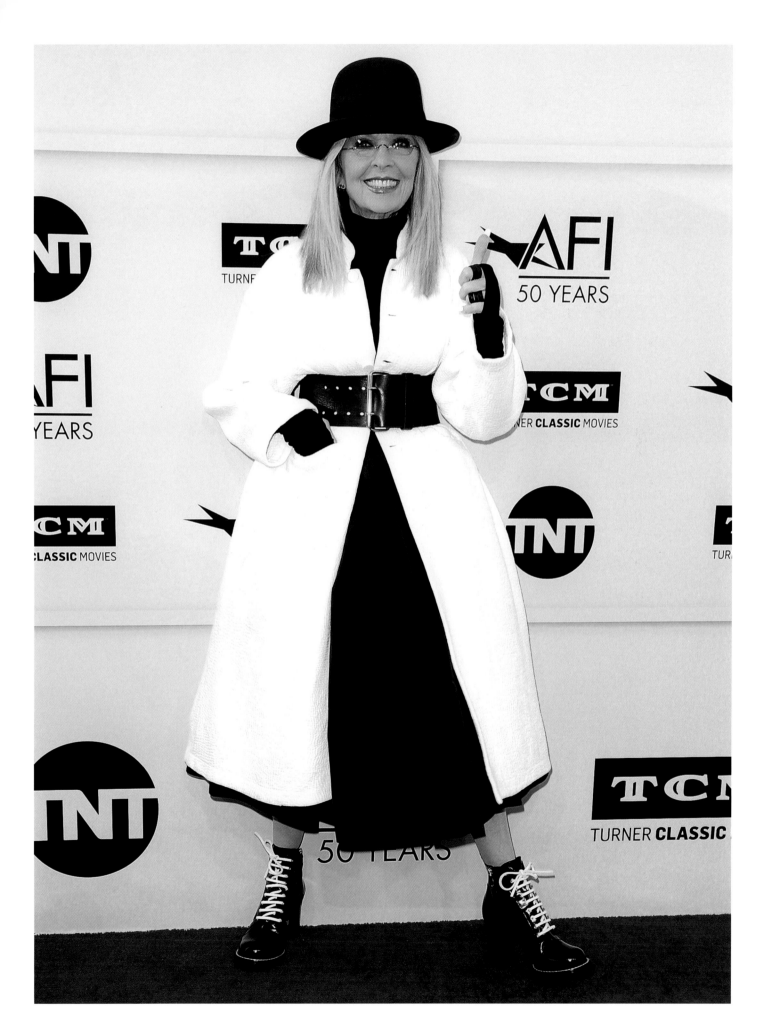

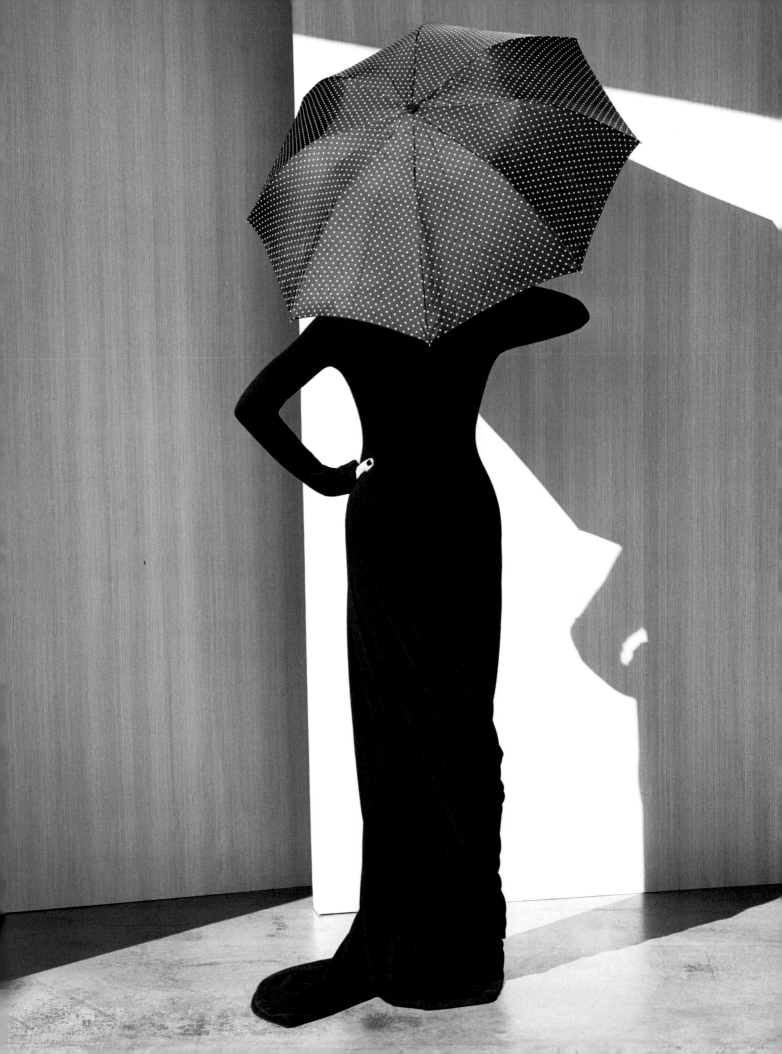

DRESSES

To be honest, I don't really like dresses. I don't wear them often and when I do, I don't get it right. If I wear them, they are rarely form-fitting and usually with a belt. (Shocking, I know.)

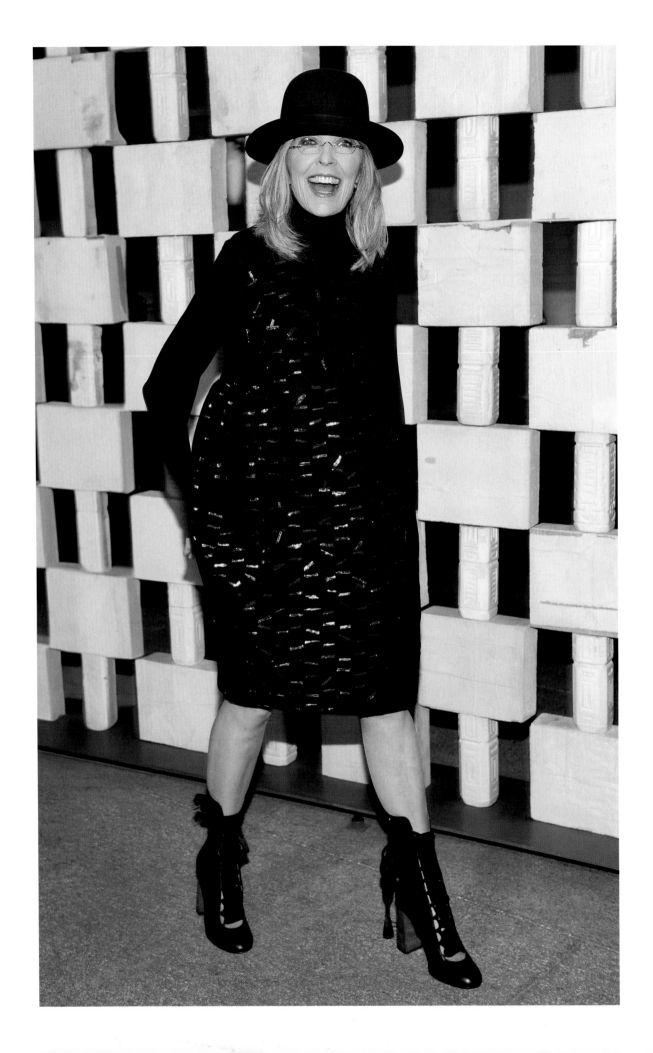

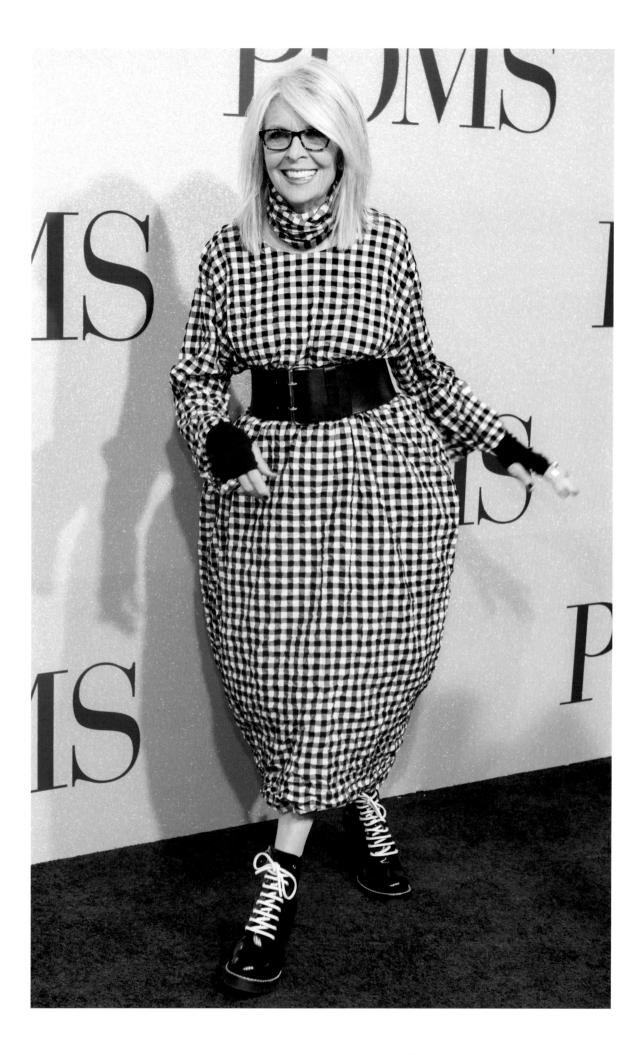

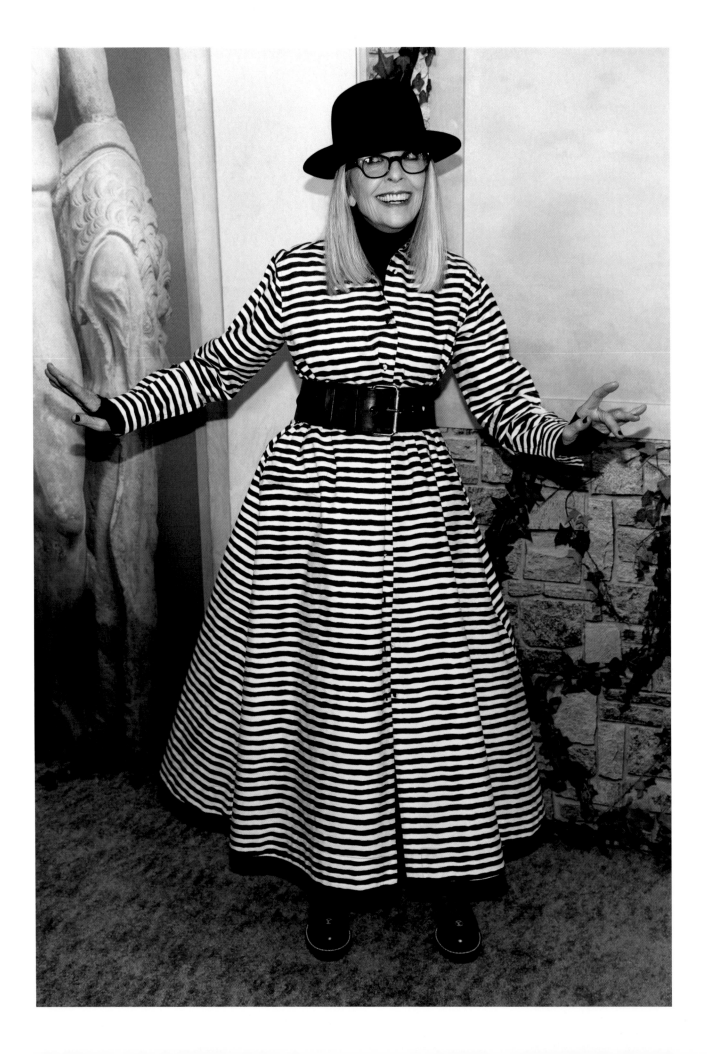

SHOES

I remember diving into a swimming pool once with shoes on. I had to be about nine years old. I didn't think to take them off at the time. I would probably do something like that even now, but nobody ever invites me to their pool. (That's a conversation for another time.) It must have meant something that I didn't even feel the shoes on my feet. Did I love them that much? Or did they just go well with whatever swimsuit I was wearing? Long story short: I love, love, love, love shoes.

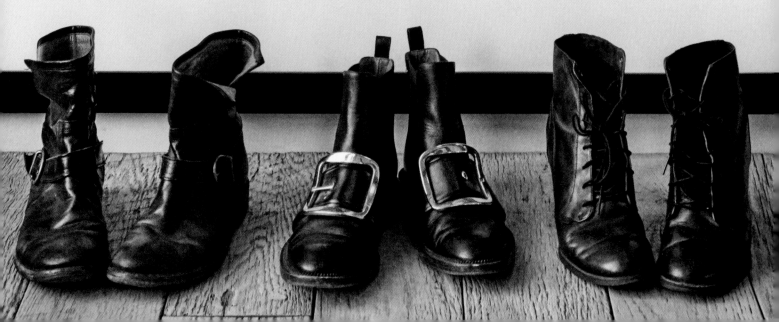

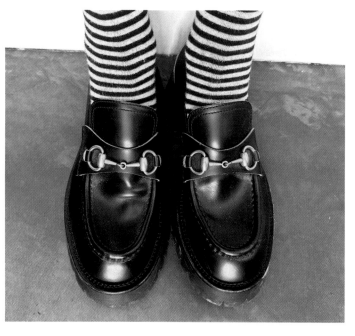
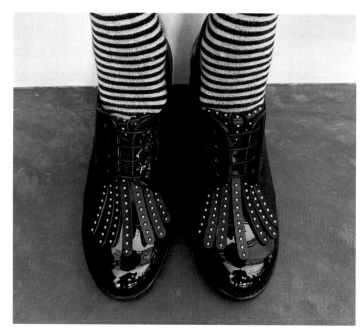
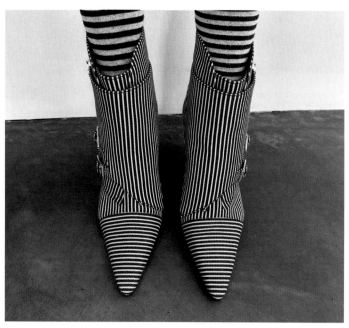
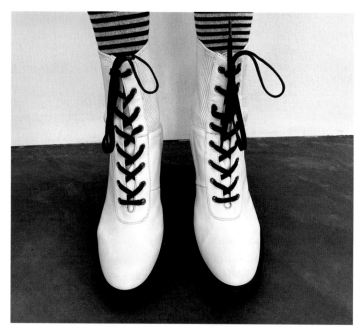
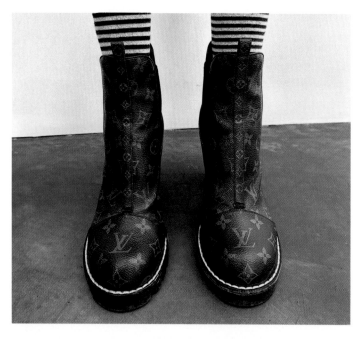
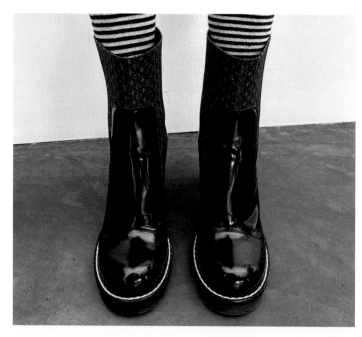

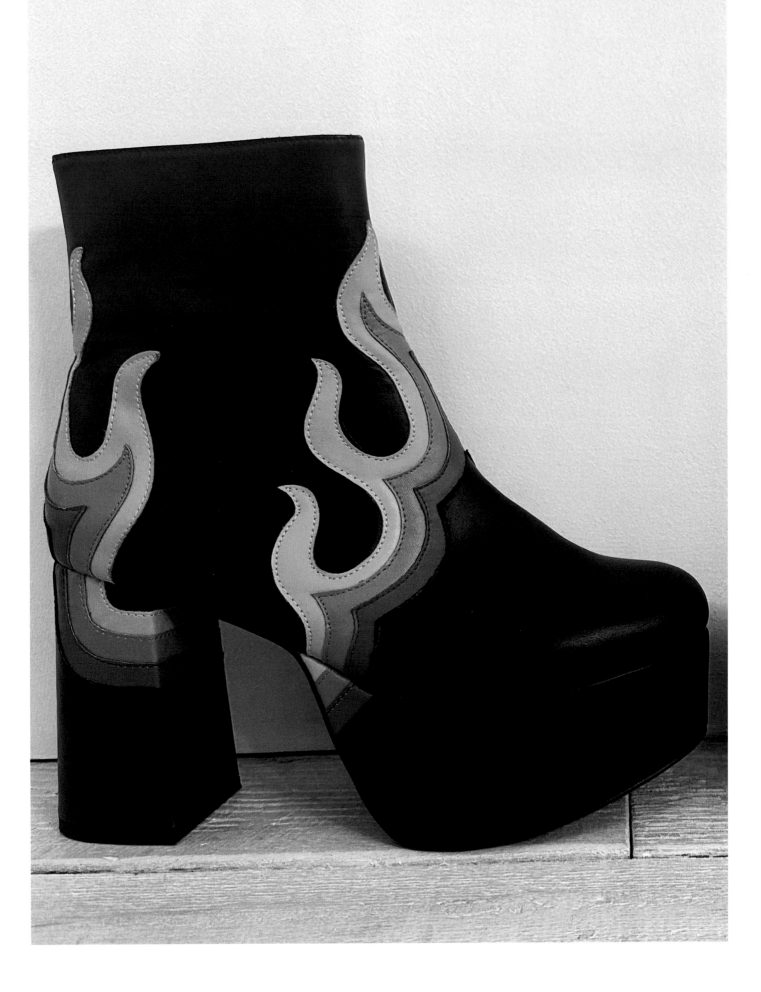

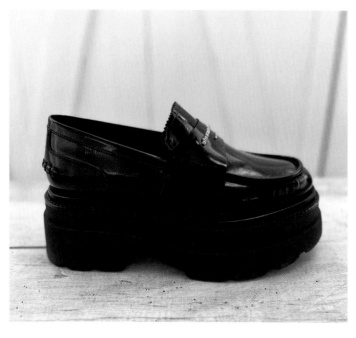
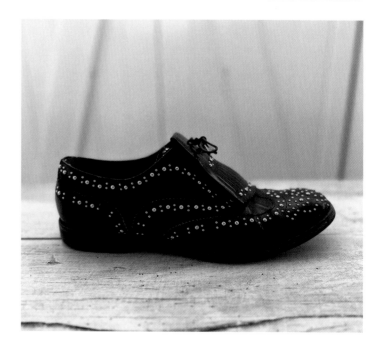

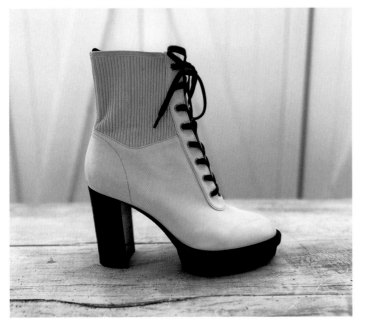
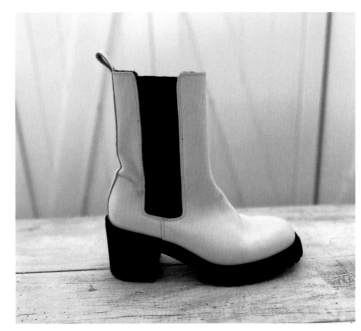
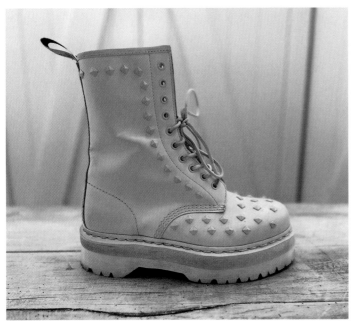
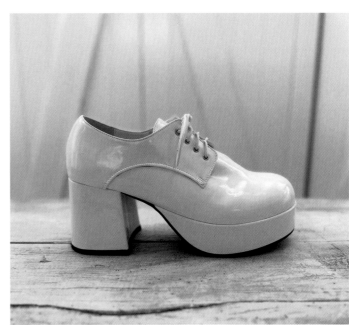
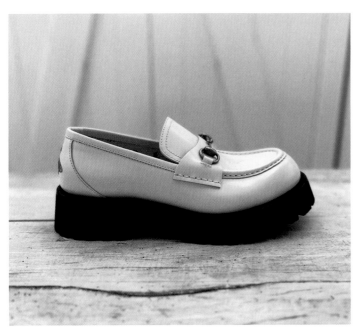
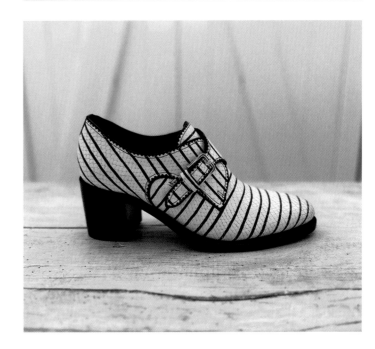

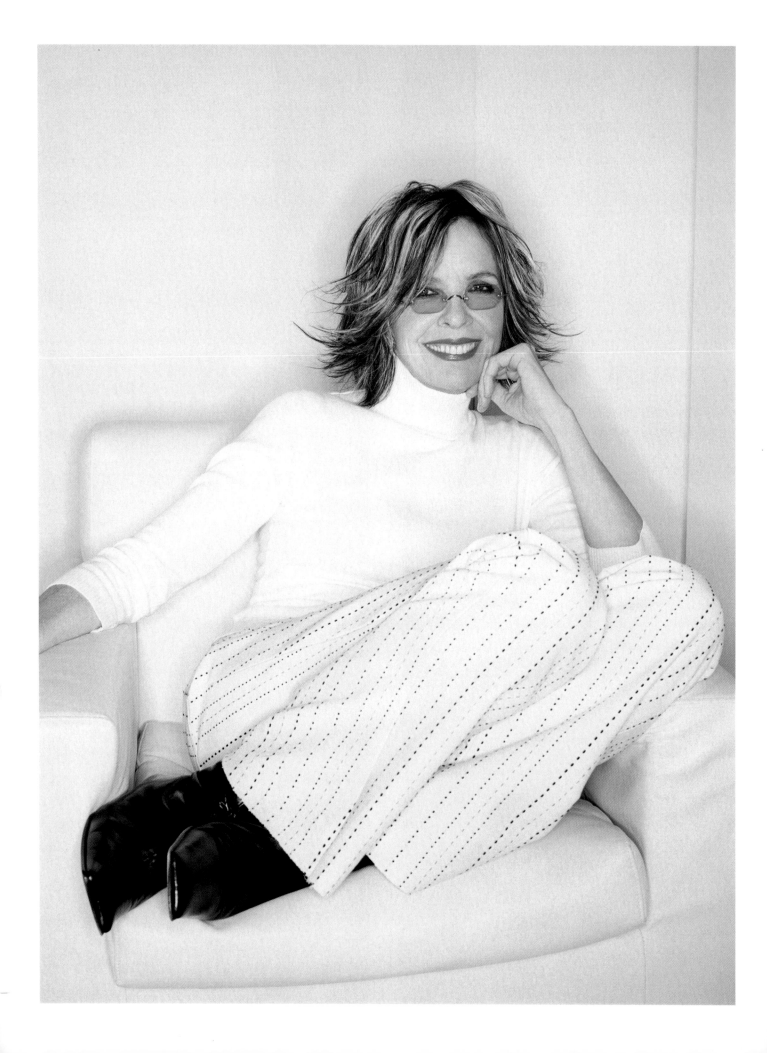

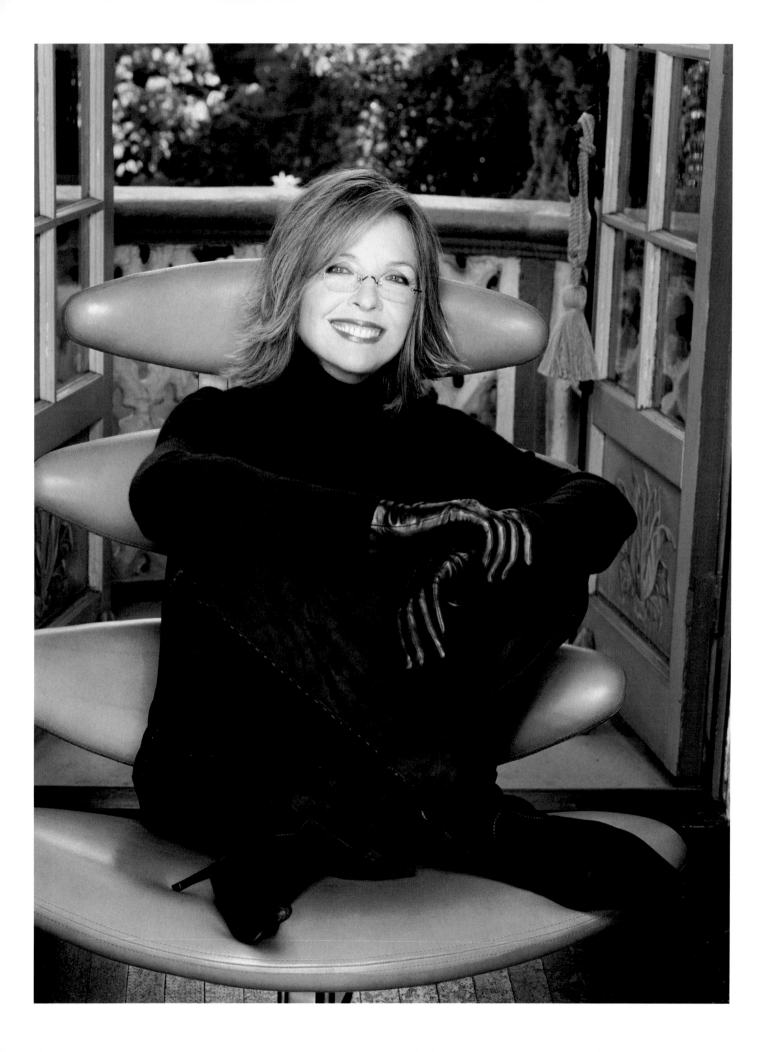

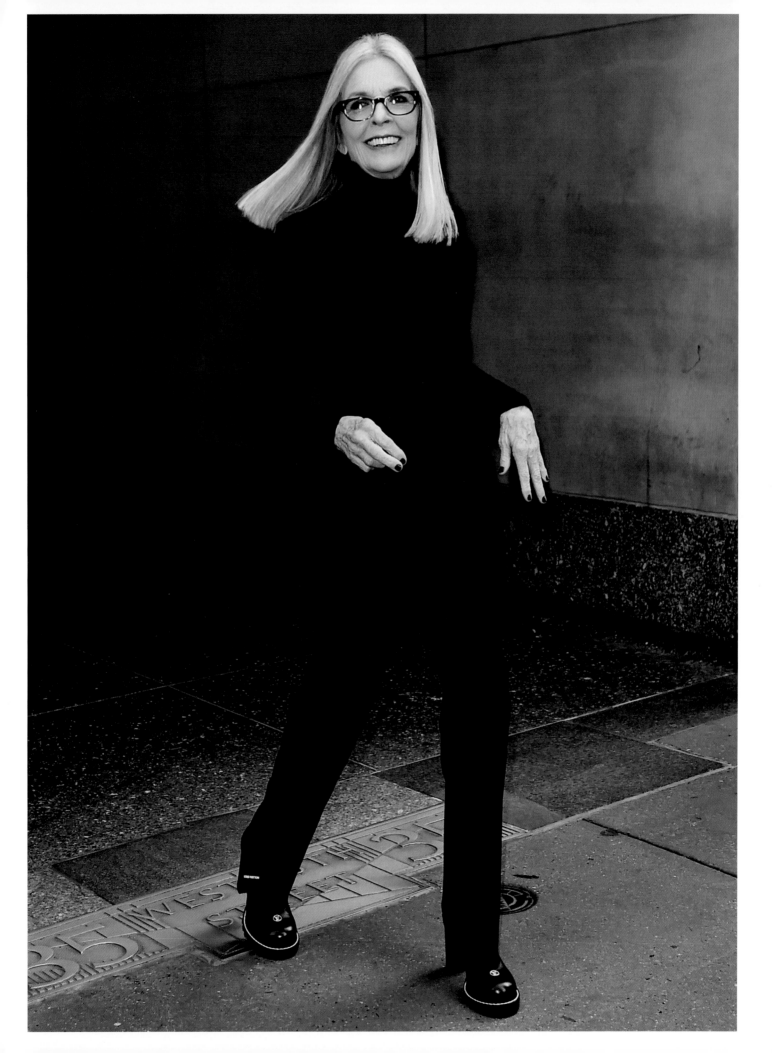

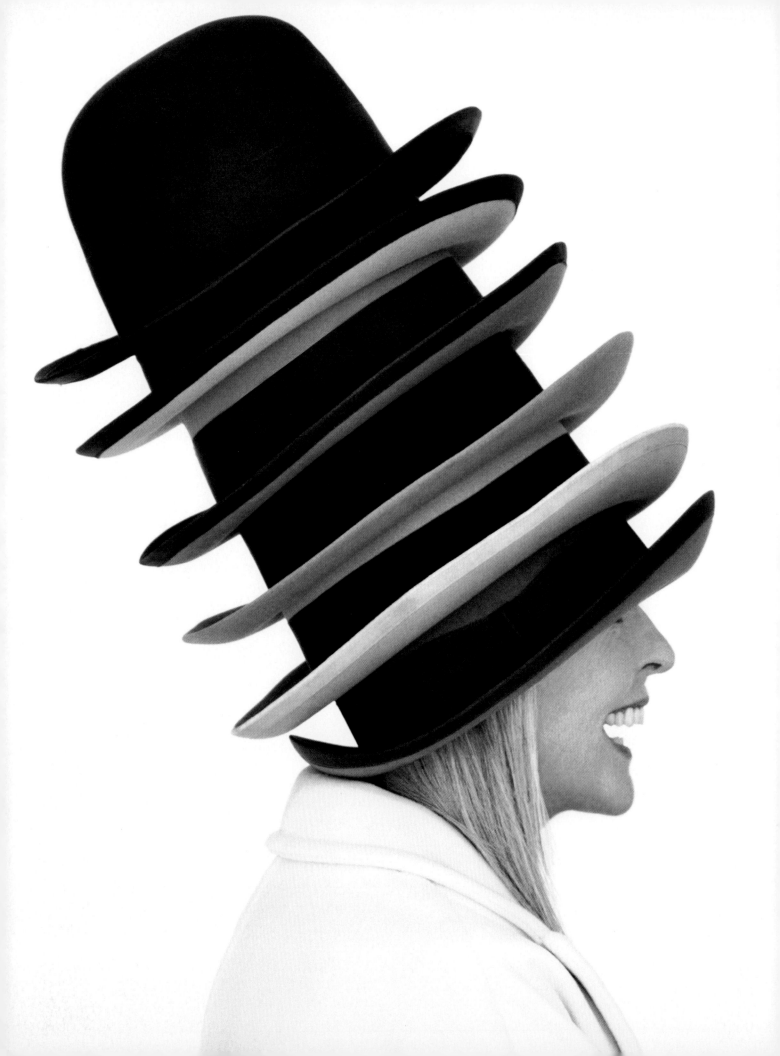

HATS

I started wearing hats as soon as I realized I hated my hair. A hat allows me to hide the worst part of the head. You know, that strange area from your eyebrows to your hairline? Some like to call it a forehead. I like to call it "my least favorite part of the body." A hat is the final touch to a great outfit.

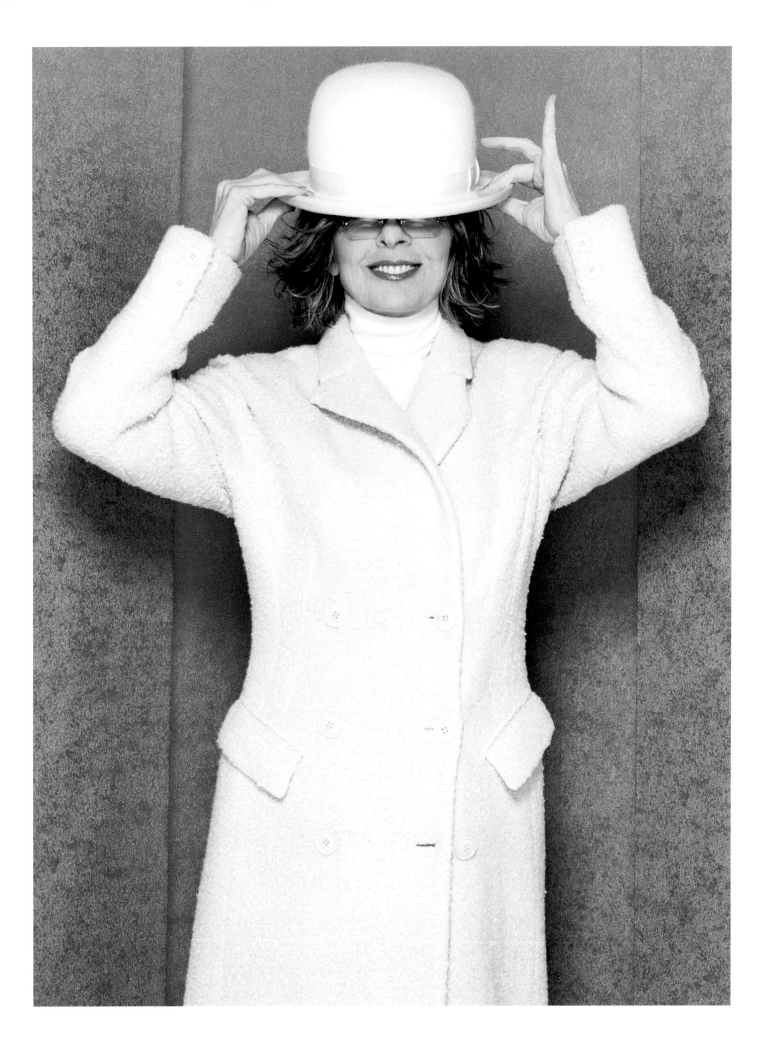

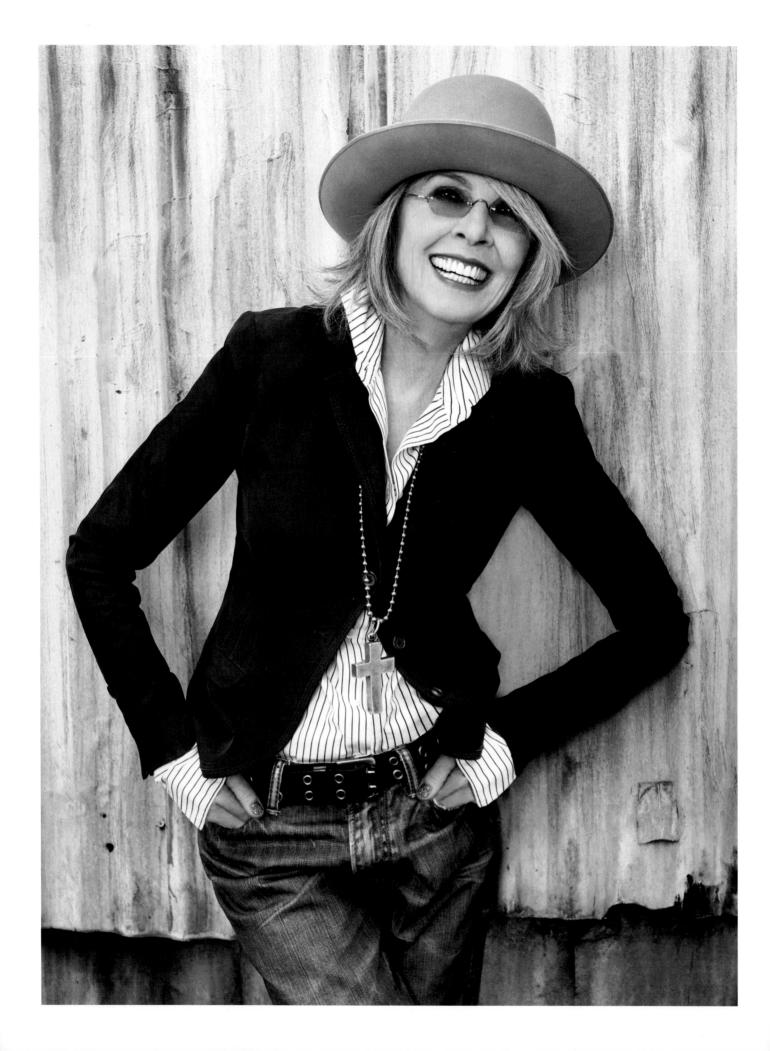

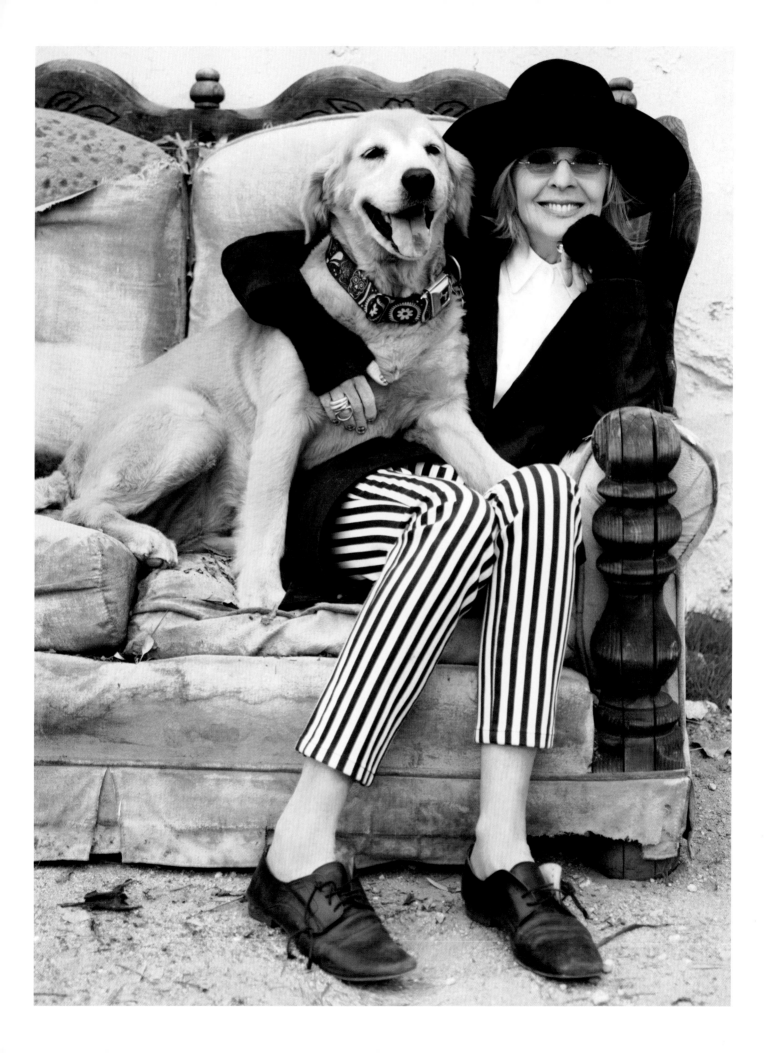

CANDICE BERGEN

Personally, I'm grateful everyone doesn't dress like her because we'd be surrounded by lunatics. I mean, who else could pull that off? The hats, the belts, the highest of collars, the weirdest boots. She's like a wacky secret service agent. And it's ALL THE TIME! She never does normal. She just does her, and she came up with it all by herself. In an age where we are tripping over stylists, nobody does it better than Diane.

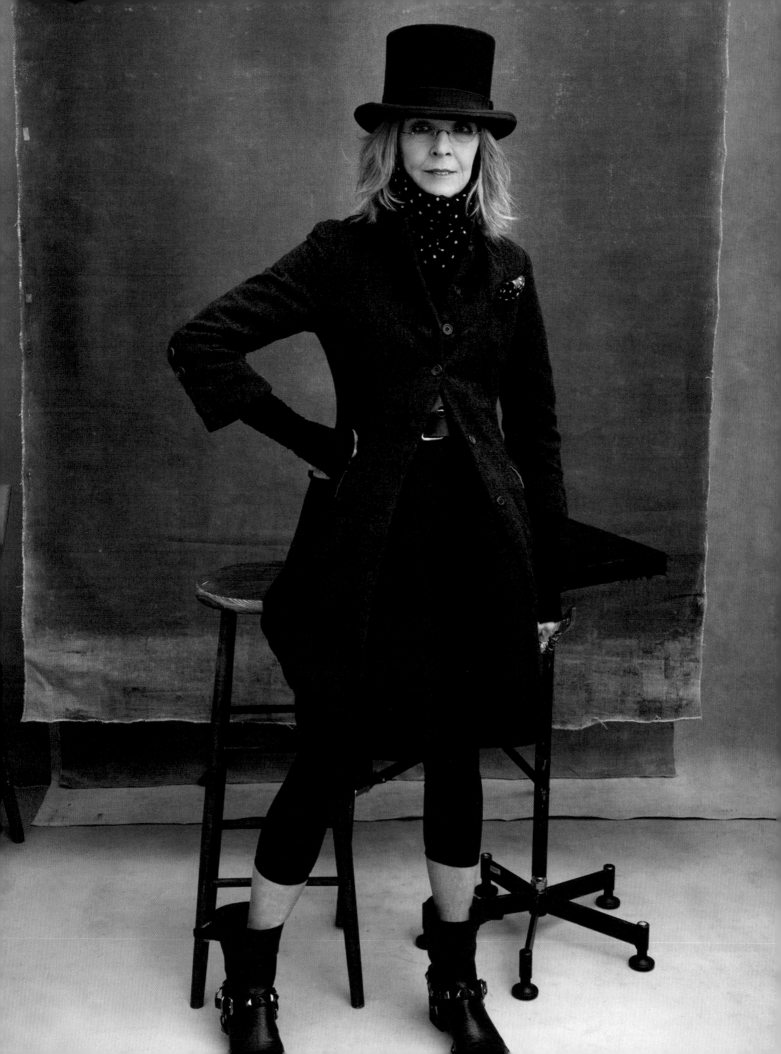

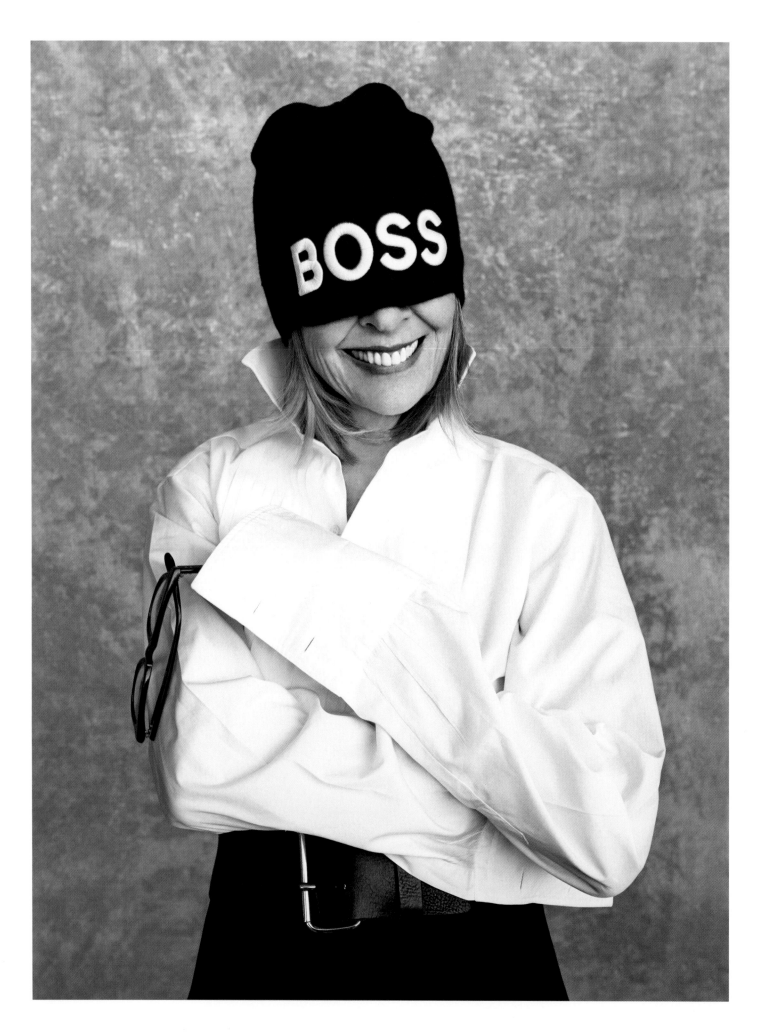

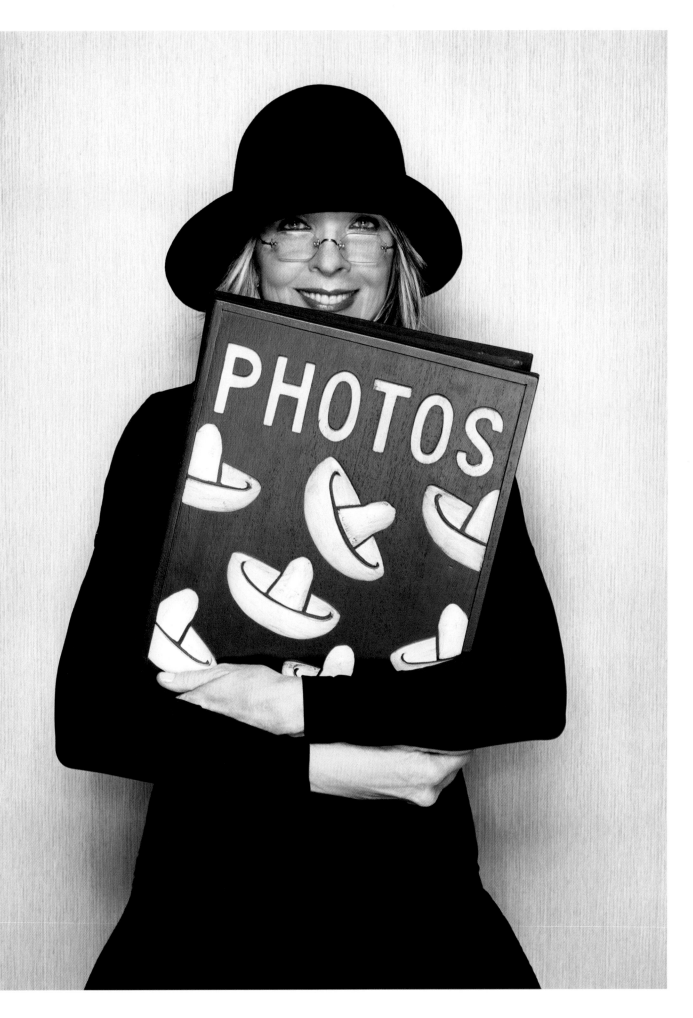

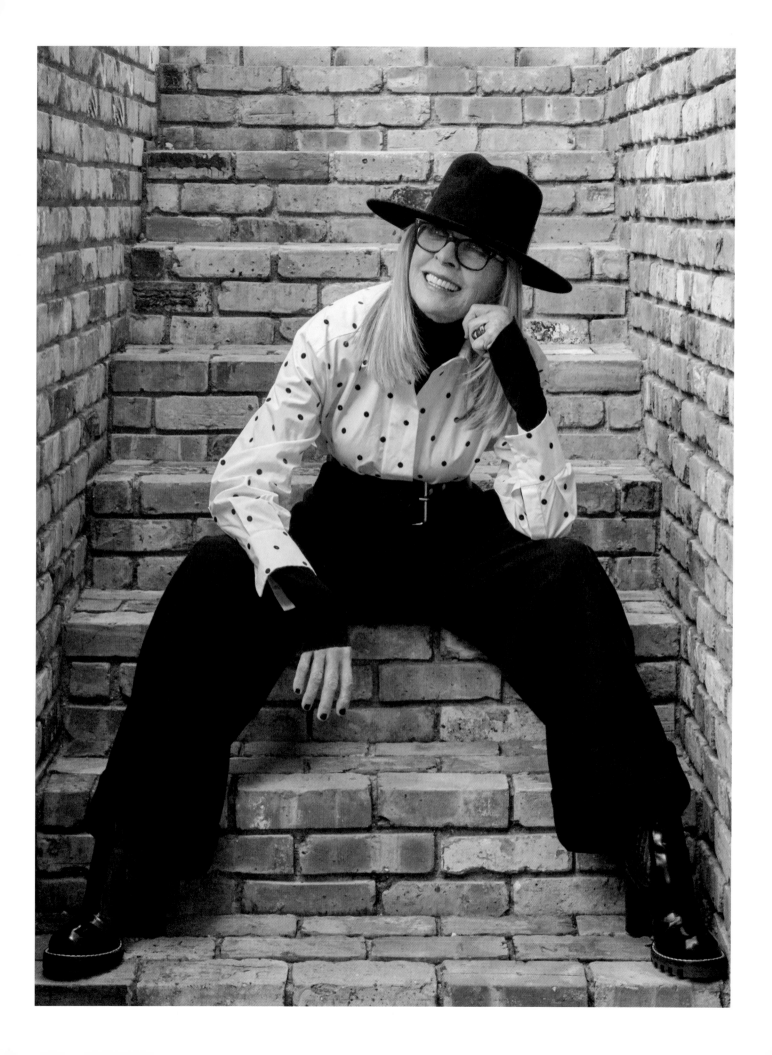

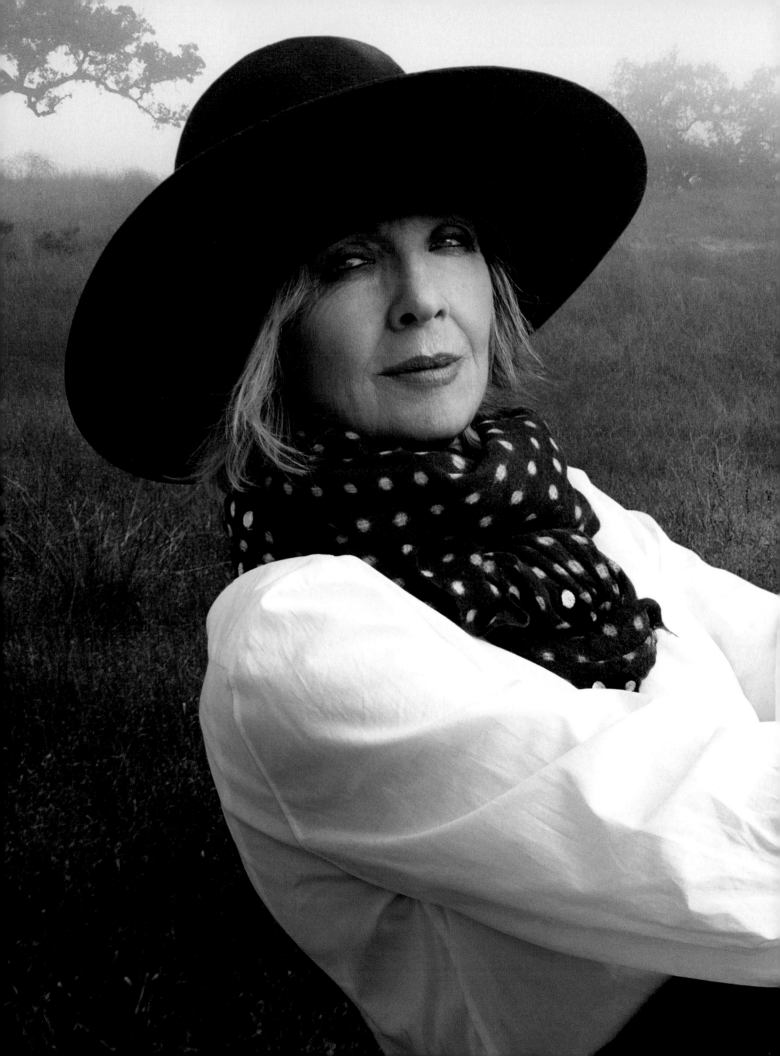

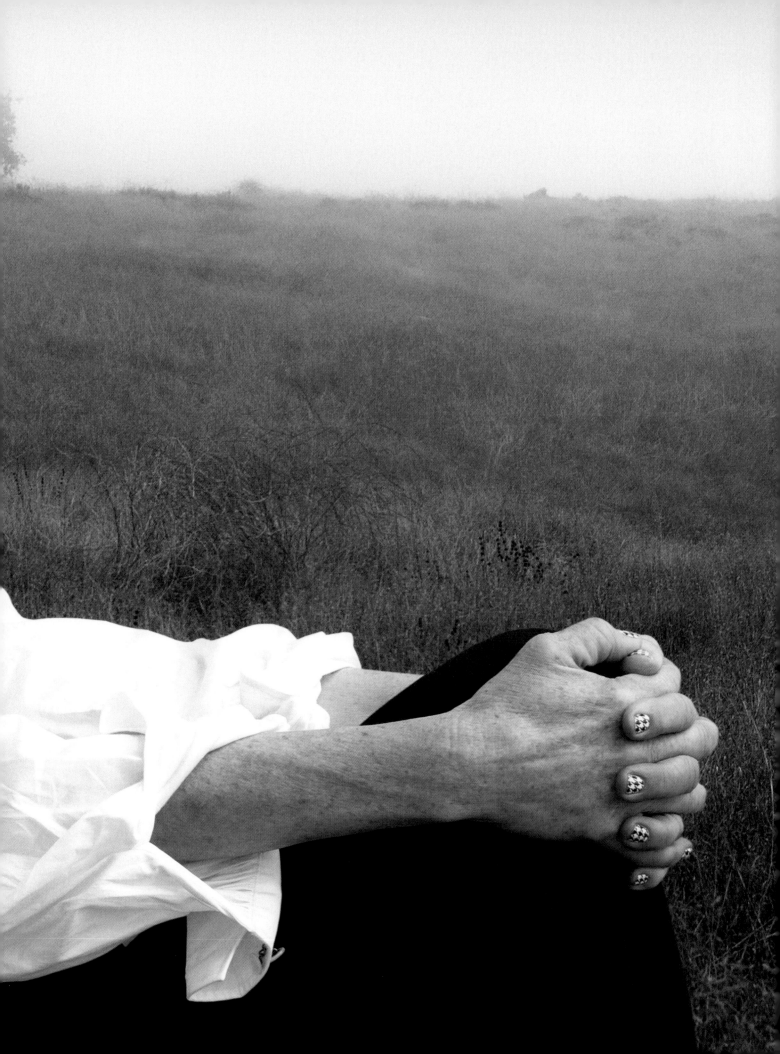

SUITS

I remember seeing people wear suits on television when I was younger and desperately wanting one despite being worn mostly by men. I was completely envious of people who wore them. There are so many wonderful things to love about a suit. The pants don't have to be too tight. Neither does the jacket. I like my sleeves to go down long, to cover me up. Suits make me feel comfortable. I remember in the '70s going into Ralph Lauren's store. I couldn't believe what I was seeing. It was the beginning of women's clothes being slightly more masculine—but not too masculine that you couldn't pull it off.

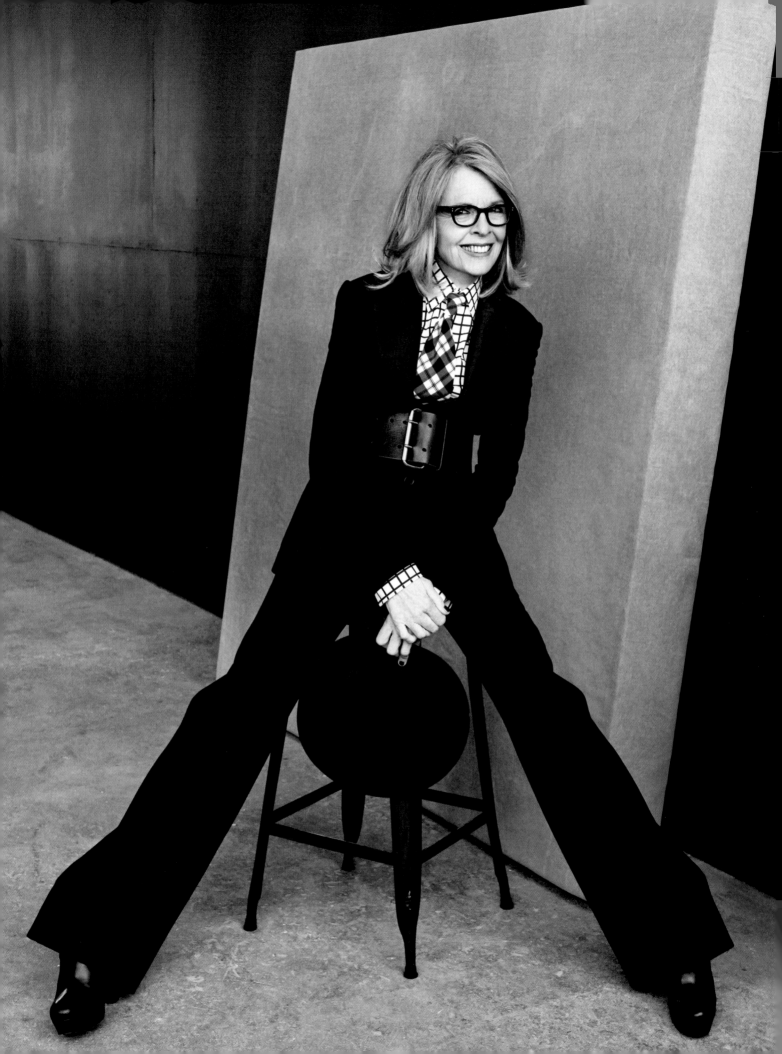

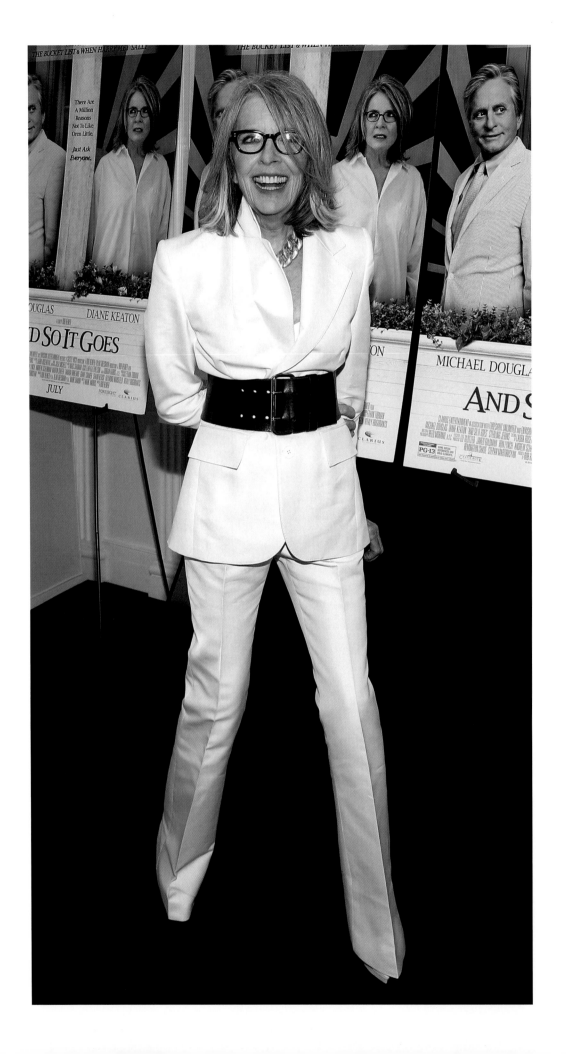

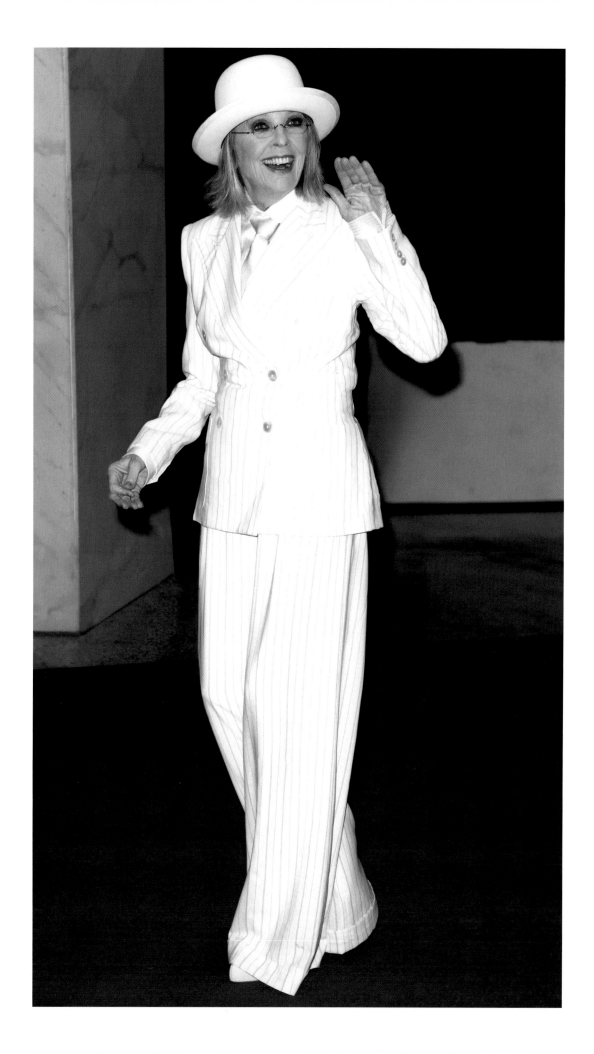

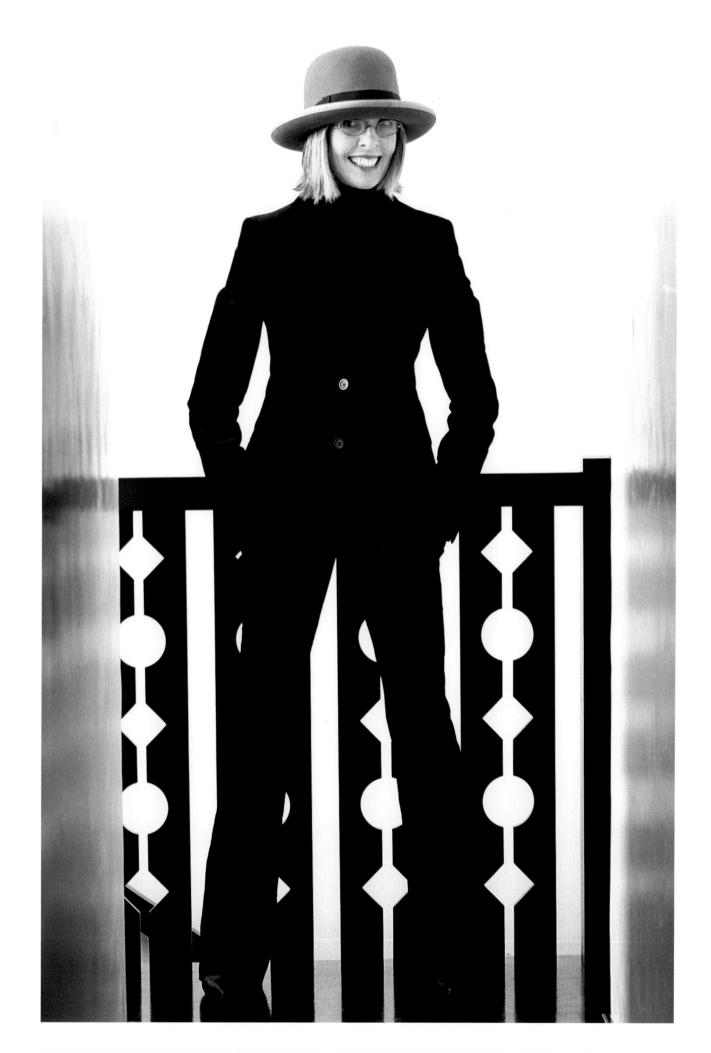

OLYMPIA GAYOT

A huge part of having great style is trusting your instinct, and Diane has always done exactly that. There's nothing cooler than confidence, which is why we all fell in love with Diane in *Annie Hall*—from her memorable performance to her impeccable eye. The way she wore traditional men's tailoring felt so fresh and playful, not to mention she styled all her own outfits in the movie! And before "street style" was such a common phrase in fashion, she was finding inspiration for those looks from all the chic New Yorkers she saw on the sidewalks. And who doesn't love a true innovator?

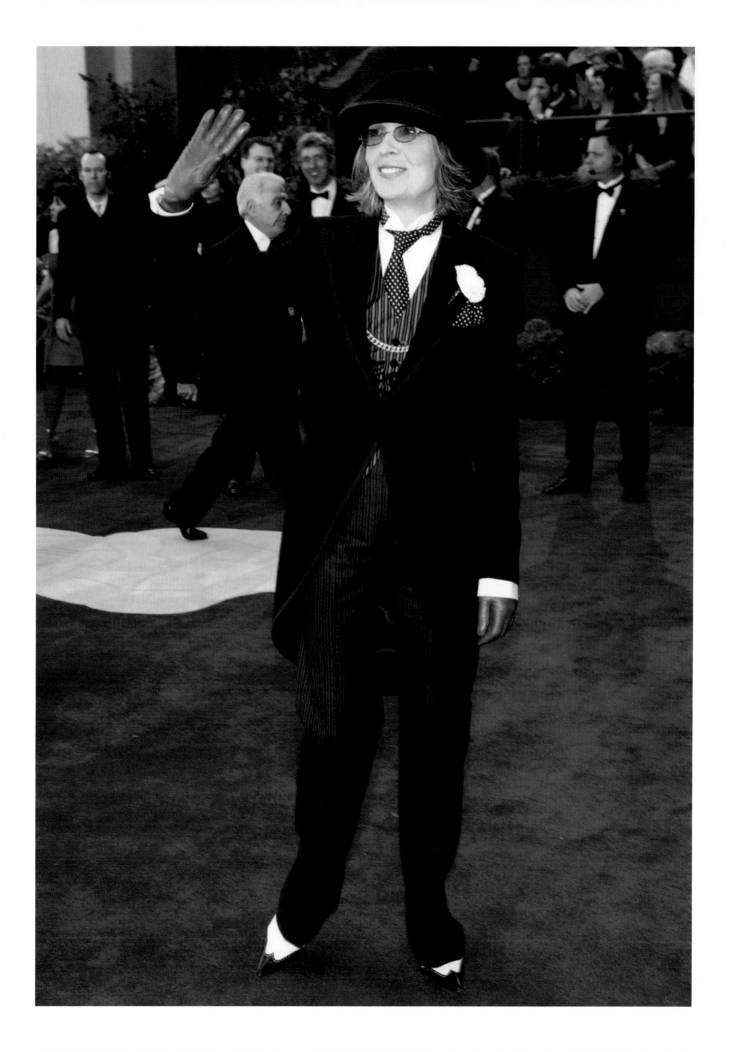

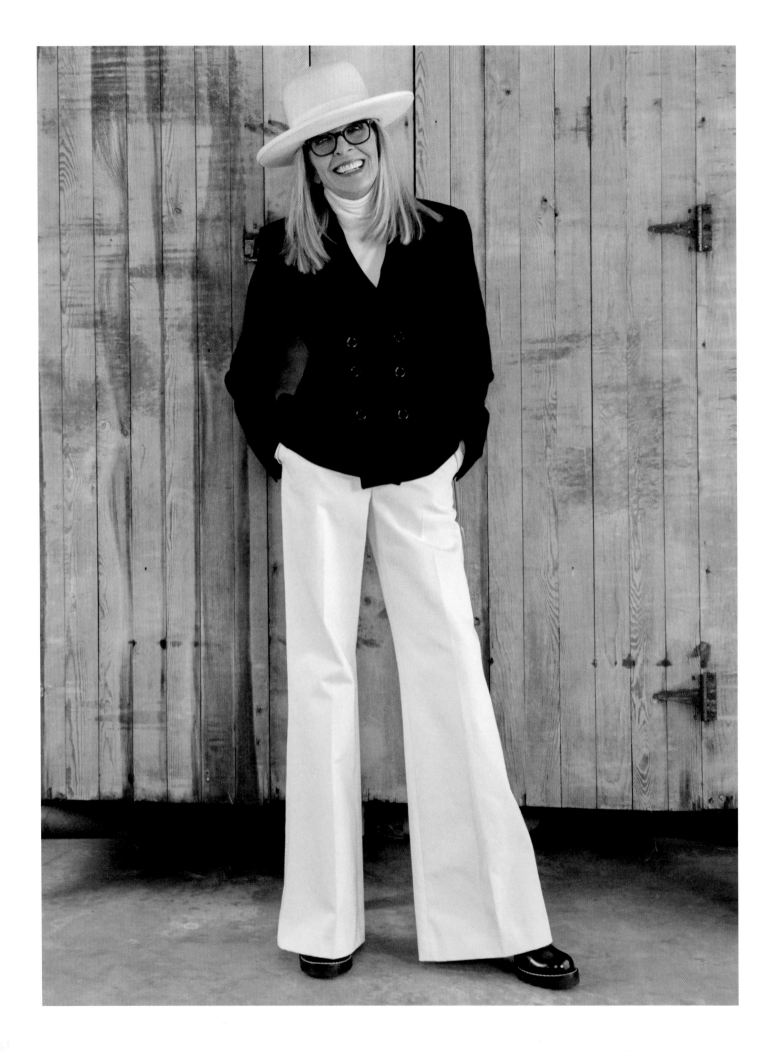

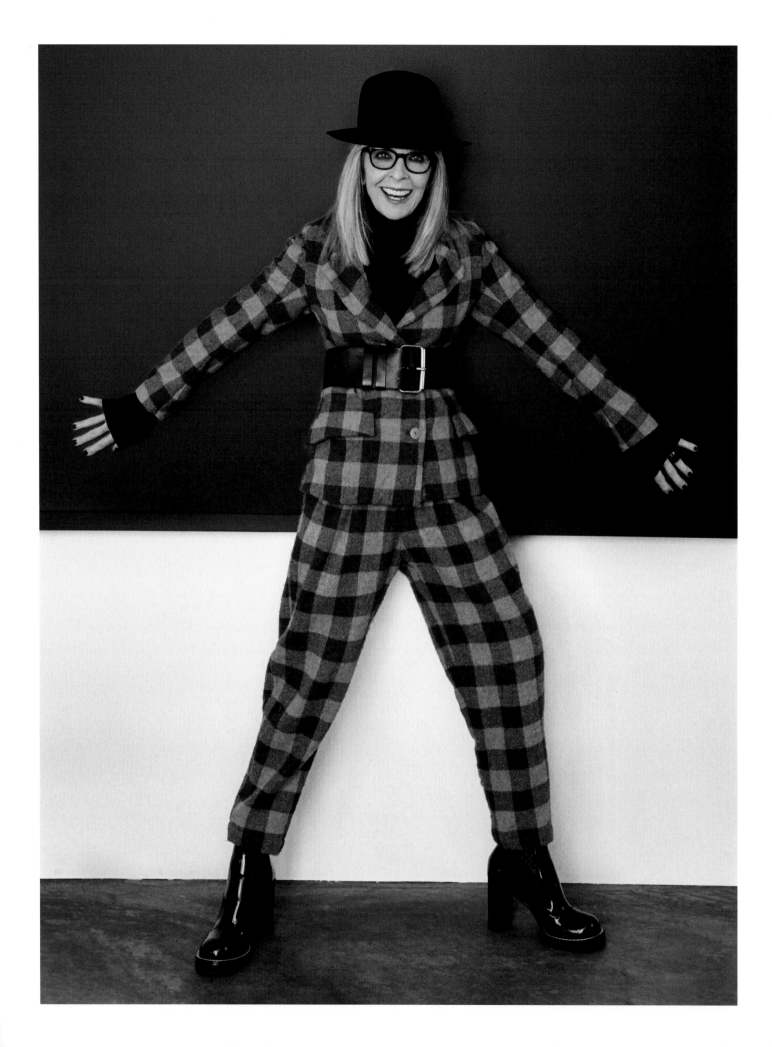

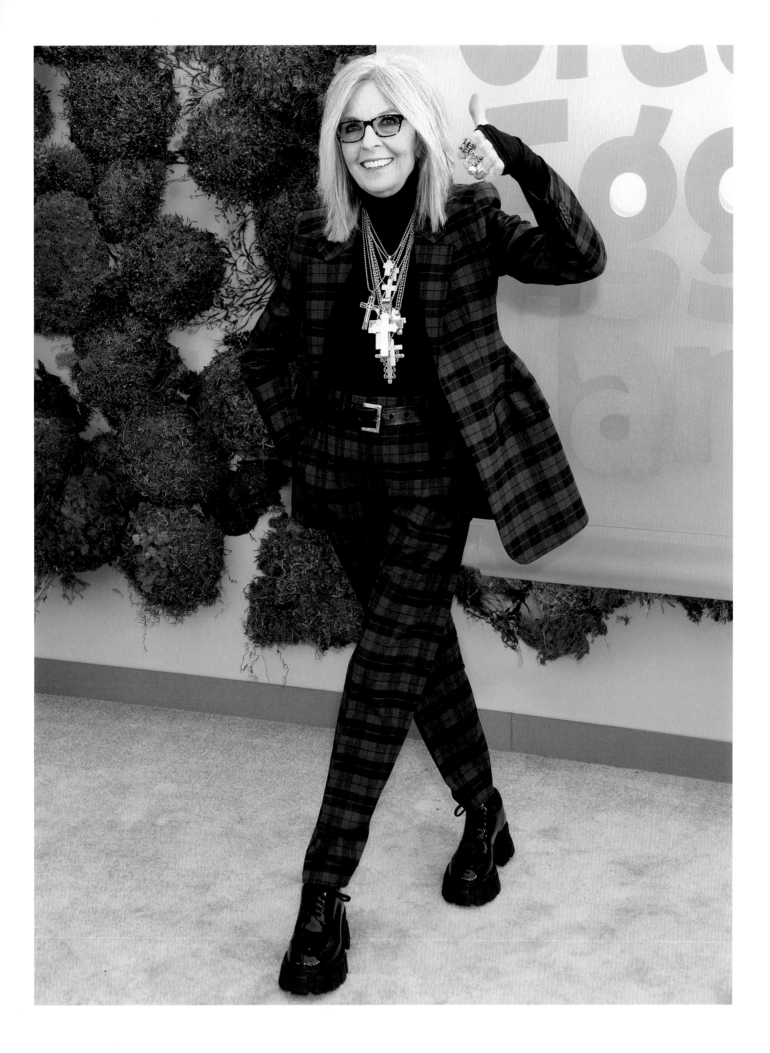

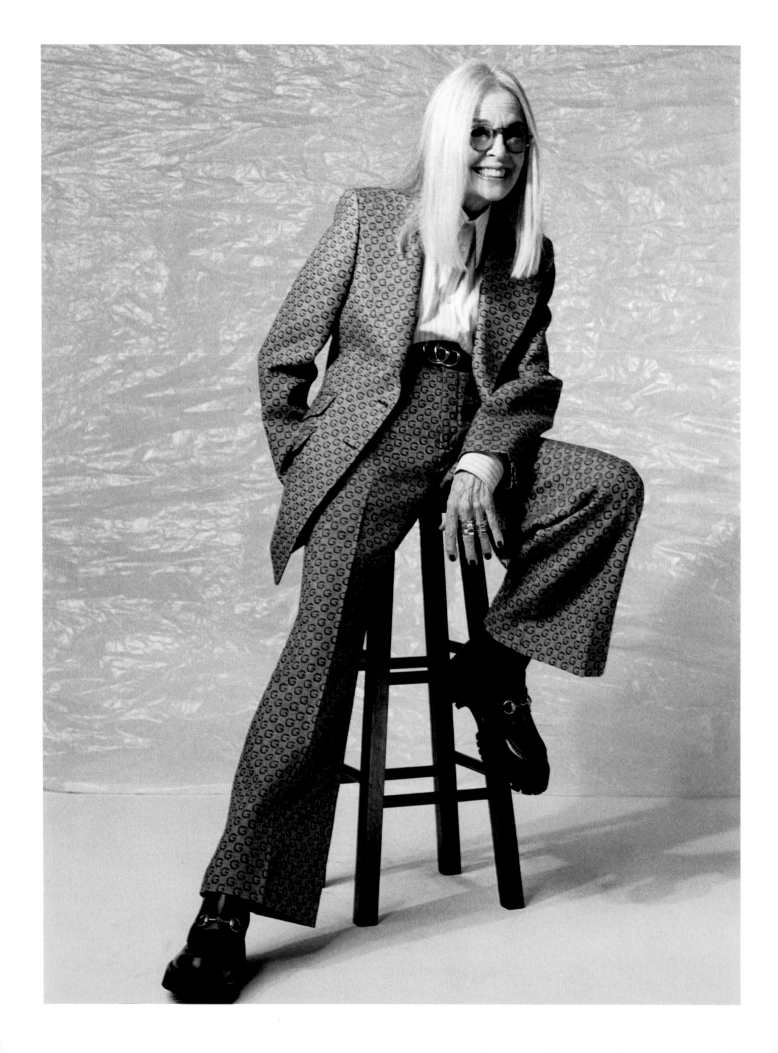

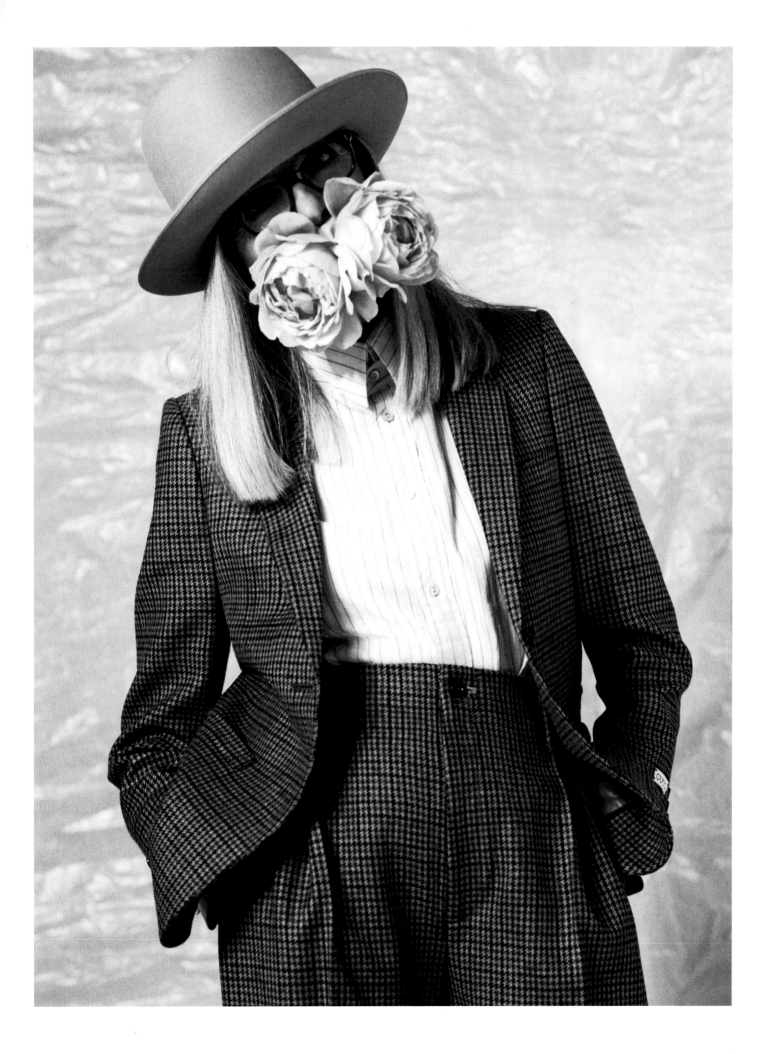

STREET STYLE

If I were to describe my so-called "street style," I would say, GET RID OF MY EN-TIRE BODY, including my eyes, my nose, my mouth, all of my legs, and the rest of me. Basically, I simply do not want my skin to be seen. Sadly, I need a nose and a mouth to live and breathe, but that doesn't mean I need to show them off.

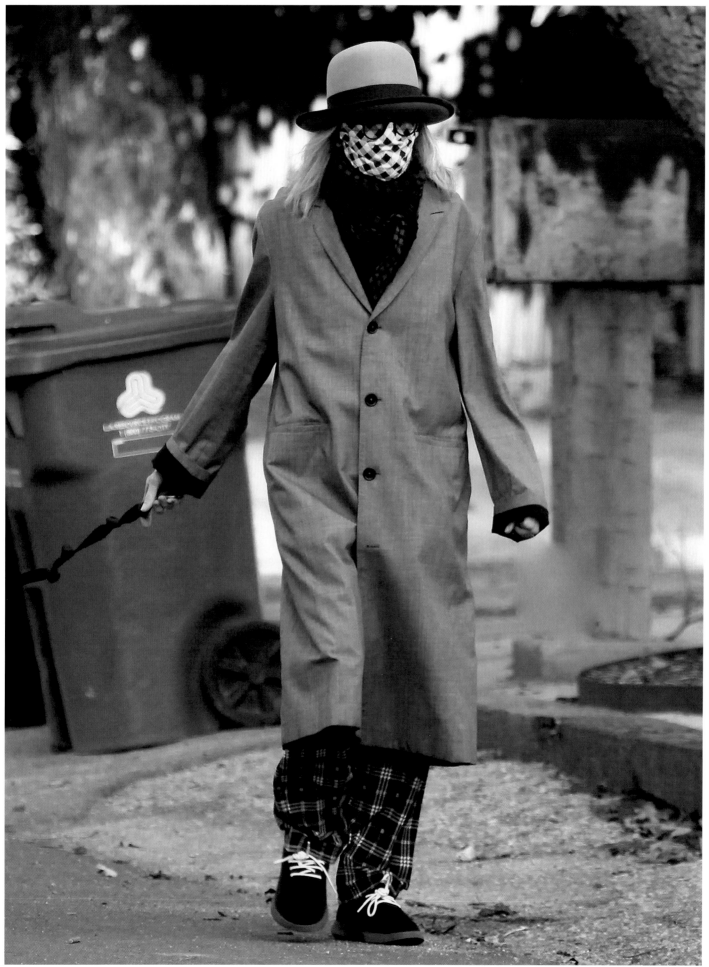

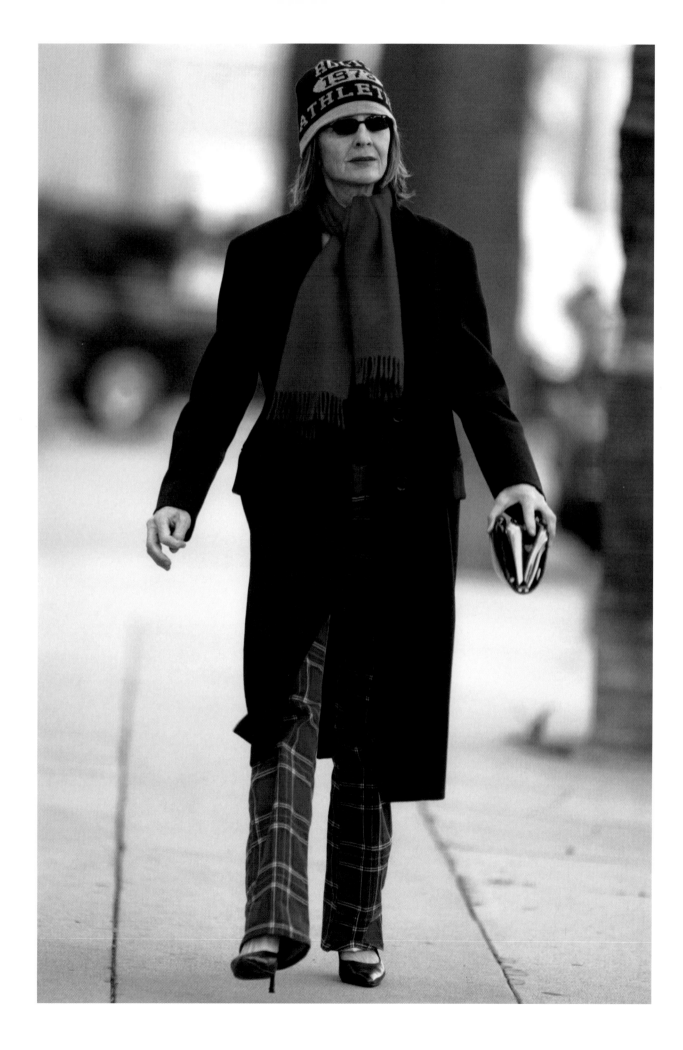

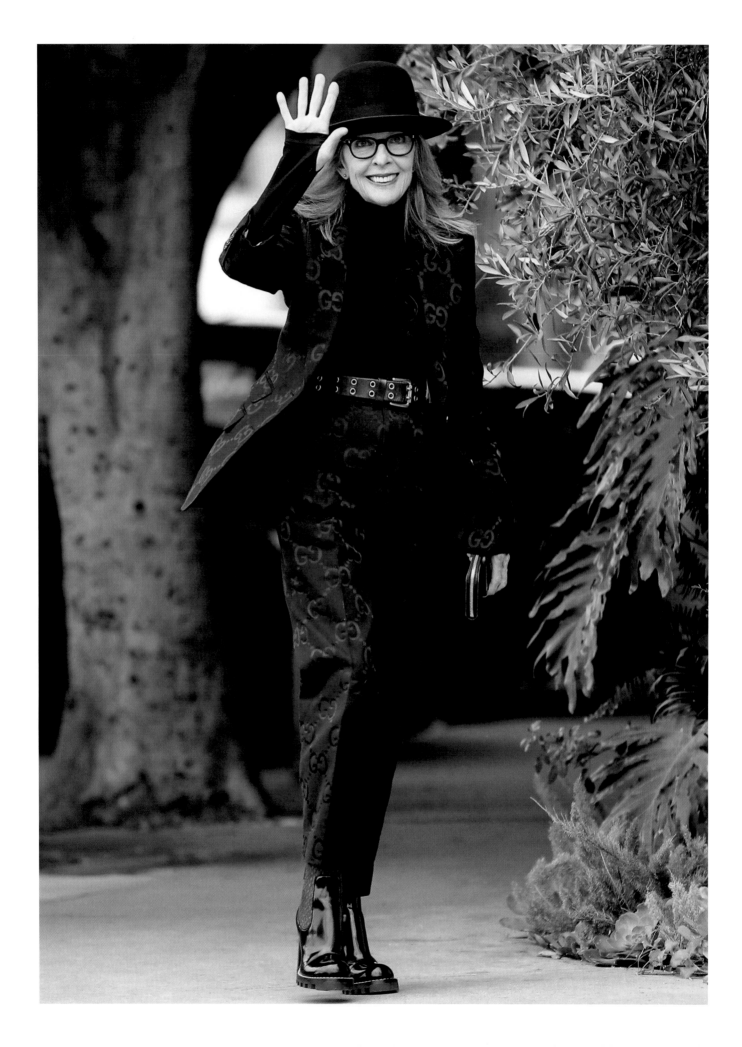

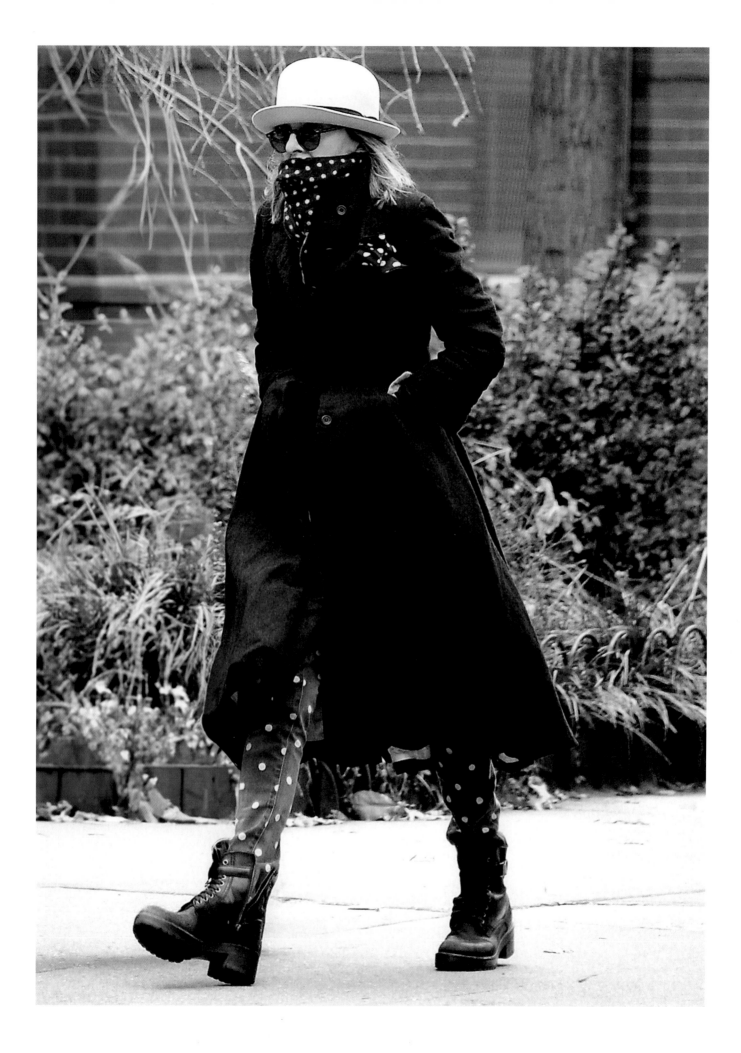

I can't help myself.

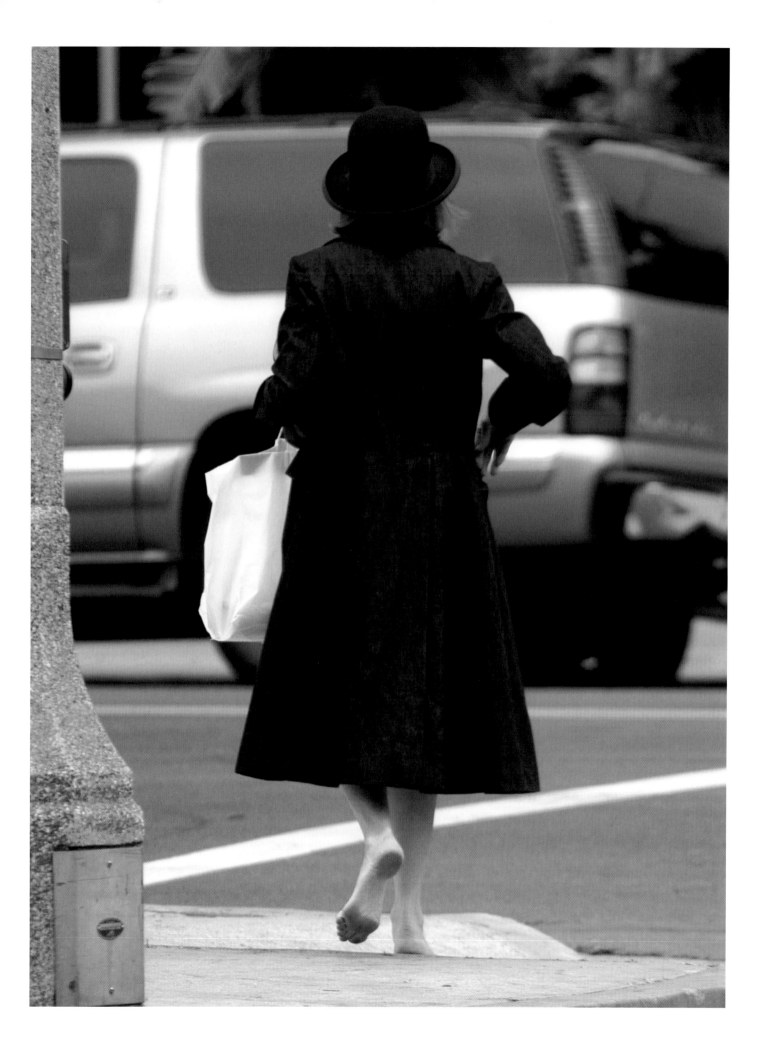

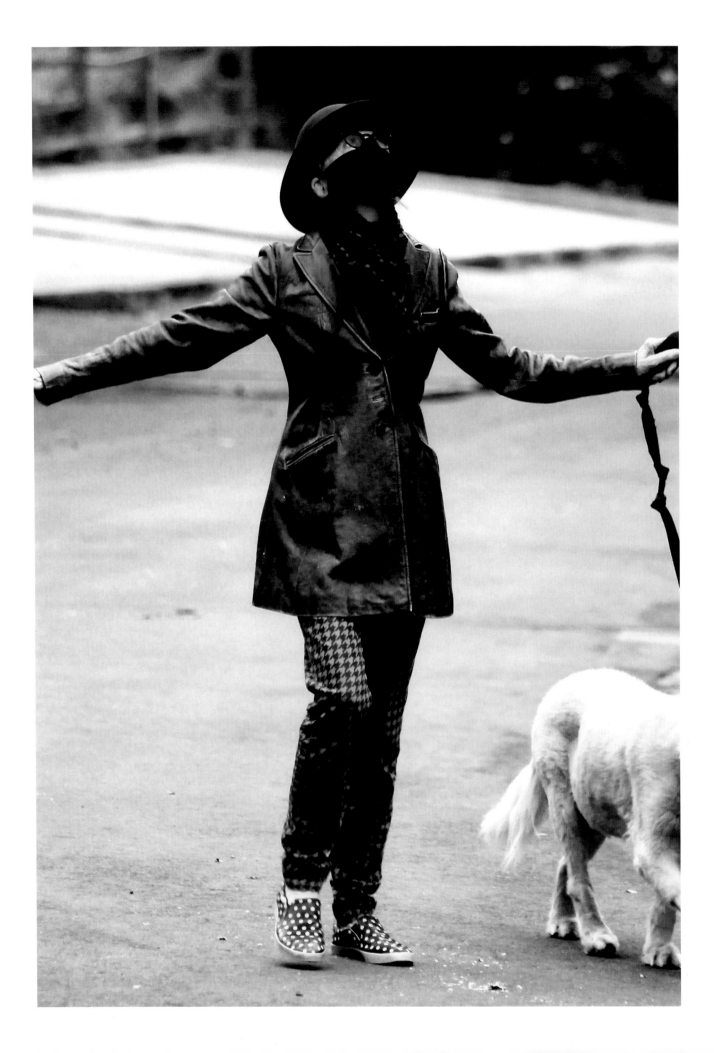

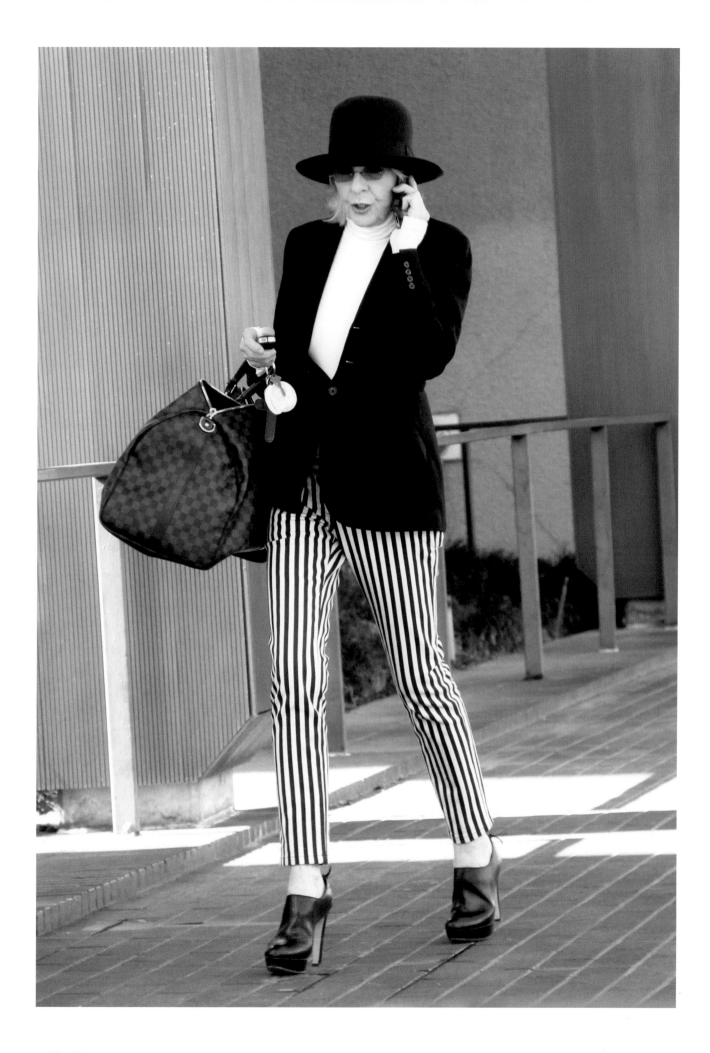

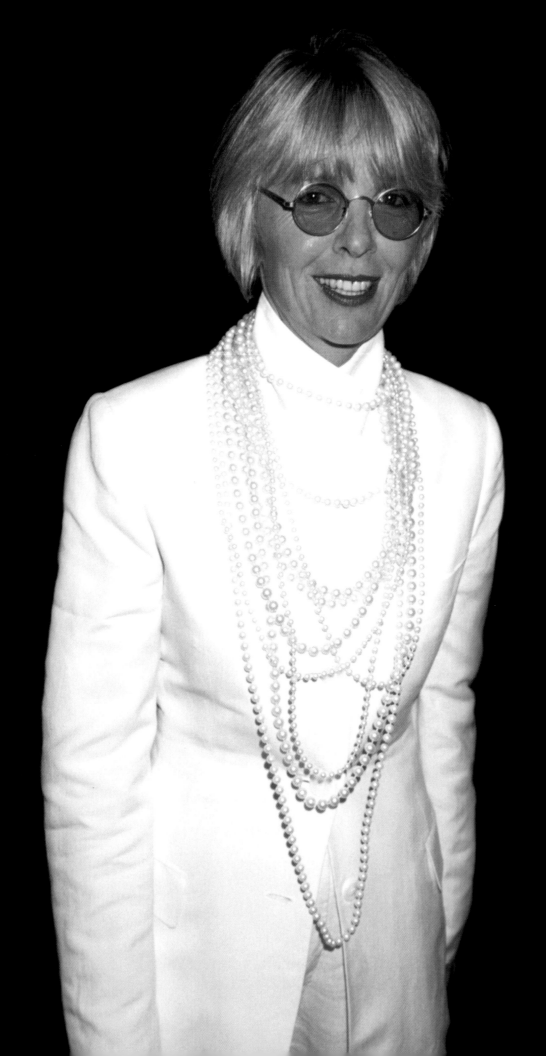

Here lies my many mistakes. Clearly, I didn't know what I was doing most of the time. Some of these outfits make me wonder if my family was worried about me. What can I say? I was trying things. But let's just put them to rest here, formally and forever—but not before making fun of them just a little bit.

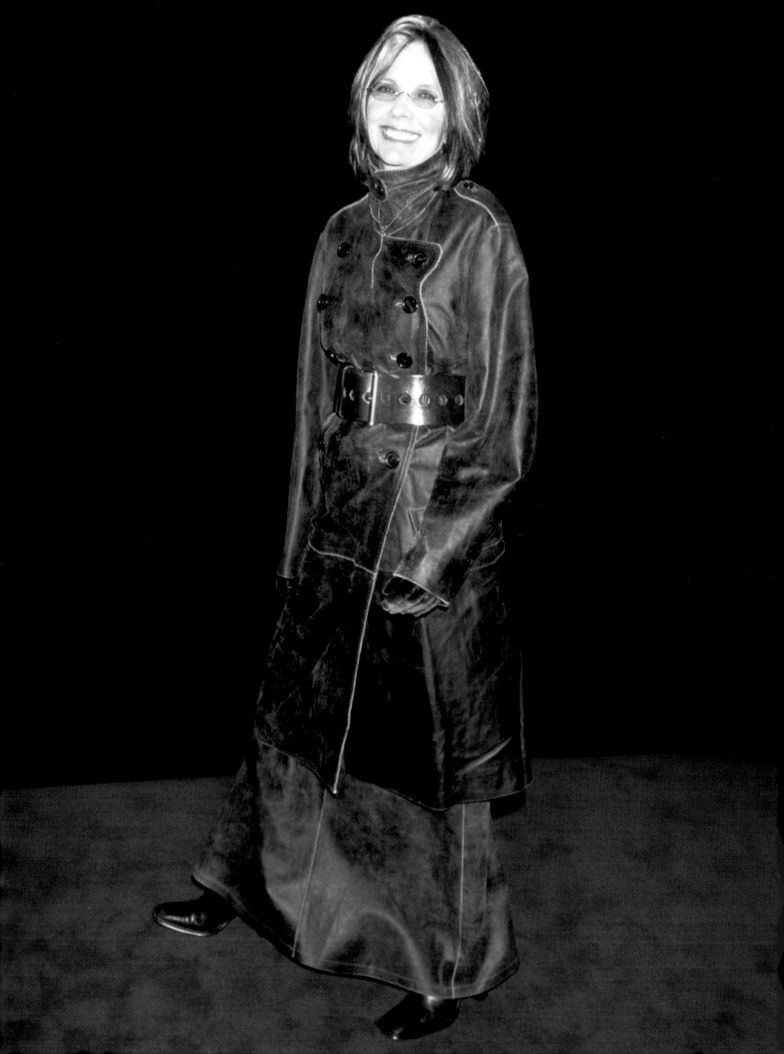

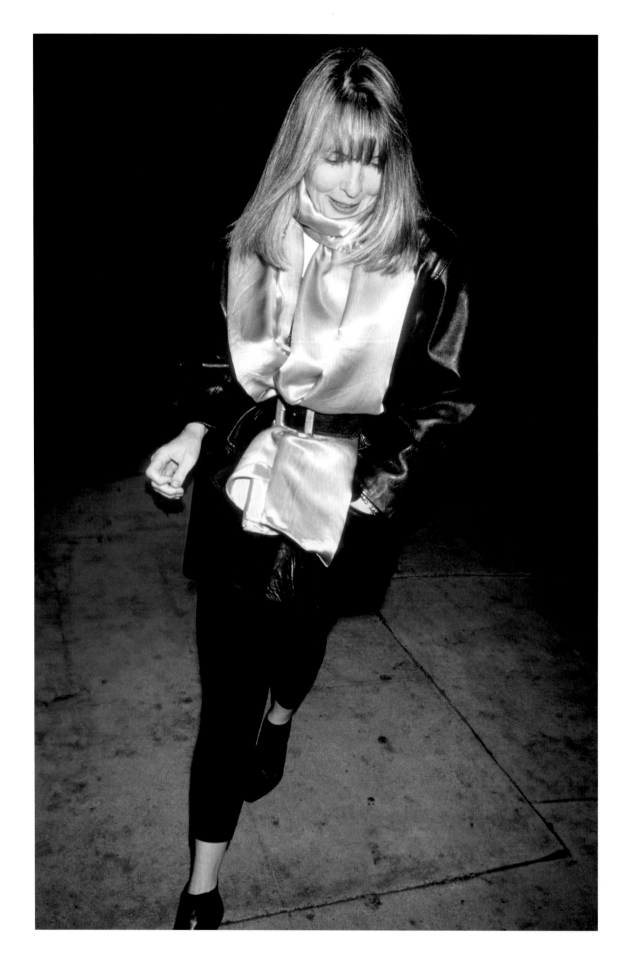

Someone, please help me.

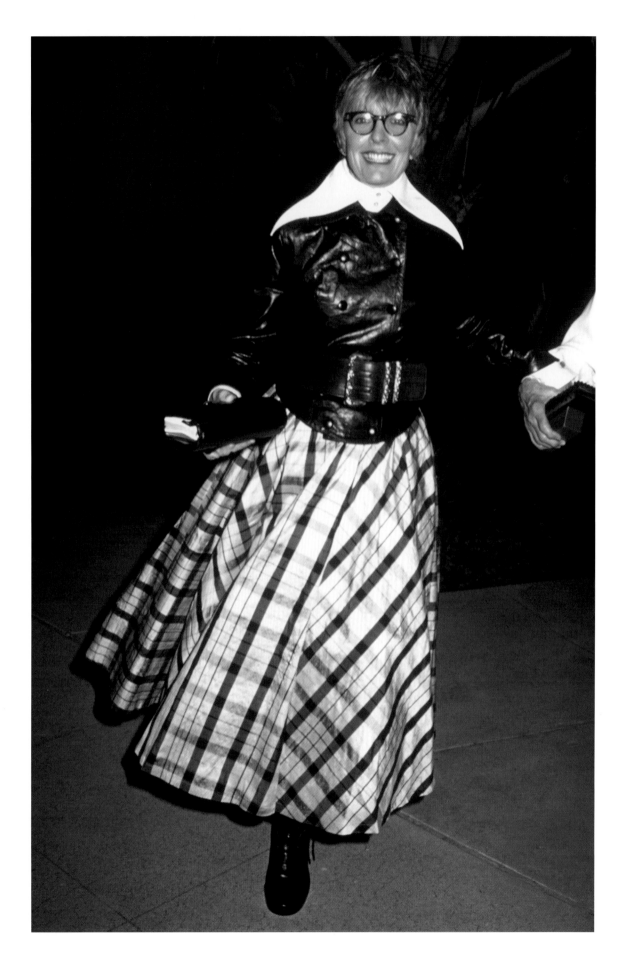

Hard to believe I chose this.

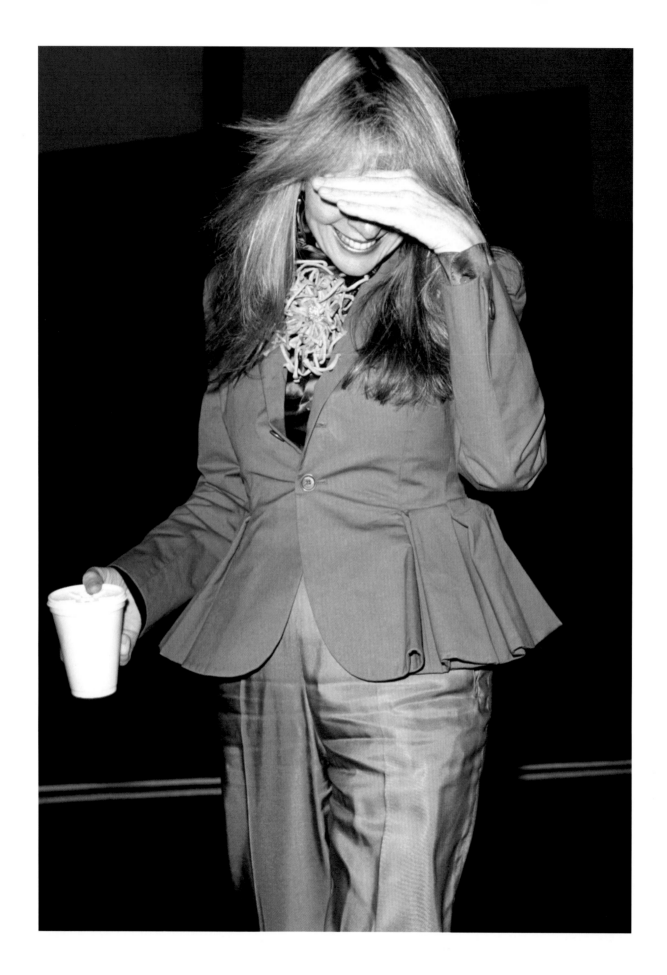

Apparently, I didn't own an iron.

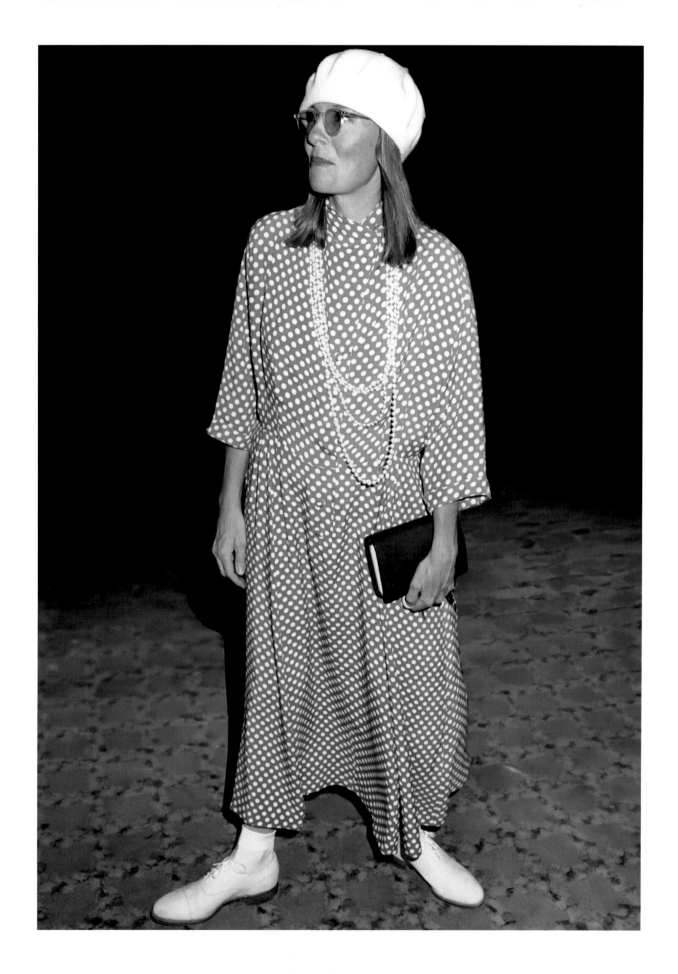

It's just disgusting.

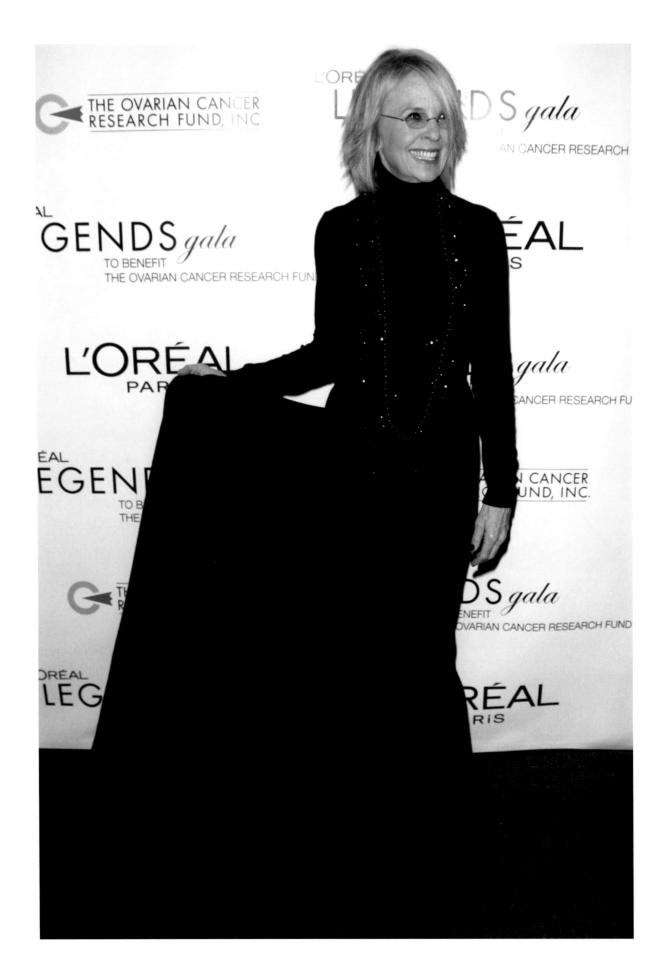

Somebody should have sued me.

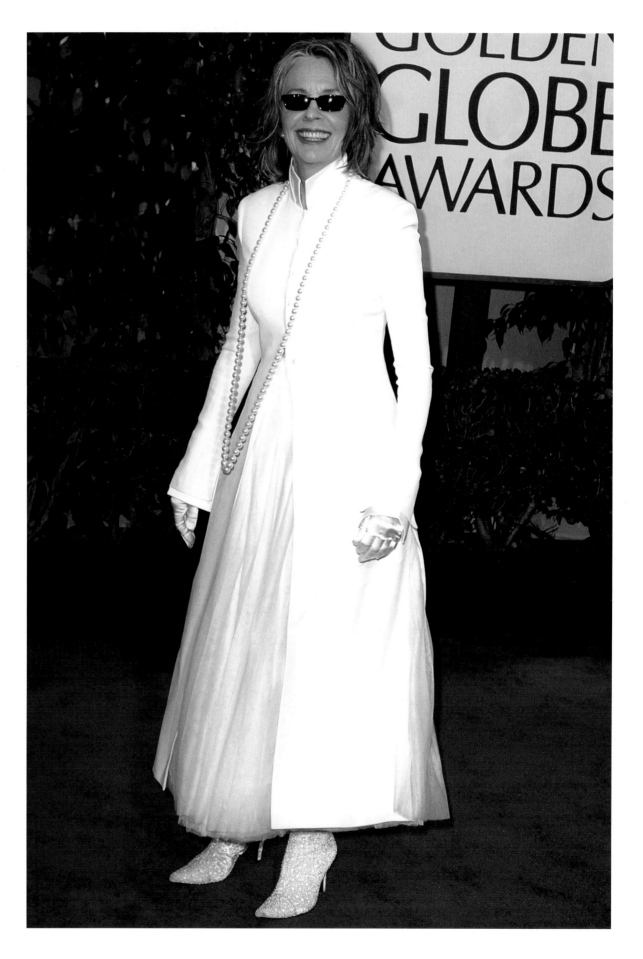

A lot of ideas, Diane.

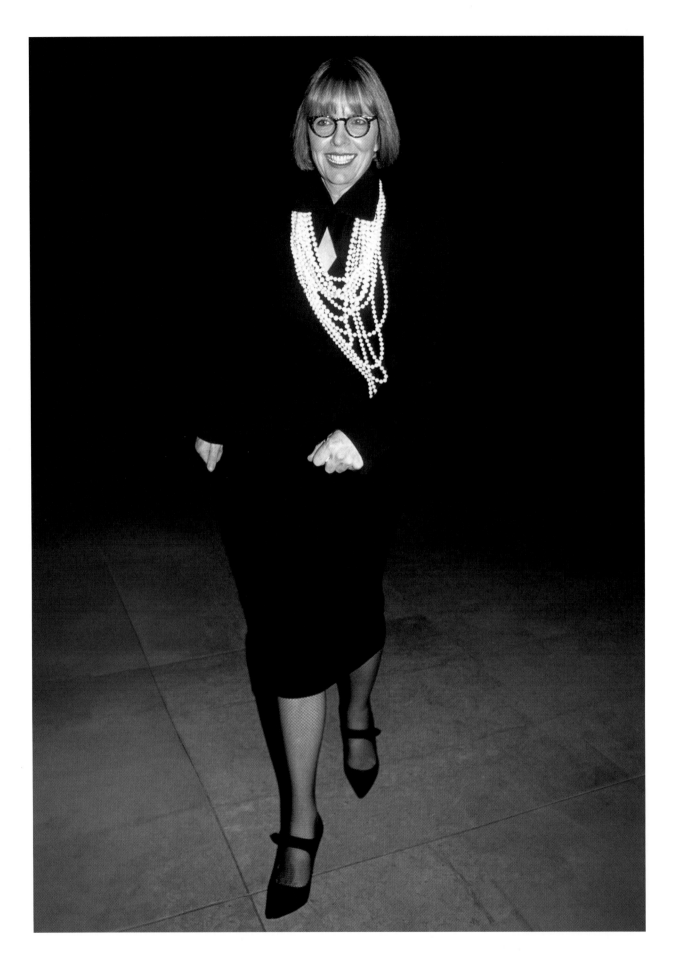

Those bangs?! No.

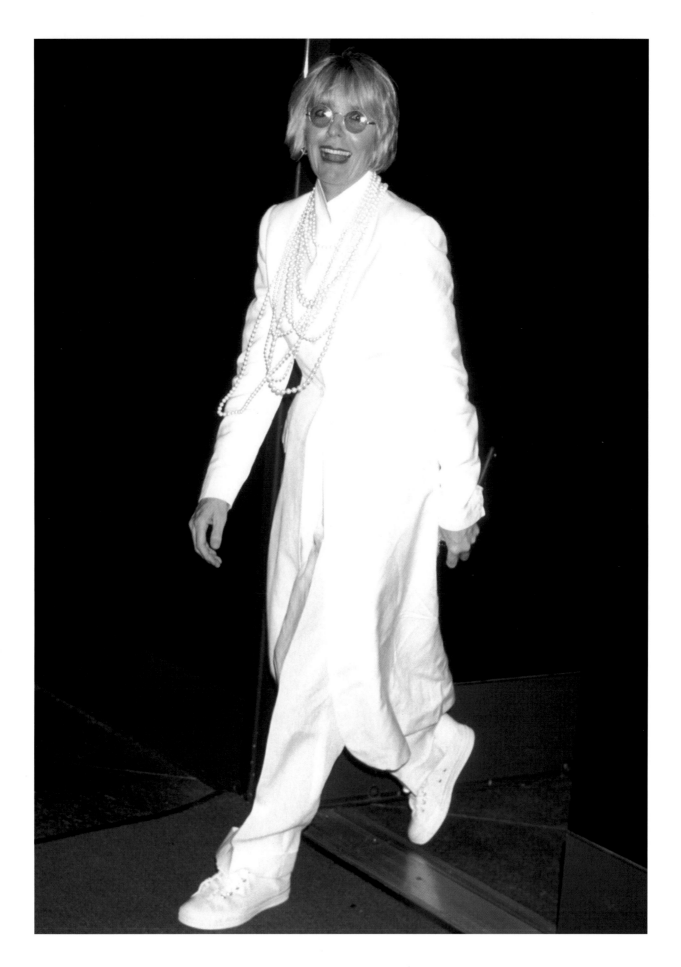

Sneakers?? Really?

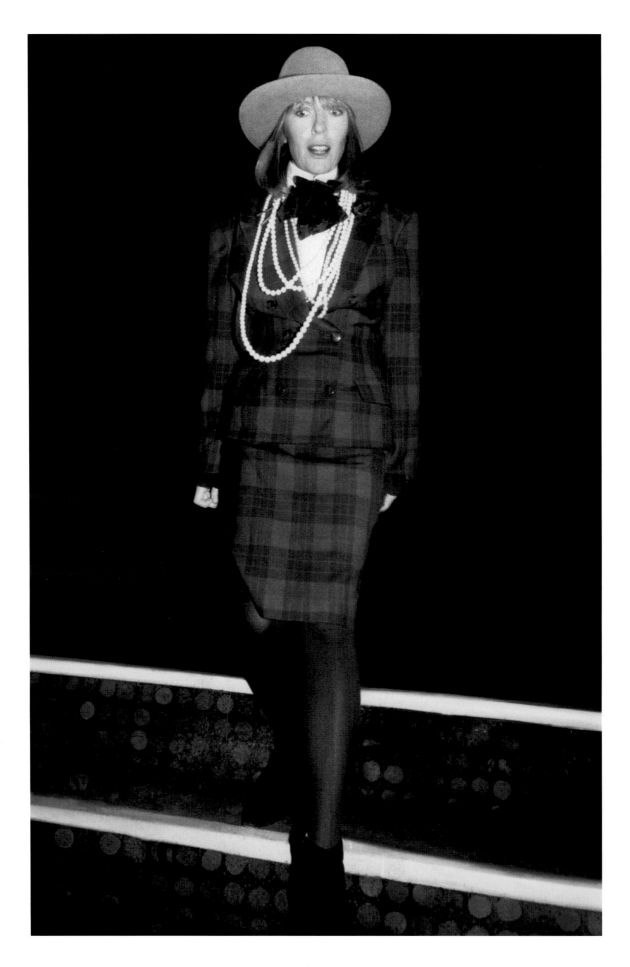

Forgive me.

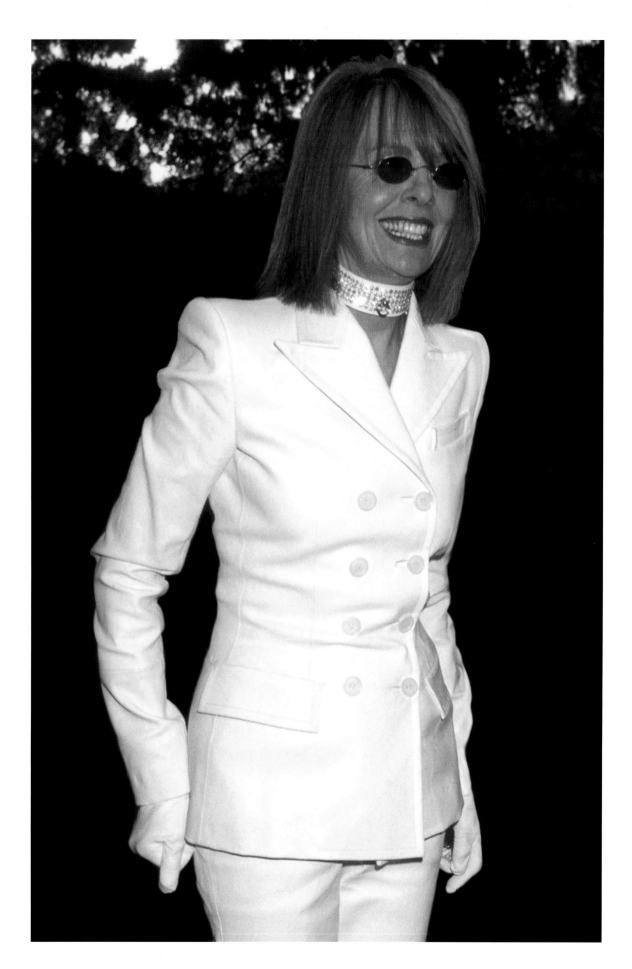

Dog collar?

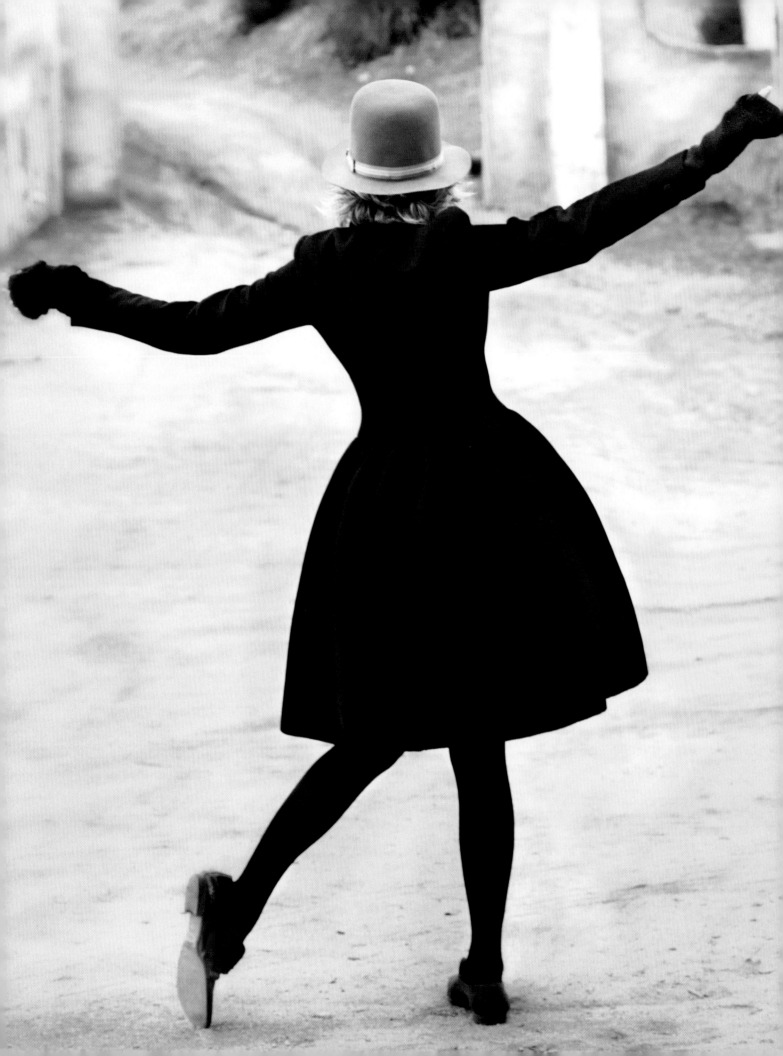

SPECIAL

ASHLEY PADILLA
STEPHANIE HEATON
REGGIE KEATON
RALPH LAUREN
GISELA AGUILAR
CHARLES MIERS
NICOLE WILLIAMS
SARAH JESSICA PARKER
KRIS JENNER
KIMBALL HASTINGS
JESSICA NAPP

THANKS

ANNIE LEIBOVITZ
RUVÉN AFANADOR
NORMAN SEEFF
ANTOINETTE PERAGINE
MARILYN ANDERSON
ROYA ROBATI
MILEY CYRUS
NANCY MEYERS
CANDICE BERGEN
OLYMPIA GAYOT
FIROOZ ZAHEDI

CREDITS

The Early Days
Pages 11–16, 18–22, 24, 26–28, 30–32, 34–37: Courtesy of Diane Keaton

1960
Pages 38, 41–44, 47–50, 53–55, 57–60, 69: Courtesy of Diane Keaton
Pages 51, 70: © Estate of Guy Gillette
Page 61: © Fairchild Archive/Penske Media via Getty Images
Pages 63, 65: © Image by Peter Basch, Basch LLC
Page 67: © Photo by Friedman-Abeles ©The New York Public Library for the Performing Arts
Page 72: © Photo by Kenn Duncan ©Billy Rose Theatre Division, The New York Public Library for the Performing Arts
Pages 74–75: © ZUMA Press, Inc./Alamy Stock Photo

1970
Pages 76–77, 79–89, 91–93, 95–99, 102, 103, 105, 107–110, 113, 118: Courtesy of Diane Keaton
Page 101: © Neal Barr
Pages 114, 115: © Ron Galella/Ron Galella Collection via Getty Images
Pages 116, 117: © Harry Benson
Pages 120–121, 123: © Norman Seeff
Page 124: © Gary Lewis/mptvimages.com
Page 127: © James Hamilton
Page 128: © Brian Hamill/Getty Images
Page 130 (top left): © Allstar Picture Library Limited./Alamy Stock Photo
Page 130 (top right): © Album/Alamy Stock Photo
Page 130 (bottom left): © Ronald Grant/ROLLINS-JOFFE PRODUCTIONS/Alamy Stock Photo

Wrong

First published in the United States of America in 2024 by
Rizzoli International Publications, Inc.
300 Park Avenue South
New York, NY 10010
www.rizzoliusa.com

Foreword: Ralph Lauren
Art Direction and Design: Ashley Padilla

Publisher: Charles Miers
Associate Publisher: Anthony Petrillose
Editor: Gisela Aguilar
Production Manager: Colin Hough Trapp
Managing Editor: Lynn Scrabis
Design Coordinator: Tim Biddick

Printed in Singapore

2024 2025 2026 2027 2028 / 10 9 8 7 6 5 4 3 2 1

ISBN: 978-0-8478-2781-7
Library of Congress Control Number: 2024933820

Visit us online:
Facebook.com/RizzoliNewYork
X: @Rizzoli_Books
Instagram.com/RizzoliBooks
Pinterest.com/RizzoliBooks
Youtube.com/user/RizzoliNY
Issuu.com/Rizzoli

MIX
Paper from
responsible sources
FSC® C167869